Photoshop 7:
Photographers'
Guide

David D. Busch

Photoshop 7: Photographers' Guide

Photos of Canon cameras (c)Canon USA, Inc. used with permission.

Credits: Senior Editor, Mark Garvey; Production Editor, Rodney A. Wilson; Copyeditor, Mark Goodin; Cover Design, Chad Planner, *Pop Design Works*; Interior Design and Layout, *GEX Publishing Services*; Indexer, Kevin Broccoli, *Broccoli Information Management*.

Publisher: Andy Shafran

Library of Congress Catalog Number: 2002105477

ISBN 1-929685-68-8

1 2 3 4 5 6 7 8 9 TC 06 05 04 03 02

MUSKA&LIPMAN

Muska & Lipman Publishing

2645 Erie Avenue, Suite 41

Cincinnati, Ohio 45208

www.muskalipman.com

publisher@muskalipman.com

Printed in Canada

About the Author

A former full-time professional photographer who was later seduced by technology, David D. Busch has since 1983 been a leading demystifier of computer and imaging technology. With books like *Digital Photography and Imaging, Digital Photography for Dummies Quick Reference, Photoshop Complete, Photoshop 6! I Didn't know You Could Do That..., Photoshop Instant Expert, Guerilla Guide to Great Graphics with the GIMP,* and *Astonishing Web Graphics with Kai's Power Tools,* Busch was the first person to win top category honors twice from The Computer Press Association (for both Macintosh and PC-oriented books). He's written nearly 70 books and has been a contributing editor and monthly columnist for ten different computer magazines (including *HomePC* and *Internet World*) and a regular contributor to others in both the IBM PC and Macintosh realms, such as *Computer Shopper, Macworld, NetGuide, Windows Sources, ZDNet,* and *Windows Magazine.*

Dedication

As always, for Cathy.

Acknowledgments

Most of all, thanks to Andy Shafran, who realizes that a book about a sophisticated full-color image editor like Photoshop doesn't make sense unless it's done in color, (D'oh!) and who is creative enough to publish such books cost-effectively. Extra thanks to Andy for giving me the time to do my very best. Also, thanks to developmental editor Mark Garvey for valuable advice as the book progressed, as well as production editor Rodney Wilson, copyeditor Mark Goodin, book/cover designer Chad Planner, and ANYBODY ELSE I FORGOT. Due credit also must go to several of the behind-the-scenes masterminds like Kris White and Sherri Schwartz, who were instrumental in getting this book packaged and out on the shelves.

Thanks also to my family and the country of Spain, without whom there would have been a lot of blank spaces in this book where the illustrations were supposed to be; and to historian/photographer Candace Wellman for her gorgeous photos of Ireland (they're the ones with the really green foilage). Who says research has to be tedious?

Special thanks to my agent, Carole McClendon, who has been telling me for years that I would really enjoy doing a book for Course Technology/Muska & Lipman. She was right.

Preface

If you're serious about photography, you should be serious about Photoshop 7, too. Whether you're a casual snapshooter, a dedicated photo buff, or a professional photographer, you have a major advantage over those who approach Adobe's flagship image editor from other backgrounds. You have experience and a working knowledge of the kinds of imaging and darkroom techniques that Photoshop was designed to mimic, enhance, and surpass. You'll find that approaching Photoshop from a photographer's perspective can put you on the fast track to mastering all the tools Adobe puts at your disposal.

Using Photoshop as an extraordinary photography tool can also work for you even if you are *not* currently a serious photographer. If you specialize in computer technology, art, or graphics, you will find that learning about the imaging techniques that form the basis for each of Photoshop's capabilities can help you, too. A deeper understanding of photography will help you make better use of the image editor, thus allowing you to improve latent photographic skills you may not have known you had. Anyone who fine-tunes and manipulates photos will find this book makes them a more proficient, well-rounded image worker.

If you feel there isn't enough photography in the average Photoshop book, and there isn't enough Photoshop in the average photography book, then the book you're looking for is right in your hands. Whether you're a snapshooting tyro, or an experienced photographer moving into the digital realm, you'll find the knowledge you need here.

Introduction

Photoshop and photography were made for each other. Whether you're using a digital pixel-grabber or a conventional film camera, Adobe's revamped flagship image editor, Photoshop 7, has the tools you need to fine-tune your photos; correct errors in exposure, lighting, or color balance; and go beyond your basic picture to create triumphant prizewinning photographs from shoe box rejects.

Photoshop 7: Photographers' Guide is aimed squarely at those who want to creatively use photography to produce compelling images and who want to master all the tools available to them. The emphasis here is on both traditional and cutting-edge photographic techniques, and how to reproduce or enhance them in Photoshop.

You don't need to be an ace photographer or a Photoshop expert to create these eye-catching effects. All you need is this straight-forward, "all meat" book that shows you how to use Photoshop to enhance your images with the kinds of effects you admire. Did you know that using easily mastered Photoshop tools you can:

> ▶ Duplicate colorful cross-processing darkroom effects
> ▶ Correct perspective in architectural photos even if you don't own an expensive perspective control lens
> ▶ Add zoom lens blur effects without using a zoom lens
> ▶ Move a storm-ravaged seashore 500 miles inland to the foothills of a mountain range
> ▶ Excise your obnoxious ex-relative from a family reunion photo without resorting to violence
> ▶ Transform daylight scenes into images of a moody dusk or a ruddy dawn
> ▶ Make mountains out of foothills
> ▶ Morph images to blend or distort them
> ▶ Seamlessly extract images from their backgrounds

For photographers, this book cuts right to the heart of all of the most misunderstood[md]but easily applied[md]tools in the latest version of Photoshop. This book bristles with surprisingly effective examples, simple to follow techniques, and tricks that serve as a jumping-off point to spark your own creativity into action.

While other Photoshop photography books give lip service to true photography, this book examines each topic from every photographic angle. Which effects are best achieved with a film or digital camera? Which effects are best applied in Photoshop? How can camera techniques and Photoshop augment and enhance each other?

Just browsing through the book can lead you to a half dozen stunning effects you can recreate in five minutes or less, plus a wealth of photographic techniques you can reproduce with Photoshop. Invest a few hours, and you'll be able to:

▶ Create 3-D effects, add metallic sheens, or neon glows.

▶ Fix color problems. Even if you can't tell your color correction from your brightness-contrast controls and think a histogram is a cold remedy, Photoshop has at least four different ways to bring off-color or dull originals to blazing life, ready for use in Web pages and other applications.

▶ Build composites that fool the eye, or that form gateways to fantasy worlds. Blend multiple pictures to create a new image in which all the elements work in perfect harmony to create that photo you never could catch with your camera.

▶ Duplicate darkroom effects not easily accessible to darkroom-challenged digital photographers.

Why This Book?

There are dozens, if not a hundred or more, books on how to use Photoshop. There are already three dozen books on digital photography, and hundreds more on conventional photography. Yet, oddly enough, only a half dozen of these combine Photoshop and photography in any meaningful way. One or two are written for professional photographers and contain little that the average picture taker can use or understand. A few more are dumbed down, include lots of pretty pictures, but contain techniques that you'll quickly outgrow.

Others are weird hybrids that tell you more than you wanted to know about camera technology; CCD, CMOS, and CIS image sensors; how cameras work; the history of digital photography; and *less* than you wanted to know about image editing. I suspect you don't need any convincing that photography is a great idea, nor do you need detailed comparisons of Photoshop with the other image editors on the market. Instead, you want to know how photography and Photoshop can work together to give you great pictures that will astound your friends and astonish your colleagues.

I wrote this book for camera buffs, both digital and conventional, and business people who want to go beyond point-and-shoot snapshooting and explore the world of photography to enrich their lives or increase their performance on the job. If you've learned most of your camera's basic features and now wonder what you can do with them, this is your dream guide to pixel proficiency. If you fall into one of the following categories, you need this book:

▶ Individuals who want to take better pictures, or to transform their growing interest in photography into a full-fledged hobby or artistic outlet using Photoshop as a catalyst

▶ Those who want to produce images that are more professional-looking for their personal or business Web site

▶ Small business owners with more advanced graphics capabilities who want to use photography and Photoshop to document or promote their business

▶ Corporate workers who may or may not have photographic skills in their job descriptions, but who work regularly with graphics and need to learn how to use digital images for reports, presentations, or other applications

▶ Professional Webmasters with strong skills in programming (including Java, JavaScript, HTML, Perl, etc.), but little background in photography

▶ Graphic artists and others who may already be adept in image editing with Photoshop, but who want to learn more about its relationship with digital and conventional photography

▶ Trainers who need a non-threatening textbook for digital photography classes

Who Am I?

With a few exceptions, Photoshop books aren't purchased because the author is famous or is pictured in an attractive photo on the cover. You may have picked this book off the shelf because you found some of the gorgeous, meaty books from Course Technology/Muska & Lipman useful in the past and were looking for more of the same. Then, like most Photoshop book buyers, you flipped through the pages looking for cool pictures or interesting techniques. If I've captured your interest enough to have you reading this far, you probably don't need my life story at this point. However, a little background might be useful to help you understand exactly where this book is coming from.

Before I was seduced by the dark side of technology, I was a professional photographer. I've made my living as a sports photographer for an Ohio newspaper and an upstate New York college; I've operated my own commercial studio and photo lab; and I've served as the photo-posing instructor for a modeling agency. People have actually paid me to shoot their weddings and immortalize them with portraits. I wrote several thousand articles on photography as a PR consultant for a large Rochester, New York, company of which you may have heard. Since 1980, I've successfully combined my interests in photography and computers to an alarming degree, bringing forth a few thousand articles, eight books on scanners, and four that encompass photography.

In practice, this means that, like you, I love photography for its own joys, and view technology as just another tool to help me produce the images I want. It also means that, like you, when I peer through the viewfinder, I sometimes forget everything I know, take a real clunker of a picture, and turn to Photoshop to help me out of the hole I've dug. My only real advantage is that I can usually offer quite detailed technical explanations of what I did wrong and offer a convincing, if bogus, explanation of how I intentionally bent technology to my will to correct the error.

You can learn from my mistakes and benefit from what experience I have, so your picture taking and image editing can travel a more comfortable gain-without-pain route than I took.

How to Use This Book

I'm not going to weigh you down with sage advice about reading this book from front to back, reviewing portions until you understand what I'm trying to say, or remembering to hunt for dozens of icons lodged in the margins that point out the only portions actually worth reading. I don't care if you go through and read just the chapters that interest you, or scan only the odd-numbered pages, as long as you get busy having fun with your camera and Photoshop. Each of the chapters should stand alone sufficiently well that you can read them in any order. A book that needs its own instruction manual hasn't done its job.

I've tried to make your job easier by relegating all the boring parts to the bit bin long before this book hit the printing press. All you need is the text, some photographs in digital form, Photoshop, and access to the CD-ROM bundled with this book. Here's a summary:

▶ You need a Windows PC or Macintosh operating system with enough RAM to run Photoshop comfortably (that is, from 256 to a gazillion megabytes of RAM).

▶ To ease the learning process, you want to work with Photoshop 7. Earlier versions can also be used with this book, except, of course, for the sections dealing with new features like the Healing Brush. However, Adobe changed or moved quite a few of the menu items, modified some dialog boxes, and changed some terminology. If you haven't upgraded yet and you're willing to hunt for the Extract command (it was in the Image menu under Photoshop 6, and has been moved to the Filters menu under Photoshop 7), and can figure out that Image > Adjustments means the same thing as Image > Adjust, about 95% of this book can be meaningful and fun.

▶ You need digital photos. If you're shooting on film, you or your photo lab will need to convert your pictures to pixels before you can use them with Photoshop. It doesn't matter whether you scan the pictures, receive them on a photo CD, or originate the pictures electronically with a digital camera. Photoshop works with them all just fine.

▶ Access to the book's CD-ROM. It's a dual-mode CD that should work with any Macintosh or Windows PC, and contains working files you need to complete the exercises in this book. You can substitute your own photos, of course, but if you want to closely duplicate my work, you need to use the same photos I worked with.

Using the CD

The CD-ROM content falls into three categories:

Demos of Andromeda filters

There are hundreds of third-party filters for Photoshop on the market, but I've elected to feature the Andromeda line in this book for two simple reasons: Andromeda filters are the only ones oriented almost exclusively to the needs of photographers, and these filters aren't as widely known as they should be. Chapter 9 is devoted to an exploration of some of the Andromeda filters with a photographic emphasis. You'll find they do an excellent job of duplicating some popular effects available in the conventional photography realm. The CD-ROM includes both Windows and Macintosh demo versions of the cMulti, Vari-Focus, LensDoc, and Perspective filters, all of which are described in Chapter 9.

Figures and Illustrations

Every figure and illustration in the book is included on the CD-ROM as a separate file. Even when a book is published in full color, like this one, there are times when you'd like to examine an illustration up close. While the figures that are likely to be of most interest are those picturing a process, I've also included the less compelling illustrations, such as dialog boxes, for completeness.

Working Files

Each of the original images used to produce the examples in this book are also included on the CD-ROM. You'll be able to work with the same pictures I did if you want to follow along. Many of the photos have defects of some type that are discussed in the text, but may also have some dust spots or color imbalances, or need resizing. Supplying slightly imperfect pictures in this way simulates your real-world experience. If the pictures I supply need a little work, those you actually manipulate on your own may be even worse!

The Andromeda filters are located in a folder of their own on the CD-ROM. You'll find the figures and working files within separate folders devoted to each chapter and labeled Chapter 1, Chapter 2, Chapter 3, and so forth. Within each chapter folder are folders marked Figures and Working files. So, if you need a file called Kitten to work on a project in Chapter 5, just navigate to the Chapter 5 folder's Working Files folder, and there you can find it.

Your Next Stop

While I'm not your one-stop source for toll-free technical support, I'm always glad to answer reader questions that relate to this book. Sometimes I can get you pointed in the

right direction to resolve peripheral queries I can't answer. You can e-mail me at *photoguru@dbusch.com.* You can also find more information at my Web site at *www.dbusch.com.* Should you discover the one or two typos I've planted in this book to test your reading comprehension, I'll erect an errata page on the Web site, as well, along with an offer of a free copy of the next edition to the first reader to report anything that, on first glance, might appear to be a goof.

A final warning: I first came to national attention for a book called *Sorry About the Explosion!* This book earned the first (and only) Computer Press Association award presented to a book of computer humor. Since then, my rise from oblivion to obscurity has been truly meteoric[md]a big flash, followed by a fiery swan dive into the horizon. So, each of my books also includes a sprinkling of flippancy scattered among all the dry, factual stuff. You aren't required to actually be amused, but you can consider yourself duly cautioned.

Chapter Outline

This section is a brief outline of the chapters in this book. If you want to know exactly where to find a topic that interests you, consult the table of contents or index.

Chapter 1: Photoshop and Photography From 50,000 Feet

This chapter provides an overview of Photoshop's origins, secret identity, and evolution, along with an overview of the basic skills that photographers can expect to transfer directly to their Photoshop experience. These include knowledge of composition, use of lenses, selective focus, film choice, and other valuable skills that serve Photoshop users well.

Chapter 2: Camera and Lens Effects in Photoshop

Here, you learn how to duplicate creative traditional effects such as perspective control, zoom, lens flare, motion blur, and selective focus using Photoshop's built-in tools. These techniques are great to know when you just don't happen to have on hand the exact lens or other accessory you really need on a photo shoot.

Chapter 3: Darkroom Techniques

Those who remember fondly the acid-tinged, humid air of the photo darkroom will love this chapter's tips for reproducing solarization, reticulation, push-processing, cross-developing, and dodging and burning techniques with Photoshop. Best of all, you won't need to ruin expensive film experimenting!

Chapter 4: Secrets of Retouching

This chapter reveals the most valuable secret of retouching: how to avoid the need for it in the first place. However, if you must remove the dust, you'll also find information on how to enhance and repair photos using advanced retouching techniques. Best bet: Learn how to use Photoshop 7's new Healing Brush and Patch tool.

Chapter 5: Compositing

Although each chapter explains how to use the Photoshop tools needed for a task, this one delves deeply into the fine art of making selections and extracting images from their backgrounds. You also discover how to merge objects smoothly and match lighting, texture, colors, scale, and other factors that scream, "Fake!" when they aren't considered.

Chapter 6: Correcting Your Colors

Color can make or break an image. This chapter offers four ways of adjusting color in terms photographers can immediately understand. If you've ever slipped a CC 10 Cyan filter into a filter pack, or stocked your camera bag with an 85B or 80A conversion filter, you'll appreciate the advice here. However, even if your color correction experience extends no further than using the white balance control on your digital camera, this chapter has everything you need to correct your colors in Photoshop.

Chapter 7: Beyond Black and White

Photoshop includes a simple command that can magically transform a great color picture into a terrible grayscale image. You'll learn why the most common color to black and white travesties happen, and how to avoid them. Also included is a slick trick for mimicking the look of orthochromatic film.

Chapter 8: Using Photoshop's Filters

This chapter explains how to get the most from Photoshop's built-in filters, with an emphasis on reproducing traditional camera effects, such as diffusion, cross-screen filters, and polarizers. Then, you'll get a glimpse of how Photoshop can transcend conventional photography with some amazing new capabilities.

Chapter 9: Working with Andromeda Filters

Andromeda's amazing filters can create multi-image effects, rainbows, diffraction grating looks, stars, and lots of other photographic effects within Photoshop. If you've been thinking of purchasing any of the Andromeda filters, this chapter shows you what you can do. Demos of four of these filters are included on the CD-ROM bundled with this book.

Chapter 10: Hard Copies Made Easy

You'll find lots of useful information in this chapter relating traditional printing of film images onto photosensitive paper with the modern digital printing alternatives. Learn about your options, calculate the maximum print size you can expect from a given digital camera resolution, and glean some tips for getting the absolute best digital prints.

Glossary

This illustrated compendium of all the jargon words you encounter in this book (and a bunch of them you run across in the real world) provides a quick reference guide to photography, digital imaging, and Photoshop terminology.

Photoshop Menu/Command Summary

This appendix is a quick guide to the menus, palettes, and tools of Photoshop 7.

1

Photoshop and Photography from 50,000 Feet

If all roads lead to Rome, you can meander along almost as many paths to reach Photoshop. For example, I began my career as a photographer working for newspapers and then later in a studio. Like many photojournalists, I was seduced by the dark side of technology—computers—when I saw the many ways the desktop computer could help me do my work.

Other Photoshop fanatics reach the same destination through other routes. Artists find computers invaluable for enhancing digitized versions of their canvases, or for creating original works from scratch. Those whose job descriptions include graphic arts and prepress production find tools such as Photoshop priceless for enhancing scans or fine-tuning color separations. Other Photoshop masters start out in the classic computer nerd mold and wallow in pixel pushing for the same reason that Tenzing Norgay first climbed Mt. Everest: because it's there—and, as a bonus, there's a little money to be made doing it.

No matter which route you used to arrive at Photoshop, when you disembarked, two things probably grabbed your immediate attention. First, even a cursory examination of Photoshop's feature set reveals that it can do just about *anything* you need to do with images. The second thing you doubtlessly noticed is that the program has about five dozen completely different tools (there are actually only 55 tools in Photoshop 7); millions of menu entries (actually, more like 530 menu items, including some that are duplicated, plus another 100 or so menu entries for Photoshop's plug-in filters); and 10,000 different dialog boxes (that estimate is accurate, I think).

How do you *learn* all this? With Photoshopoholics Anonymous, the challenge is the same as with any 12-step program: one day at a time. Your advantage as a photographer is that you already have an understanding of much of the underlying techniques that make Photoshop what it is. You don't have to rediscover the wheel. In fact, if you're a half-serious photographer and more than a casual Photoshop user, you're ready to shift into overdrive with this book.

This brief chapter, a view of Photoshop and photography from 50,000 feet, provides an overview that's oriented, like the rest of this book, from a photographer's perspective. You'll learn why Photoshop was created expressly to meet *your* needs, and how you can use what you *already* know to make Photoshop work for you right from the start.

Images in the Digital Domain

If you're a photographer and don't use all the tools Photoshop has to offer, you're putting a crimp in your creativity and seriously restricting your flexibility. For the devoted photographer—both amateur and professional—not using Photoshop is like limiting yourself to a single lens, or using only one film.

Certainly, some incredible images have been created by photographers who've worked under mind-boggling limitations (a few ingenious pictures taken with pinhole cameras come to mind). For example, one of the photos shown in Figure 1.1 was taken with a 6 × 7 single-lens reflex (SLR) camera that cost $3000, using studio lighting equipment priced at another grand or two. The other photo was taken with a $50 point-and-shoot camera and a flashlight. Even with the inevitable quality loss that comes with offset printing, I'll bet you can tell the difference between the two. However, you will agree that even the cheapie photo is acceptable for many applications, such as being displayed on a Web site. Have I discovered a way to save thousands of dollars? Or have I shown that trying to get by using the bare minimum of tools is nothing more than an easy way to impose limitations on your creativity?

Figure 1.1
One of these photos was taken with a 6 × 7 SLR, the other with a cheap point-and-shoot camera—which setup would you rather use?

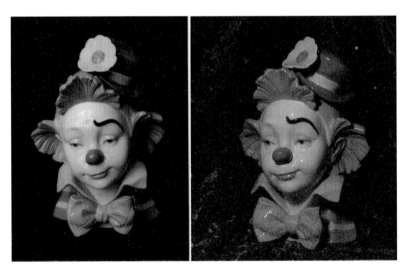

Unless you enjoy hobbling yourself as a form of creative constraint (and that is a valid exercise), I'd wager that you want to use all the photographic tools at your disposal, and

Photoshop is certainly one of them. To my mind, Photoshop is the most important innovation in photography since the zoom lens or through-the-lens viewing.

The best part about adding this image editor to your repertoire is that many of the skills a photographer acquires working behind the viewfinder are directly transferable to Photoshop. If you have darkroom skills, so much the better. I list some of these valuable skills later in this chapter.

Photographers who adopt Photoshop as an image-enhancing tool have a commanding advantage over those who approach Adobe's flagship image editor from the computer or traditional art realms. Terms such as "lens flare," "motion blur," and "grain" are familiar to you. If you are a more advanced photographer, you probably understand such techniques as "solarization," or perhaps even such graphic reproduction concepts as "halftones," "mezzotints," or "unsharp masking." Those whose perspective is more pixel- than photography-oriented must learn these terms the hard way.

To see what I mean, examine Figure 1.2. Many photographers can recognize the traditional photographic effects used to create this image. (Bear with me for a moment if you are not steeped in photographic technical minutiae.) The sun image has a halo caused by lens flare from the telephoto or zoom lens used to take the picture. The odd flag colors could be produced by partially exposing the transparency film during development, a technique which reverses some colors to produce an effect called solarization. The rich colors are a direct result of the photographer's choice of a film stock known for vivid colors. And, of course, the flag and buildings appear compressed in space because that's what telephoto lenses do.

Figure 1.2
Can you find all the traditional photographic techniques used to produce this picture?

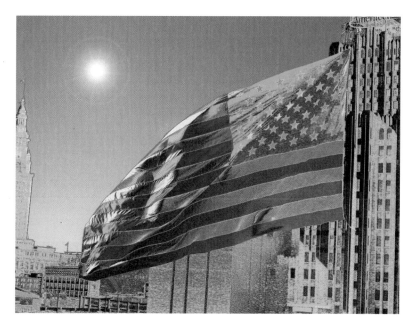

The advantage photographers have over nonphotographers is that they've seen all these techniques before, and have probably used them. The ability to reproduce every one of these effects within Photoshop is a powerful additional tool. In truth, Figure 1.2 never saw a piece of film. It was taken with a digital camera using the normal (non-telephoto/non-wide-angle) zoom setting, cropped tightly in Photoshop to simulate a telephoto picture, and then the sun was added and the flag colors manipulated to create the image you see here.

Don't panic if your photographic interests don't run to camera techniques or darkroom magic. Even if your photography skills emphasize other worthy areas of expertise, such as composition or the mechanics of camera operation, you'll still find Photoshop a comfortable fit with what you already know, and a great tool for applying what you plan to learn in the future. From its earliest beginnings, Photoshop has been modeled on photographic concepts.

Like photography itself, Photoshop was born in a dark room. Thomas and John Knoll, sons of an Ann Arbor, Michigan, college professor and photo enthusiast, worked in their father's basement darkroom, and at the same time fell in love with the Apple computer their father brought home for research projects.

By the mid-1980s, Thomas and John were working with imaging on a professional basis. Thomas was pursuing his PhD in digital image processing, and John was anticipating a career at Industrial Light and Magic, the motion picture, computer graphics firm in California. One big problem the brothers saw was that the most advanced graphics-oriented minicomputer of the time—the Macintosh—couldn't manipulate full-color images properly.

They set out to fix that. The product that was to become Photoshop went through various incarnations. A few copies of an application by that name were actually distributed by the BarneyScan Corporation along with their slide scanner. Finally, the Knolls licensed their product to Adobe Systems, Inc., then known primarily for its PostScript and font technologies and a drawing program called Adobe Illustrator. Photoshop 1.0 was released to the world in January of 1990.

In Figure 1.3, you can see the original tool palette of Photoshop 1.0 alongside the tool palette currently found in Photoshop 7. Although the icons have been moved around or combined (the latest Mac OS has added a 3-D look), it's amazing how little has changed. The twenty-four tools in the original palette are all still in use today. Nine of the tools have been nested together under five multipurpose icons; the Airbrush has become a checkbox on the tool options bar. A few, such as the Type and Brush tools, have been transmogrified so much they have little in common with their ancestors.

Photoshop wasn't the first image editor for the Macintosh by any means. Photoshop drew a great deal from the concepts and interface popularized by Apple's own MacPaint, introduced in 1984. There were programs with names like PixelPaint, ImageStudio, SuperPaint, and, notably, Silicon Beach's Digital Darkroom. However, the precocious Photoshop was the first program to really grab the imagination of photographers and the publications that employed them.

Figure 1.3
Photoshop's original tool palette (left) and its latest (right) share more features than you might expect.

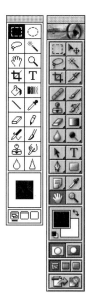

Happily, reasonably priced color scanners became available (early color scanners cost up to a million dollars each, making them practical only for the largest newspapers and magazines). Scanners supplied Photoshop with ample fodder for its magic, and within a very short period of time vast numbers of publications adopted Macs and Photoshop as key tools. By then, the critical battles in the imaging war were over, and Photoshop was all but crowned the victor.

Adobe augmented its darkroom paradigm with some other powerful advantages. The first of these was a program interface that made it possible to seamlessly incorporate add-on miniprograms called plug-ins that were developed by Adobe and other third-party developers. Although plug-ins first appeared in Digital Darkroom, Photoshop's already commanding lead in the image editing market made the ability to use Photoshop compatible plug-ins a must-have feature for competing products such as PixelPaint and Fractal Design Painter.

The final battle was won in April, 1993, when Adobe released Photoshop 2.5 for Microsoft Windows 3.x. There had been earlier image editors for PCs that (barely) worked under Windows, or that used proprietary DOS-based interfaces. But, once Photoshop became a cross-platform tool available to the Macs that dominated the graphics and photographic industries, as well as the diehards in the Windows realm, there were really no reasons to use anything other than Photoshop for sophisticated image editing tasks.

Today, the term "digital darkroom" has become a generic description. You find it used in Web sites, books, and magazine articles by pixel pushers who've never set foot in an actual darkroom. (Alas!) And, as an interesting footnote, the rights to the Digital Darkroom trademark were purchased by MicroFrontier after Silicon Beach was purchased by Aldus Corporation, which in turn, ironically, was bought out by Adobe.

Transferring Skills

The photographic skills you possess can be transferred to Photoshop in a variety of ways, as befits the multifaceted nature of photography itself. Photography has always been part art, part craft, and part technology. Some of the earliest photographers were originally trained as artists, and they used their cameras to produce landscapes, portraits, and other works from a classical artistic perspective.

Modest skills as an artisan were also helpful, for many of the earliest cameras were hand-built by the photographers themselves. Even as mass produced cameras became available, photographers continued to craft their own custom-built devices and accessories. Today, you still find that some of the coolest gadgets for photography are home-brewed contraptions.

An early photographer also had to be something of a scientist to experiment with various processes for coating and sensitizing plates and film, and exposing images using the illumination from electrical sparks. As late as the mid twentieth century, serious photographers were still dabbling in photographic chemistry and darkroom technology as a way to increase the sensitivity and improve the image quality of their films. Now that many chemical tricks can be reproduced digitally, photo alchemy has become the exception rather than the rule.

In the twenty-first century, acquiring the skills a photographer needs is not as difficult as in the nineteenth century, although a basic familiarity with computer technology has become something of a prerequisite for using microprocessor-driven digital and conventional film cameras. Although photography has become "easier," don't underestimate the wealth of knowledge and skills you've picked up. A great deal of that expertise is easily transferable to Photoshop. The things you already know that will stand you in good stead when you advance to computer-enhanced photo manipulation in Photoshop fall into ten broad categories. Let's run through them quickly.

Basic Composition

Compositional skills, so necessary for lining up exactly the right shot in the camera, are just as important when you're composing images in Photoshop. Indeed, Photoshop lets you repair compositional errors that escaped your notice when you snapped the original picture. If you want your subjects in a group shot to squeeze together for a tighter composition, Photoshop lets you rearrange your subjects after the fact. The ability to recognize good composition and put it into practice with Photoshop is an invaluable skill that not all image-editing tyros possess.

Lens Selection

The choice of a particular lens or zoom setting can be an important part of the creative process. Telephoto settings compress the apparent distance between objects, while wide-angle settings expand it. Faces appear to be broader or narrower, depending on lens selection. If you understand these concepts, you'll find you can apply them using Photoshop's capabilities, too.

Selective Focus

Choosing which objects in an image are in focus and which are not is a great creative tool. With a conventional or digital camera, you need to make the decisions at the time you take the photo. To complicate things, digital cameras often make *everything* reasonably sharp regardless of what lens settings you use. With Photoshop, selective focus is not only easy to apply, but can be used in a precise, repeatable, and easily modified way. The digital photos shown in Figure 1.4 were taken seconds apart, with similar lens and focus settings. The version on the right was processed in Photoshop to create a less obtrusive, blurry background.

Figure 1.4
Photoshop can make techniques such as selective focus more precise and easier to apply.

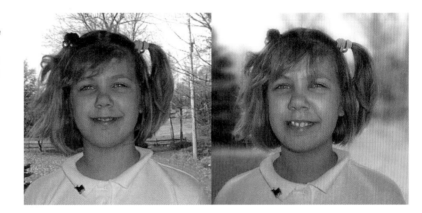

Choosing the Right Film

Selecting the right film can be as important as choosing an appropriate lens. Some films are known for their bright, vibrant colors. Others are considered more accurate or more capable of reproducing flesh tones. Some films are sharper or have finer grain. Others are more sensitive to light and make it possible to shoot pictures in near darkness, or when very short shutter speeds are needed to freeze action. Photoshop can help when you choose the wrong film or don't set your digital camera's controls exactly right. Your image editor lets you boost colors or tone them down, disguise noisy grain or emphasize it, and compensate for images exposed under less than ideal lighting.

Darkroom Techniques

There's a reason why Photoshop's predecessors had names like Digital Darkroom. The number of darkroom techniques that have been directly transferred to Photoshop is enormous. From the Dodging and Toning tools to the tremendous range of masking techniques, dozens of Photoshop capabilities have direct counterparts in the darkroom. If you've used a darkroom, you'll be right at home in Photoshop. Even if you haven't dipped your fingers into stop bath, you'll find this image editor performs its manipulations in a logical, photography-oriented way.

Retouching

When I started in photography, retouchers were true artists who worked directly on film negatives, transparencies, or prints with brush and pigment. Photoshop enables those with artistic sentiments who lack an artist's physical skills to retouch images in creatively satisfying ways. You can remove or disguise blemishes, touch up dust spots, repair scratches, and perform many tasks that were once only within the purview of the retouching artist.

Compositing

Would you like to transplant the Great Pyramid of Egypt to downtown Paris? Or perhaps you're just interested in removing your ex-brother-in-law from a family photo. Photographic masters of the past spent hours figuring ways to combine images in the camera, or spent days sandwiching negatives or transparencies, cutting film or prints to pieces, or using other tedious methods to build great images from multiple originals. Compositing still requires skill with Photoshop, but you can do things in a few hours that were virtually impossible to achieve only 20 years ago. The scene shown in Figure 1.5 doesn't exist in the real world, but it took me only five minutes to fake it using Photoshop and the original photos shown in Figure 1.6.

Figure 1.5
It took only five minutes to create this composite in Photoshop.

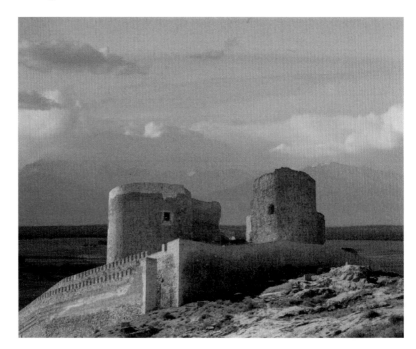

Figure 1.6
These are the original photos used to produce the composite shown in Figure 1.5.

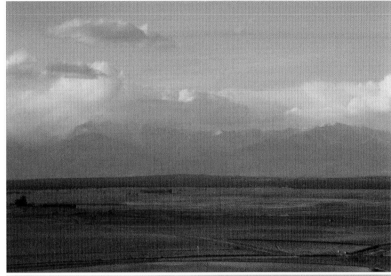

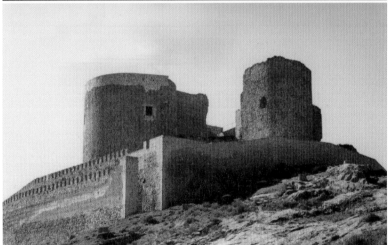

Color Correction

With traditional photography, color correction is achieved in several ways. You can put filters over the lens of your camera to compensate for a slight bluish or reddish tint in the available light. Other filters can correct for the wacky lighting effects caused by some fluorescent lamps. Some color correction can even be done when making a print. Photoshop has an advantage over most traditional methods: Its effects are fast, repeatable, and reversible. You can fiddle with your image as much as you like, produce several corrected versions for comparison, or really dial up some outlandish color changes as special effects. If you don't like what you come up with, return to your original image and start over.

Creative Use of Black and White

Black-and-white photography, like blues music, seems to enjoy a resurgence every five or ten years. In truth, neither black-and-white imagery nor blues ever goes anywhere—it's only widespread public perception of them that changes. Monochrome photos are a great creative outlet, letting you strip down your pictures to the basics without the intrusiveness and bias of color. Photoshop is a great tool for working with black-and-white images, both those that were originally conceived and created in monochrome as well as those that were derived from color images. Indeed, Photoshop offers some powerful tools for transforming a full-color image into black and white, mimicking specialized films and filters in flexible ways.

Filters

Let's not get started on filters just yet. In traditional photography, filters are handy gadgets you place in front of the camera's lens to produce a variety of effects. These can range from multiple images to split-field colorization (that is, blue on top and red on the bottom of an image, or vice versa) to glamour-oriented blur filters. Using third-party add-ons like those from Andromeda or Alien Skin, Photoshop can reproduce virtually any optical effect you can achieve with glass or gelatin filters, plus hundreds more that are impossible outside the digital realm. If you've used filters with your film camera, and especially a set of Cokin series filters, you'll love what Photoshop can do.

Next Up

Now that we've taken a look at Photoshop and Photography from 50,000 feet, it's time to skydive down to treetop level and below to investigate some of the techniques you can use to improve your images at the pixel level. The next chapter explores camera and lighting effects in Photoshop.

2

Camera and Lens Effects in Photoshop

Photography is not the only artistic endeavor in which the tools can hold as much fascination as the process itself, or even the end result. Serious cabinetmakers may be just as proud of their new, sophisticated, hollow chisel mortiser as they are of the drop-front desk crafted with it. In the same vein, it's common to meet a photographer who feels you can never be too rich, too thin, or have too many lenses.

You don't actually *need* a dozen lenses, a bag full of filters, or enough light sources to illuminate the Statue of Liberty to take great pictures. Many of you probably get along very well with nothing more than the zoom lens or electronic flash built into your camera. But, whether you're a photo gadget freak or a photo gadget-phobe, Photoshop has some tools you'll find extremely useful. Built into your favorite image editor are capabilities that let you duplicate many camera and lighting effects.

Simulating traditional photographic techniques in Photoshop is useful for several reasons. First, even if you own every lens or piece of lightning gear known to civilization, you may not always have your prized gadget with you when you need it. For example, I've traveled to Europe carrying just one camera body, a 35mm and a 105mm lens. My intent on that trip was to shoot video, and I wanted to keep my still equipment to a minimum. Or you might have had a particular piece of equipment available but didn't think to use it, or were unable to put it to work in a fast-moving shooting situation.

A second reason to use Photoshop to mimic traditional photographic techniques is that you simply don't have the interest in (or budget for) a particular item but, from time to time, would still like to take advantage of its capabilities. Many photographers who generally work with a single zoom lens might want a fish-eye picture on occasion. Photoshop can help.

This chapter shows you how to mimic many traditional camera and lens effects using Photoshop. In each section, I describe the traditional camera technique first to give you an idea of what the technique is supposed to do. Then, I follow with some instructions on how to duplicate—or improve on—the effect in Photoshop.

Lens Effects

Photoshop can duplicate the look of many different lenses, particularly some of those specialized optics that cost an arm and a leg even though you probably wouldn't use them more than a few times a year. For example, I own two fish-eye lenses (7.5mm and 16mm versions), a perspective control lens, several zoom lenses, and a massive 400mm telephoto. Other than the zooms, I don't use any of these very often. I use even fewer lens add-ons with my digital cameras, relying on the camera's unadorned built-in lens for 95 percent of my shots. So, if I happen to encounter a shooting situation that can benefit from one of these limited-use lenses, I often end up taking a straight photograph and using Photoshop to apply the special effects.

Perspective Control

Most of the pictures we take, whether consciously or unconsciously, are taken head-on. In that mode, the back of the camera is parallel to the plane of our subject, so all elements of the subject, top to bottom and side to side, are roughly the same distance from the film or digital sensor. Your problems begin when you tilt the camera up or down to photograph, say, a tree, tall building, or monument. The most obvious solution, stepping backwards far enough to take the picture with a longer lens or zoom setting while keeping the camera level isn't always an option. You may find yourself with your back up against an adjacent building, or standing on the edge of a cliff.

Indeed, it's often necessary to use a wide angle setting and *still* tilt the camera upwards to avoid chopping off the top of your subject. Figure 2.1 shows the relationship between the back of the camera and a monument when the camera is held perpendicular to the group. Notice that both the top and bottom of the subject are cut off.

Figure 2.1
When the back of the camera is parallel to the plane of the subject, it's sometimes impossible to include the entire subject in the photo.

plane of subject

plane of camera back

resulting photo

Switch to wide-angle mode and tilt the camera to include all of the subject, and you get the distorted photo shown in Figure 2.2. The monument appears to be falling back, and the base appears disproportionately larger than the top because it's somewhat closer to the camera.

Figure 2.2
In wide-angle mode, tilting the camera makes the monument look as if it's falling backwards.

plane of subject

resulting photo

plane of camera back

The traditional workaround to this dilemma is one that's generally available only to those who do a great deal of architectural photography. The solution for 35mm photographers is to use something called a perspective control lens, an expensive accessory which lets you raise and lower the view of the lens (or move it from side to side; perspective control can involve wide subjects as well as tall) while keeping the camera back in the same plane as your subject. A more sophisticated (and expensive) solution requires a professional camera called a view camera, a device that uses 4 × 5-inch (or larger) film and has lens and film holders that can be adjusted to any desired combination of angles. Those who can't afford such gadgets, or who own digital cameras without interchangeable lenses, appear to be left out in the cold.

That's where Photoshop comes in. You can make some reasonable adjustments to the perspective of an image within your image editor. Often, the manipulations are enough to fully or partially correct for perspective distortion. Just follow these steps using the original image on the CD-ROM bundled with this book, or use an image of your own.

1. Open the file **Toledo Cathedral Tower** in Photoshop. The image looks like the one shown in Figure 2.3.

2. To give yourself a little working space, choose Image > Canvas Size, and change the width of the image to 1500 pixels and the height to 2500 pixels. Zoom out (View > Zoom Out) to make the image fit on your screen, if you need to.

3. Create two vertical guides to let you judge the perspective of your image. Choose View > New Guide, and make sure the Vertical radio button is marked. Click OK to create the guide.

CHAPTER 2

Figure 2.3
This bell tower appears to be falling backwards, because the camera was tilted up to shoot the picture.

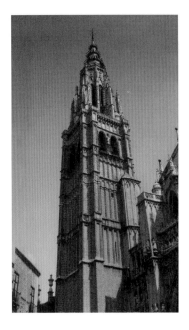

4. Press V to activate the Move tool, and drag the guide line to position it next to one of the sides of the tower.

5. Repeat steps 3 and 4 to create a second vertical guide for the other side of the tower. Your image should look like Figure 2.4.

Figure 2.4
Apply guides to help line up your image as you change its perspective.

USING RULERS

If you have Rulers turned on, you can simply use the Move tool to drag guides from the left-side ruler to the position you want them.

6. Use the Rectangular Marquee tool to select only the image of the tower, not the blank space you created around it.

7. Choose Edit > Transform > Distort to activate Photoshop's distortion feature.

8. Hold down the Shift key and drag the upper-left and upper-right corner handles of the selection outward, using the guides to gauge the position of the tower walls. You broaden the top of the tower as you do this.

9. Hold down the Shift key and drag the lower-left and lower-right corner handles of the selection inward, narrowing it, and providing some fine-tuning as you straighten the walls. Your image should now look like Figure 2.5.

Figure 2.5
The tower has been straightened.

10. Crop the image to arrive at the final version, shown at right in Figure 2.6. The original, distorted picture is shown at left for comparison.

Zoom

Zooming while making an exposure became popular in the 1960s as a way of adding movement to an otherwise static image. The technique is fairly easy to achieve with a conventional camera, especially one with manual controls: Simply take a picture using a shutter speed that is slow enough to let you zoom your lens during the exposure. Depending on how quickly you can zoom with your left hand on the lens barrel after you've pressed the shutter release with your right hand, a zoom blur of this type can be made successfully at speeds from 1/30th second or slower.

Figure 2.6
The final cropped image should look like this.

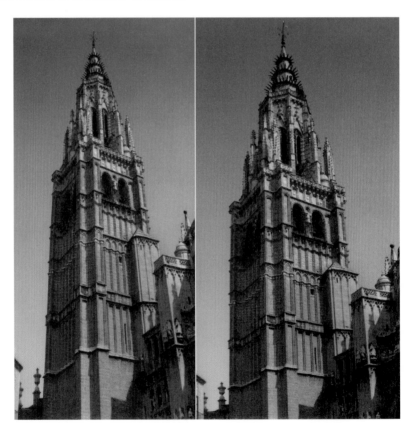

Zoom in or out, as you prefer, and use a tripod with longer exposures if you want the smoothest effect. While the image will be blurred as it changes in size from the minimum/maximum zoom settings, there is often a relatively sharp image at some point in the zoom (usually the beginning or end) if you pause during the zooming. An electronic flash exposure, most easily made (automatically) at the beginning of the exposure, can also provide a sharp image to blend with your zoom blurs.

Digital camera owners are pretty much left out in the cold, because motorized zooms aren't fast enough to produce a blur effect except for very long exposures. But don't worry. Photoshop can come to your rescue with its own built-in zoom blur effect. Try the following technique:

1. Locate the **Basketball** file included on the CD-ROM bundled with this book, or use your own image. My sample image looks like Figure 2.7. The photo is a cropped portion of a digital camera image taken under available light at about 1/500th of a second and f/4. Notice how the girls' hands are a little blurry, but everything else is static and frozen in time. I thought it would be interesting to keep the basketball sharp, but add a little zoom blur to the players.

Figure 2.7
The picture looks like this prior to adding the zoom effect.

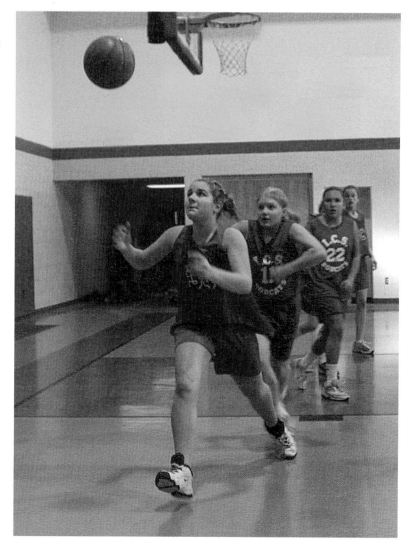

2. Press Q to activate Photoshop's Quick Mask feature, which allows you to "paint" a selection using ordinary brush tools.

CHOOSE MASK OR SELECTION

I usually choose Color Indicates Selected Areas, so I can paint my selection directly. You can change Photoshop's default (Color Indicates Masked (Unselected) Areas) by double clicking the Quick Mask icon (a black rectangle with an inset white circle) on the tool palette.

3. In Quick Mask mode, paint an area around the basketball using the Brush tool (press B to select it) and a soft, 100-pixel brush chosen from the drop-down palette at the left side of the Options bar. Paint an area about 125 percent of the diameter of the ball itself.

4. Press Q again to exit Quick Mask mode.

5. We actually want to select everything in the image except the ball, so if you are in the habit of painting selections, like I am, invert the selection by pressing Shift+Ctrl/Command+I. That leaves the ball masked, and everything else selected.

6. Choose Filter > Blur > Radial Blur from the menu to produce the Radial Blur dialog box shown in Figure 2.8. Choose 85 for the Amount, Zoom as the Blur Method, and Best as the Quality level. While you can shift the point around which Photoshop will zoom by dragging the crosshair in the middle of the preview box, the sample picture already has the main subject centered right where the zoom will go.

Figure 2.8
Choose your settings
in the Radial Blur
dialog box.

7. Click OK to apply the zoom. Your image should look like Figure 2.9.

Figure 2.9
The zoom effect has been applied full-strength to all of the image except for the basketball.

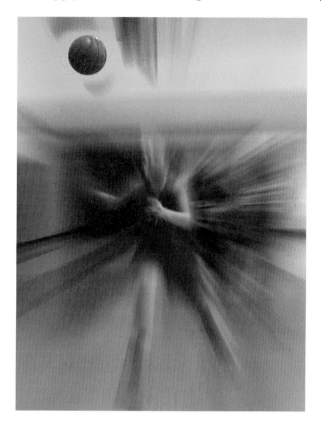

8. Use the Edit > Fade control (or press Shift+Ctrl/Command+F) to reduce the amount of zoom blur and restore some of the original image. That makes the blur effect less overwhelming, and makes your original image a bit more recognizable. I scaled back the blur to 71 percent to create the version shown in Figure 2.10.

Figure 2.10
Fading the zoom blur to 71 percent makes the image a little more recognizable.

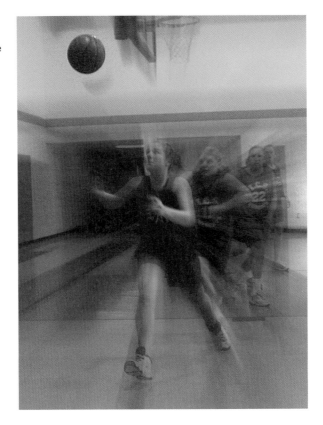

9. Be a little creative, if you like. I took the fully blurred image from Figure 2.9 and pasted it onto the original image from Figure 2.7. Then, I used an eraser with a large, soft brush to selectively erase part of the blurry layer, creating an image that is sharp in the center, and becomes dramatically zoomed everywhere else. You can see the final image in Figure 2.11.

Zoom blurring works especially well with sports events, rock concerts, and other fast moving situations where a little blur can liven up a photo.

Telephoto Effects

Photoshop can help you compensate for that long telephoto you can't afford or that isn't available for your digital camera. Telephoto lenses are great for bringing your subject closer when you can't get physically close. Telephotos also compress the apparent distance between objects that are actually more widely separated than they appear to be. Telephoto lenses are often used in those car chase sequences you see in the movies. From the head-on view, it looks like the hero is weaving in and out of cars that are only a few feet apart. In real life, the cars are probably separated by 40 feet or more, but crammed together through the magic of a telephoto lens.

Figure 2.11
Combining a blurred
image with the original
selectively gives you a
picture that looks
like this.

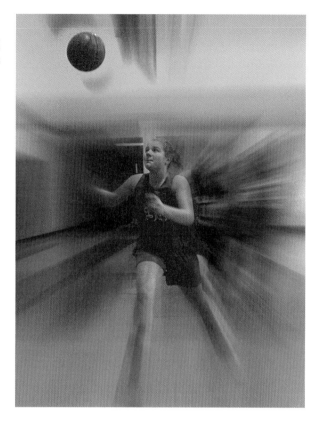

Unfortunately, most digital cameras don't have really long telephoto lenses available. Even $1000 digital models may have skimpy 3:1 zoom lenses that simulate at their maximum the view you'd get with, say, a short 105mm or 135mm lens on a conventional 35mm camera. Some semipro models offer 10:1 zooms that still don't bring you close enough. The so-called "digital" zoom built into many models claims to offer more magnification, but it does nothing more than enlarge a selection of pixels in the center of the sensor to fill your entire image area. You don't actually gain any additional information. You can purchase add-on telephotos for most digital cameras, but these can cost hundreds of dollars, and you might not use them very often. You might as well do the job in Photoshop, where you can enlarge and sharpen your image in real time under your full control.

The key to successfully mimicking a long telephoto with Photoshop is to start with the sharpest original picture possible. Follow these suggestions to get your best picture:

▶ Use the sharpest film (conventional camera) or lowest ISO setting (digital camera) you can, given the lighting conditions and your subject matter. That might mean using an ISO 100 film (or its digital equivalent setting) for a scenic photo, or an ISO 200 to 400 film or setting for an action picture.

▶ If your camera has manual settings or can be set to shutter priority mode (in which you choose the shutter speed and the camera sets the lens opening) use the shortest shutter speed you can. I've found that even a brief 1/500th second exposure can still be blurred by camera motion in the hands of someone who isn't accustomed to holding the camera *really* steady. A short exposure stops subject motion, too.

▶ Consider using a tripod, if you have one available, to steady your camera. At the very least, try bracing the camera against a rigid object, such as a tree, building, or rail.

▶ Use your longest lens or zoom setting to provide the most magnification you can in your original picture.

Figure 2.12 shows the view from the $7.00 seats at Jacobs Field in Cleveland, with a box drawn around the view I wish I'd had. Fortunately, the rowdy gang of kids I'd brought with me couldn't tell the difference between these seats and the $40 lower box accommodations, so it was money better diverted to hot dogs, even if my photo opportunities suffered.

Figure 2.12
This is the sort of picture you can expect to take 380 feet from home plate.

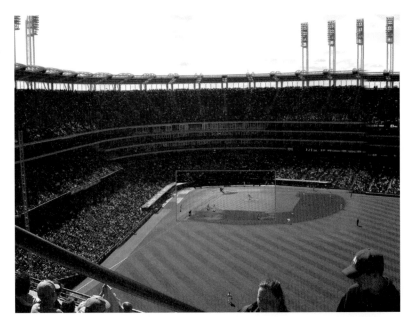

The original was a full-frame digital image taken with a 3.3-megapixel camera. I zoomed in as far as I could, loaded the resulting image into Photoshop, and applied Photoshop's Filter > Sharpen > Unsharp Mask filter, which lets you "dial in" the amount of sharpness you want, using the dialog box shown in Figure 2.13.

Figure 2.13
The Unsharp Mask dialog box allows you to dial in the amount of sharpness you want.

UNSHARP MASKING

Unsharp masking is derived from a conventional photographic technique, and, despite its name, is used to sharpen images. The technique was first applied to images made on 4 × 5 and larger sheet film. In the darkroom, a film positive is made from the original film negative, a sort of reversed negative in which all the parts of the image that were originally black are black, and all the parts that were white are white. This positive is slightly blurred, which causes the image to spread a bit (like any out-of-focus image). When the positive and negative are sandwiched together and used to expose yet another image, the light areas of the positive correspond very closely to the dark areas of the negative, and vice versa, canceling each other out to a certain extent. However, at the edges of the image, the blurring in the positive produces areas that don't cancel out, resulting in lighter and darker lines on either side of the edges. This extra emphasis on the edges of the image adds the appearance of sharpness. Figure 2.14 might help you visualize how this works.

Figure 2.14

A blurred positive and negative image (left) are combined to produce a new, sharpened negative that can be used, in turn, to print an image like the one at right.

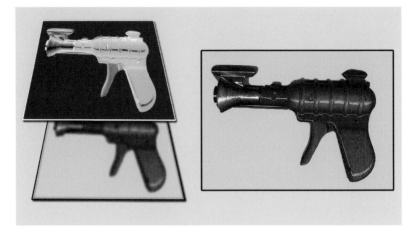

It's fairly easy for Photoshop to create the blurry positive "mask" and then match it with a negative image of the original picture. As a bonus, you end up with greater control over the amount of blur in the mask, the distance around the edges that are masked, and a threshold level (relative brightness) at which the effect begins to be applied. The Unsharp Mask filter is similar in many ways to the Sharpen Edges filter, but with this enhanced control. There are three slider controls:

▶ The Amount slider controls the degree of edge enhancement applied. You can vary the sharpening effect from one percent to 500 percent, and view the results in the Preview window as you work.

▶ The Radius slider determines the width of the edge that is operated on, measured in pixels, with valid values from one (very narrow) to 250 pixels (very wide). You can preview the results visually, but use a few rules of thumb to decide how much to move this control. The main thing to keep in mind is the original resolution of your image. Low-resolution images (under 100 dpi) can't benefit from much more than one- to three-pixels worth of edge sharpening, while higher resolution images (300 dpi and up) can accommodate values of ten or more. You'll know right away if you have set your values too high. You'll see thick, poster-like edges that aren't realistic, accompanied by a high degree of contrast. You may, in fact, actually *like* the weird appearance, but at this point you've left the realm of sharpening and ventured into special effects.

▶ The Threshold slider sets the amount of contrast that must exist between adjacent pixels before the edge is sharpened. Sharpness is actually determined by how much the contrast varies between pixels in an area, as shown in Figure 2.15, a super-enlargement of the clock face in the tower

that holds Big Ben (which is actually a bell) in London. Low contrast equals a blurry, soft image, while high contrast tends to mean a sharp, hard image. You can see that the pixels on either side of the enlargement are exactly the same size, but that the contrast between them is greater on the left, or "sharper," side.

Figure 2.15
The pixels are the same size, so the resolution must be the same, yet the half of the image with more contrast, on the left, looks sharper than the lower-contrast image on the right.

When working with the Threshold slider, values from zero to 255 can be used. A very low value means that edges with relatively small contrast differences are accentuated. High values mean that the difference must be very great before any additional sharpening is applied. Normally, you need this control only when the default value produces an image with excessive noise or some other undesirable effect. To be honest, in all the years I've used it, changing the Threshold slider produces effects that were hard to predict, because they varied widely depending on how the other two controls were adjusted, as well as the nature of the image itself. Your best bet is to set the Amount and Radius sliders first, then experiment with Threshold to see if you like the results any better.

Figure 2.16 shows my baseball picture after I experimented with the Unsharp Mask filter to optimize the sharpness. The view is still not as good as a front row seat, but then, I didn't have to pay a lot for my tickets or tote around a mammoth telephoto lens, either.

Figure 2.16
Photoshop simulated a long telephoto lens by helping sharpen this tightly cropped image.

Compressing Distances

As I mentioned earlier, telephoto lenses also are used to compress apparent distances. The good news is that this effect, sometimes called "telephoto distortion," has nothing to do with the lens itself. It's simply an effect caused as you move farther away from a subject.

For example, if you are photographing a series of fence posts that are spaced 10 feet apart, and you're standing 10 feet from the first post, the second post is twice as far away (20 feet), the third one three times as far away (30 feet), and the fourth one four times as distant (40 feet).

Now, move 50 feet away from the first post. The second post is now only 1.2× as far from you as the first post (60 feet instead of 50), the second is 1.4× as far, the third 1.6× as far, and the fourth one 1.8× the distance. The apparent distance between them is much less in your photograph. However, the fence posts are *waaay* down the road from you, so if you use a telephoto lens to bring them closer, you see the images as relatively compressed together, as shown in Figure 2.17. The exact same thing happens if you take the picture with a much shorter lens and enlarge it. The distances are relatively compressed. Figure 2.17 shows an image of the town walls around the city of Avila, Spain, and an enlargement made in Photoshop that shows how compressed the distances appear when the picture is blown up.

Figure 2.17
An enlargement of a portion of the photo at left produces a "compressed" image at right.

Fish-eye Lens

Fish-eye lenses were originally developed as a way to provide a hemispherical view in unreasonably tight places, generally for technical reasons, such as examining the insides of a boiler or for photographing things such as the sky's canopy for astronomical research. Because of their specialized nature, they tended to cost a fortune to buy, but that didn't stop photographers of the 1960s who were looking for a way to come up with novel images. My own first fish-eye lens was a second-generation Nikon optic (an improved 7.5mm lens that replaced the original 8mm Nikon fish-eye), which required locking up the single-lens reflex's mirror and using a separate viewfinder. I later got Nikon's 16mm "full-frame" fish-eye lens, which did not produce a circular image like the original.

Today, fish-eye lenses are available as prime lenses for conventional cameras, or as attachments for many digital cameras, but they're still not something you'd want to use everyday. So, you might want to try Photoshop's equivalent effect. Figure 2.18 shows you an image of a gold-inlayed plate in its original perspective (left) and transformed by a fish-eye view with Photoshop (at right).

Figure 2.18
A gold plate (left) and its fish-eye version (right); it's hard to see the difference, because the original subject was already round in shape.

Because the original image was already circular, the fish-eye look shows up only as an abstract effect. You can get additional fish-eye views working with more conventional subjects. Try the following technique:

1. Load the file **Toledo View** from the CD-ROM bundled with this book, or use your own image. The sample image looks like Figure 2.19.

2. Use the Elliptical Marquee tool to create a circular selection in the center of the image. Hold down the Shift key as you drag to create a perfect circle.

3. Choose Filter > Distort > Spherize to produce the dialog box shown in Figure 2.20. Set the Amount slider to 100 percent to produce the maximum amount of spherization (to coin a term). Click OK to apply the modification.

4. With the circular section still selected, copy the selection and paste onto a new layer (press Ctrl/Command+C to copy and Ctrl/Command+V to paste).

5. Use Image > Adjustments > Brightness/Contrast and move the brightness and contrast sliders each to the right to lighten the fish-eye view and increase its contrast.

CHAPTER 2

Figure 2.19
This is a view of a
military academy
located in
Toledo, Spain.

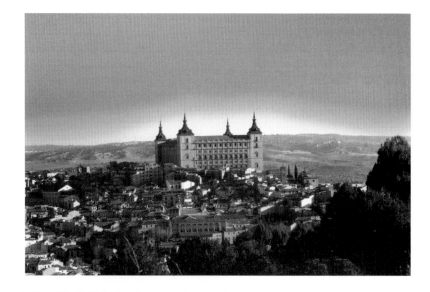

Figure 2.20
The Spherize dialog
box lets you apply
fish-eye effects to
an image.

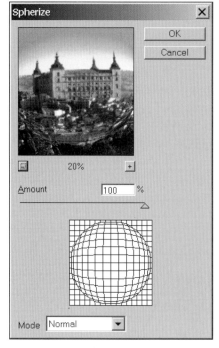

6. Use Filter > Sharpen > Unsharp Mask to sharpen up the fish-eye view a bit.

7. Choose Layer > Layer Style > Outer Glow to add an eerie glowing effect around your fish-eye view, making it look a bit like a crystal ball.

8. With the circular area still selected, click on the original image layer and press Shift+Ctrl/Command+D to invert the selection so it includes only the area outside the fish-eye view.

9. Use the brightness and contrast controls again to darken the area surrounding the fish-eye, providing greater contrast. Your image should now look like Figure 2.21.

Figure 2.21
After lightening the fish-eye view and darkening the surroundings, the image looks like this.

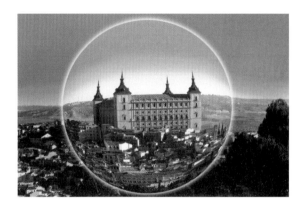

Don't be afraid to experiment. Figure 2.22 shows the same picture with some additional tweaking. At top, I added a glass lens filter, like the one provided in Kai's Power Tools. For the bottom image, I applied the spherize filter a second time to the first fish-eye view, making it even more distorted.

Figure 2.22
The image at top looks like a crystal ball, thanks to a glass lens filter—the image at the bottom has had the spherize filter applied a second time, producing a more exaggerated look.

Lens Flare

In computer terms, lens flare is a bug that became a feature. Like grainy, high-contrast film images, lens flare started out as an undesirable image defect that was eventually embraced as a cool artistic effect. As you might expect, Photoshop can duplicate this look with great versatility.

Lens flare is generally caused by light bouncing around within the elements of a lens in uncontrolled ways. A bright light source within the picture area, such as a spotlight or the sun, can generate flare. Very bright lights that are outside the area you've framed can also cause a kind of overall flare that reduces the contrast of your image. Lens hoods are designed to keep this stray light from reaching your lens' glass, thus improving contrast and making your images appear sharper and snappier.

Some kinds of lenses are more susceptible to lens flare than others. Telephoto lenses have a narrow field of view, and light from outside that view can be objectionable. That's why telephotos are virtually always furnished with a lens hood, usually one custom designed to precisely exclude illumination from outside the intended perspective of the lens. There is less you can do with normal and wide-angle lenses, as their much wider field of view automatically takes in every stray light source. However, lens hoods are a good idea for these lenses, as well. Even my ultrawide 16mm fish-eye has the stubby, almost vestigial fingers of a lens hood mount on its outer edge.

The design of a lens also is a factor. Zoom lenses or any lens with many, many elements (as well as lenses with very large front surfaces) are virtual magnets for image-obscuring stray light. With some lenses and in certain shooting environments, flare is almost unavoidable. That may be why so many photographers have decided to grin and bear it by incorporating lens flare into their pictures as a creative element. Photoshop lets you put the lens flare exactly where you want it, with precisely the degree of flare that you desire. Follow these steps to see for yourself:

1. Load the file **Sunset** from the CD-ROM included with this book. The image, a moody sunset picture, is shown in Figure 2.23.

2. The first thing to do is brighten the picture a little and give it more zip. Choose Image > Adjustments > Hue/Saturation. Move the Hue slider to −33 and the Saturation slider to +40. Click OK and you end up with a more vivid image, like the one shown in Figure 2.24.

3. Choose Filter > Render > Lens Flare to produce the dialog box shown in Figure 2.25.

4. You can choose to imitate the lens flare typically produced by three different types of lenses, a 50-300mm zoom, as well as 35mm and 105mm prime (single focal length) lenses. Start off by selecting the 105mm prime lens. You can also adjust the amount of flare by moving the Brightness slider. Drag the cross hairs shown in the preview window around to precisely position the center of the flare.

5. Click OK to apply the flare. Your image should look like Figure 2.26. You can see the effects of the 35mm and 50-300mm zoom lens settings in Figure 2.27.

Experiment with different brightness settings to achieve different effects. You can also apply the lens flare only to a selected portion of your image to keep the glare from obscuring some parts of the image.

Figure 2.23
This sunset picture could use a little livening up.

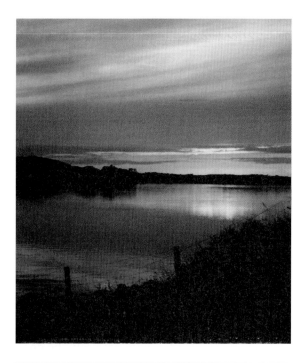

Figure 2.24
Adjusting the saturation and hue of the image provides a bit more zip.

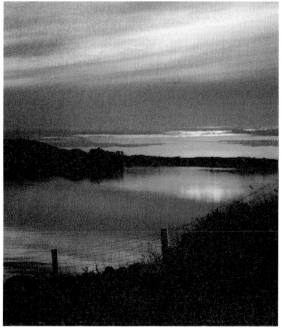

CHAPTER 2

Figure 2.25
The Lens Flare dialog
box offers a choice
of three different
lens types.

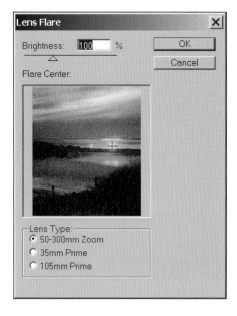

Figure 2.26
Photoshop's 105mm
Lens Flare filter
inserts a setting sun
into the photograph.

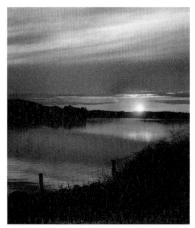

Figure 2.27
The 35mm Lens Flare
(left) and 50-300 Zoom
Lens Flare (right)
options produce their
own special effects.

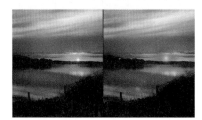

Motion Blur

The goal of neophyte action photographers is to freeze action, stopping everything in its tracks. Once you learn some reliable ways to accomplish that miracle, it soon becomes evident that people or things frozen in time tend to look a little bit like statues, and not particularly realistic or exciting from an action standpoint. We *expect* a little blur in our sports photography, especially if the blur of motion is used effectively.

If you know what you're doing (or even if you don't) capturing images with just enough blur to make them look alive is not that difficult with either digital or conventional cameras. Among the techniques at your disposal:

▶ Choose just the right shutter speed for the action at hand. Don't use a speed that's so slow that your subjects are terminally blurry, and avoid supershort shutter speeds that freeze everything. With experience, you learn which shutter speeds work with which kinds of motion.

▶ Learn to move your camera with the action (a technique called panning), which reduces the relative speed of your subject to the camera, allowing you to capture action with a slower shutter speed. As a bonus, panning often blurs the background enough to add the kind of motion blur you want to achieve.

▶ Understand the dynamics of motion. Objects crossing the camera's field of view blur more than those headed directly towards the camera. Some parts of an object, such as the wheels of a moving car or the feet of a running athlete, move faster than the rest of the subject, adding inevitable (or even desirable) blur. Subjects closer to the camera blur more than those located farther away.

Understanding these concepts can help you duplicate them within Photoshop, too, as another example of how photographic experience can help you when it comes time to edit your images. Try the following exercise to see some of the ways in which you can add motion blur to your images.

1. Load the **Soccer Blur** image from the CD-ROM bundled with this book. The original image is shown in Figure 2.28.

2. Select the soccer ball using the Elliptical Marquee tool. Hold down the Shift key to select a perfect circle. Press the cursor arrow keys to nudge the selection a bit, if necessary, so it encompasses the entire soccer ball.

3. Choose Filter > Blur > Radial Blur. This is the same filter you used earlier to produce a zoom effect. This time, choose Spin as the blur type, and move the Amount slider until the soccer ball has a bit of a blur to it, as shown in Figure 2.29.

Figure 2.28
This image is sharp
and not blurred, and
looks as if the soccer
players were statues.

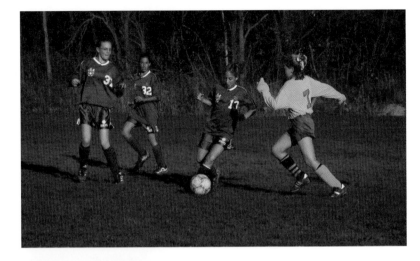

Figure 2.29
First, add some radial
blur to the soccer ball,
as if it were spinning.

4. Press Q to enter Quick Mask mode, and using a 65-pixel soft brush, "paint" a mask onto the right halves of the bodies of the players on each side of the kicker. These players are running towards the left side of the frame, so we want to add a little blur to the right sides of their bodies.

5. Press Q again to exit Quick Mask mode, then choose Filter > Blur > Gaussian Blur to invoke the dialog box shown in Figure 2.30. Move the Radius slider to about three pixels, and click OK to apply the blur.

Figure 2.30
The Gaussian Blur dialog box lets you choose the amount of blurring to add.

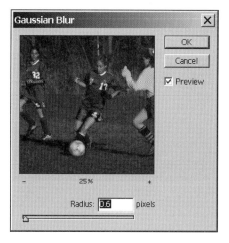

6. The relevant portion of your image should now look like Figure 2.31.

Figure 2.31
Here is some motion blur added to the players who appear to be running towards the left.

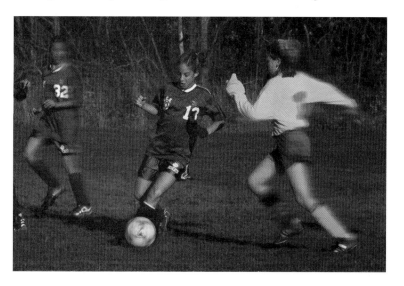

7. Repeat steps 4 and 5, only paint over the entire body of the girl at the left side of the frame to apply blur completely over her form. The finished shot looks like Figure 2.32.

Figure 2.32
Finally, add overall
blur to the girl at the
far left to produce
this final image.

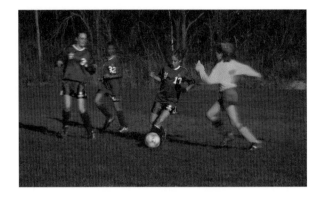

Keep in mind the dynamics of motion when applying blur. In some cases, you might want to blur only your subjects' feet and/or hands. Add some blur to the wheels of a locomotive to give it a feeling of speed and power. Put streaks behind a skyrocket rising into the heavens.

Selective Focus

Selective focus is one of the most valuable creative tools at your disposal, allowing you to isolate or feature various parts of your composition. For example, by throwing the background out of focus, you can place emphasis on the subject in the foreground. The techniques of selective focus, using depth of field (the amount of the image that is in relatively sharp focus), should be familiar to every photographer.

▶ Use longer lenses, which inherently have less depth of field, to give yourself greater control over what's in focus and what is not.

▶ Move in close to take advantage of the reduced depth of field at near range.

▶ Use larger lens openings to reduce the amount of depth of field.

▶ Use manual shutter speed settings or the aperture priority mode of your camera to allow use of those larger lens openings.

▶ Filters, slower films, and other aids can help control the lens opening you use and, thus, the amount of depth of field with which you are working.

▶ Learn the dynamics of focus, such as how two-thirds of the depth of field at any particular distance and lens opening is applied to the area behind your subject, and only one-third to the area in front of it.

▶ Preview the amount of area in focus using your single-lens reflex camera's depth of field preview or your digital camera's LCD screen.

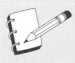

SELECTIVE FOCUS AND DIGITAL CAMERAS

Photoshop is a lifesaver for digital camera users eager to apply selective focus techniques, because digital camera lenses inherently provide much, much more depth of field for a given field of view than a conventional film camera.

The depth of field bonus of digital cameras comes from the relatively short focal length lenses they use. The maximum "telephoto" setting of a typical digital camera may be 32mm (producing the same field of view as a 150mm lens on a 35mm camera). However, the depth of field provided by the digital camera at that setting is much closer to that of a wide-angle lens than to a telephoto lens. As a result, it may be very difficult to use selective focus with a digital camera, unless you're taking a picture very, very close to your subject.

Figure 2.33 is a digital camera picture of a kitten, taken at close range (on the CD-Rom: **Kitten**). The background is already fairly blurry, but it's still distracting, and we can do better. For this image, I used the Quick Mask mode we've already deployed several times in this chapter and painted a selection that included only the cat, taking special care around the edges of the feline.

Figure 2.33
Even digital cameras can achieve selective focus when shooting close up, but we can do better.

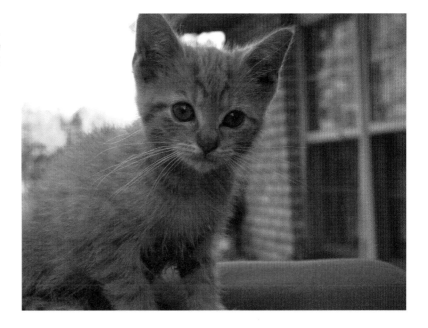

Then, I applied Photoshop's Unsharp Mask filter to sharpen the cat even more, and I followed that with an application of Photoshop's Blur tool to increase the out-of-focus appearance of the background. As a final touch, I put the Dodge tool to work to lighten the cat's eyes. You can see the final image in Figure 2.34.

Figure 2.34
Blurring the
background while
sharpening the cat
produces a more
dramatic selective
focus effect.

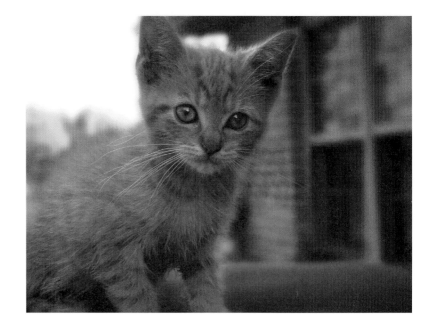

Next Up

We encounter other lens and camera techniques in some of the other chapters. But next, it's time to venture into the digital darkroom to learn how to reproduce time-honored processing techniques with Photoshop.

3

Darkroom Techniques

One of the things I miss the most—and the least—about photography in the predigital age is the fun and drudgery of laboring in the murk of a musty darkroom, surrounded by humid, acid-tinged odors and an eye-straining pale yellow glow. Despite an environment that would drive a claustrophobe nuts, miracles are created in the darkroom, and magical images often emerge from behind the heavy black curtain.

Fortunately, there's no need to throw the spectacular images out with the stop bath water. Photoshop includes a whole raft of features that let you recreate the most useful darkroom techniques quickly and repeatably, without risk of wasting film, paper, or chemicals.

This chapter shows you some of the advanced darkroom techniques that you can put to work using Photoshop's awesome capabilities.

Film Development Techniques

Some of the most interesting, and, unfortunately, permanent, special effects can be achieved by abusing your film during development. Such tricks as exposing your latent images to light, boiling the film, overdeveloping it, or plunging it into icy cold water find their way into many a darkroom worker's repertoire. As you might guess, none of these processes are very forgiving. Developing the film a few seconds too long, exposing it to a bit too much light during processing, raising the temperature of the developer a few degrees too much, or any of a dozen other "errors" can change the results you get dramatically. After you've tried out the effects that follow, you'll wish you had Photoshop's Undo features available for conventional film processing.

Solarization

Solarization is a process which, like the reticulation technique discussed in the next section, started out as a disastrous error that some photographers soon adopted as a creative

technique. Wildly popular as a means of adding a psychedelic look to photos of rock bands in the late 60s, solarization lives on as a creative tool in Photoshop. Adobe's flagship image editor offers several different ways to create solarization effects, and I'm going to show you all of them. But first, a little refresher for those who may have seen traditional solarization many times, but are a little uncertain on how it is achieved. You may be a little surprised.

First of all, what we usually call solarization isn't necessarily the same phenomenon that was initially given the solarization tag at all. First discovered in the 19th Century, solarization was originally a particular appearance caused by extreme overexposure, which reversed some tones of an image, such as the glare of the sun reflecting from a shiny object. No chicanery in the darkroom was required. In the twentieth century, some photographers, including Ansel Adams and Man Ray, took advantage of this technique to produce some memorable pictures in which the brightest object in their images, the sun, appeared as a completely black disk. At the time those innovators worked, an exposure of five to ten times normal was required to create the solarization effect. Modern films are designed to resist solarization and require an exposure at least 10,000 times as strong to generate the effect, making overexposure solarization something of a rarity.

A somewhat different look, sometimes called the Sabattier effect to differentiate it from overexposure solarization, was discovered when partially developed film or paper was exposed to light and then more completely developed. This frequently happens when a clumsy third party (or the chagrined photographer) accidentally turns on a light at the wrong time. The resulting image is part positive and part negative, an interesting mixture that gives it a psychedelic look. Color or black-and-white film as well as prints can all be solarized, but finding the right combination of development and "accidental" exposure is tricky and difficult to repeat. For that reason, in the conventional photography realm you most often see descriptions of how to solarize prints because, if you spoil a print, you can easily make another and solarize it, as well. However, the most striking solarization effects come from manipulating film, and that can get expensive very quickly. Fortunately, Photoshop lets you experiment to your heart's content, and it takes all the error out of trial and error.

Using Photoshop's Solarize Filter

Follow these steps to solarize an image using Photoshop's Solarize filter. Start with the **Clown Filter** image on the CD-ROM bundled with this book. I chose this particular image, shown in Figure 3.1, because it has lots of bright, saturated colors that clearly demonstrate the effects of solarization.

Figure 3.1
This image has lots of bright colors, making it great for solarization effects.

1. Choose Layer > Duplicate layer to create a new layer with which to work.

2. Next, select Filter > Stylize > Solarize. This filter is a single-step filter with no dialog box or settings to make.

3. You get a dark, murky image with some tones reversed. Immediately apply Image > Adjustments > Auto Levels to produce the more viewable picture shown in Figure 3.2.

4. The black background is still a little disconcerting, so you might want to use the Magic Wand selection tool to select the background, then click inside the black areas within the largest filter on the right side of the image, too. Then choose Image > Adjustments > Invert to convert the black background to white, as shown in Figure 3.3.

Figure 3.2
This solarized image has its colors reversed.

Figure 3.3
Inverting the colors
produces a more
viewable image like
this one.

5. While the Solarize filter doesn't have any controls, you can still customize your solarization. Choose Image > Adjustments > Hue/Saturation (or press Ctrl/Command+U) to produce the Hue/Saturation dialog box shown in Figure 3.4.

6. Move the Saturation slider to the right to increase the richness of the colors, according to your taste.

7. Move the Hue slider to the left or right to modify the colors to get an effect you like.

8. Click OK to apply your changes.

Figure 3.4
Use the Hue/Saturation
dialog box to enrich
the colors.

Using Photoshop's Curves to Solarize

This next section shows you a more flexible method of creating solarizations, using Photoshop's Curves command, which allows you to manipulate the amount of each primary color in an image based on the lightness or darkness of the tones. Because the traditional Sabattier effect affects the midtones of an image most strongly, manipulating Photoshop's Curves gives you much the same look, but with a lot more flexibility than the image editor's built-in Solarize filter. The best part is that you don't have to understand how manipulations to the color curves of an image affect the image itself. Because you're not trying to correct color but, instead, create new colors, feel free to play around. Just follow these steps, using the same clown and filter image you worked with earlier.

WORKING WITH CURVES

Photoshop has three main ways of adjusting the tones of an image, and we use all of them in this chapter. The Brightness/Contrast dialog box lets you change an image globally, with no difference between the way the changes are applied to the highlights, midtones, and shadows. The Levels command adds more control, allowing you to change the shadows, highlights, and midtones, separately. The Curves command, used next, goes all out and lets you change pixel values at any point along the brightness level continuum, giving you 256 locations at which you can make corrections.

You can see the Curves dialog box in Figure 3.5. The horizontal axis maps the existing brightness values before you make any image corrections. The vertical axis maps the brightness values after correction. Each axis represents a continuum of 256 levels, divided into four parts by finely dotted lines. In Photoshop's default mode, the lower-left corner represents 0,0 (pure black) and the upper-right corner is 255,255 (pure white).

Whenever you open the window, the graph begins as a straight line because, unless changes are made, the input is exactly the same as the output—a direct 1:1 correlation. As you change the shape of the curve, you adjust the values in the image at each point along the curve. If you haven't used Curves before, it's easier just to play with the curves to see what your manipulations do.

Figure 3.5
Photoshop's Curves
dialog box lets you
adjust tonal values for
grayscale and color
images.

1. Choose Layer > Duplicate again to create a new, fresh version to work on, while retaining the original, in case you need to start over.
2. Select Image > Adjustments > Curves to produce the dialog box shown in Figure 3.6.
3. Grab a point on the left side of the curve in the graph preview and drag it upwards. Your image becomes washed out, and the colors start to change.
4. Drag other points on the curve up or down, creating a series of hills in the curve. You get a variety of effects, one of which is shown in Figure 3.7.

Figure 3.6
Drag upwards to
produce a modified
curve like this one to
start the solarization
effect.

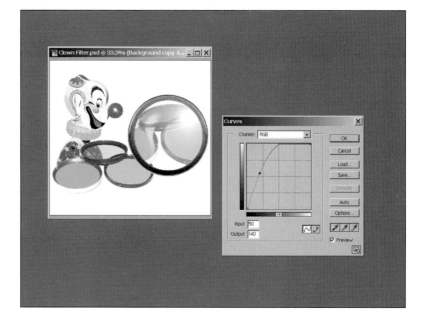

Figure 3.7
Create a series of hills
and valleys to change
the colors in a dramatic
way.

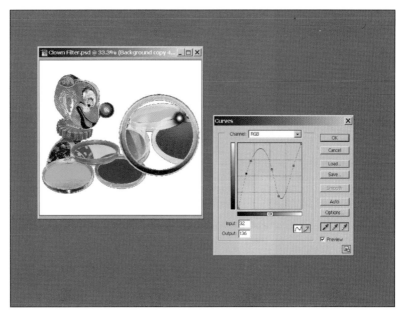

These steps operate on your image's red, green, and blue color layers at the same time. You can also select one color layer from the drop-down Channel list, and manipulate that color individually. Feel free to play around with the colors to get the exact solarization effect you like best.

Reticulation

Reticulation is another one of those darkroom processes that can either ruin your film or generate some "I meant to do that" type of images. It results from rapid temperature changes during development. As you probably know, conventional photographic film consists of a silver rich (and relatively soft) gelatin emulsion coated on a thin, but tough, substrate such as polyester. During developing, if black-and-white film is moved from a warm developer to a significantly cooler solution, the soft gelatin warps in strange looking patterns and the grain in the image increases dramatically. The result is an interesting texture that can be used as a creative tool.

Like solarization, reticulation effects are difficult to plan or duplicate. In the darkroom, a slow working developer is used at, say, 100 degrees instead of the more usual 68 to 75 degrees, and its is action stopped by plunging the film into ice cold water or acidic stop bath, prior to normal fixing and washing. Done properly, and with a bit of luck, you end up with some interesting film effects. With bad luck, you may end up with emulsion that slides right off your film substrate, as has happened to me a few times.

There's no such danger when using Photoshop to produce reticulation. While this effect is considered a black-and-white process (rapid changes in temperature ruin color film in

ways that are rarely artistic), I'm going to show you a way to get the same look in full color. We're going to use an image called **Tower**, shown in Figure 3.8, which you can find on the CD-ROM that accompanies this book. When you've loaded it into Photoshop, just follow these steps.

Figure 3.8
Start with this image to being the reticulation process.

1. Create a duplicate layer of the tower image to give you a fresh canvas with which to work.

2. Choose Filter > Sketch > Reticulation to produce the Reticulation dialog box shown in Figure 3.9.

3. Change the Density slider to a value of 9, Foreground Level to 22, and Background Level to 22 (although you're free to experiment with different settings).

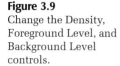

Figure 3.9
Change the Density,
Foreground Level, and
Background Level
controls.

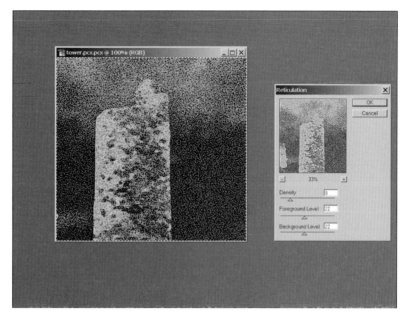

4. Click OK to apply the filter. You'll find that the texture looks very much like real reticulation. If you'd like to see reticulation in color, you need to merge this reticulated black-and-white version with the original color image in the layer below.

5. To create a color reticulation, make sure the black-and-white reticulated layer is selected in the Layers palette, then choose Color Dodge from the drop-down layer modes list at the left side of the palette, as shown in Figure 3.10. This merging mode allows the color of the underlying layer to show through, while retaining the reticulated texture of the layer on top.

Figure 3.10
Use Color Dodge to merge the black-and-white reticulated image with the color image in the layer below.

Cross-Processing

Weird color effects, such as those produced with cross-processing, are often used because they produce unusual and unique looks, until eventually the point is reached that everybody is using them and they're no longer novel. In the latter years of the last millennium, so many images with cross-processing were used in advertising that I began to wonder if perhaps evil photo labs were at work trying to undermine our color perception.

Cross-processing is nothing more than a technique in which color film is processed in the wrong chemicals. For example, color negative film can be developed in solutions intended for color transparencies, yielding a dark, blue-tinged positive image. Or, color slide film can be processed in color negative chemicals, creating an interesting negative image. Of course, the resulting negatives-cum-slides are much too dark to be used as slides, but they can be successfully reproduced in books and magazines. Likewise, the slides-cum-negatives lack the orange mask found in normal negative films, but still can be printed or reversed by a skilled darkroom technician. In both cases, the results are images with colors unlike any scenes found in nature or nightmare.

There are several methods for creating cross-processed images in Photoshop, but this is one of the easiest. Just follow these steps:

1. Open **Cross Process** from the CD-ROM bundled with this book. The basic image looks like the one shown in Figure 3.11. It's a light image with bright skin tones, a combination that works well with Photoshop's cross-processing techniques.

2. Use Layer > Duplicate to create a copy of the background layer.

3. Choose Image > Adjustments > Curves to produce the dialog box shown in Figure 3.12.

4. Select Red from the Channel drop-down list.

5. Click on the curve at the fourth vertical line from the left on the graph and drag it to the position shown in the figure, making the Input and Output levels 192 and 188, respectively.

6. Click on the curve between the second and third vertical line and drag it to the position shown. The Input and Output boxes should read about 82 and 46, respectively. This change gives the image a distinct cyan cast in the midtones.

Figure 3.11
Start with this image.

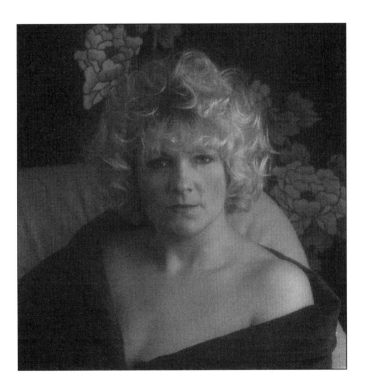

Figure 3.12
Adjust the Red
channel first.

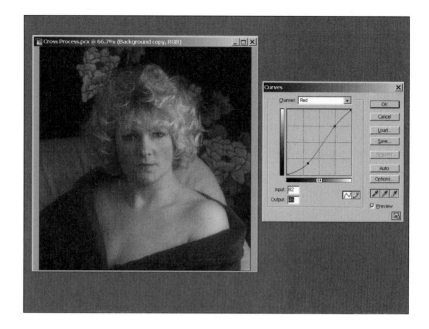

7. Select Green from the Channel drop-down list.

8. Click on the curve at the positions shown on the third vertical lines from the left on the graph and drag to the positions shown in Figure 3.13, resulting in Input and Output figures of 125 and 127. Then drag a point on the fifth vertical line to positions that equal Input and Output values of 252 and 206, respectively.

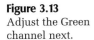

Figure 3.13
Adjust the Green
channel next.

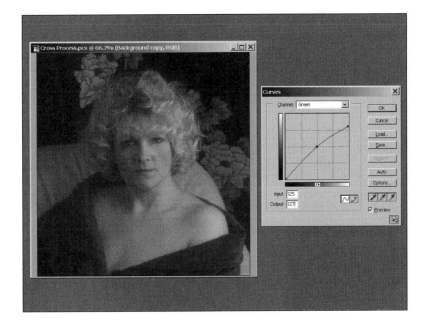

9. Select the Blue channel from the drop-down list.

10. Drag the point on the fifth vertical line down to the position shown in
 Figure 3.14, producing Input and Output figures of 255 and 176, respec-
 tively. Then drag a point between the second and third vertical lines
 upwards to create Input and Output values of about 94 and 109.

11. Click OK to apply the changes.

Figure 3.14
Finally, adjust the
Blue channel.

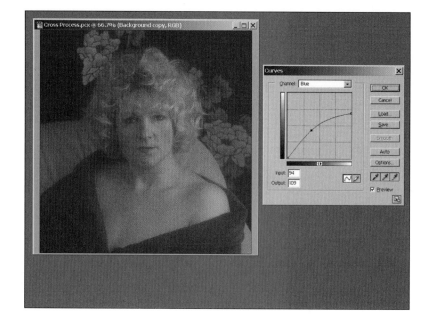

12. Next, choose Image > Apply Image, and select Hard Light from the Blending mode drop-down list.

13. Set Opacity to 50 percent, as shown in Figure 3.15, and then click OK to apply the change.

14. Use Image > Adjustments > Brightness/Contrast to lighten the image a little more and add some contrast, according to your taste. The final image should look something like Figure 3.16.

Figure 3.15
Select Hard Light to
blend the image.

Figure 3.16
The final image looks
like this.

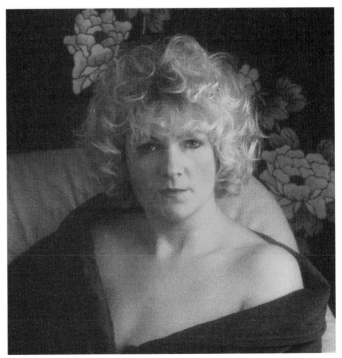

High-Contrast Images

Many years ago, some well-meaning soul discovered that superhigh-contrast images had an interesting, minimalist look that stripped images down to their bare bones. Andy Warhol, although not known as a photographer, used this effect in his work, including his famous Marilyn Monroe series. Indeed, high contrast images are easy to achieve simply by using lithographic films intended for reproducing line art.

Litho films have a built in "threshold" that must be exceeded before an image is formed. That is, if a portion of an image is below the brightness threshold of the film, it won't register at all. If the portion of an image is above that threshold level, it is recorded as black. Figure 3.17 shows a black-and-white image at left, with a high-contrast version at right. While this example could have been produced using lithographic film, Photoshop lets you do much the same thing without resorting to special films and litho developers.

Figure 3.17
A normal black-and-white image (left) and a high-contrast version (right).

High-contrast images can be created in color or black and white, and can consist of just two or three tones (for example, black and white, or white and a color or two) or may encompass more tones to create a poster-like effect. The important thing to remember when choosing a subject for a high-contrast image is to make sure that the most important part of the subject matter has one of the lightest tones in the image. As the contrast is boosted, the dark tones and most midtone areas become black, while the very lightest tones remain white. If your key subject matter is too dark, it turns black along with the other midtones and deep tones and is not visible in your finished image.

You can easily create high-contrast images by manipulating Photoshop's brightness and contrast controls. Select Image > Adjustments > Brightness/Contrast, and then manipulate the brightness and contrast sliders to get the effect you want. The contrast control determines the number of different tones in the final image. A typical black-and-white image

contains up to 256 different tones; moving the contrast slider to the right reduces that number gradually until, when it reaches 100 percent, you're left with only black and white. The brightness control adjusts the lightness of all the tones in an image, making the darkest tones brighter and the lightest tones gradually so bright they merge into white. Figure 3.18 shows a series of six versions of the same image, with the contrast set at 25, 35, and 50 percent (top row), and 65, 75, and 85 percent (bottom row). If you compare the individual images side by side, you can easily see how details are gradually lost as the increase in contrast moves the details across the threshold boundary, and they change from gray to black or white.

Figure 3.18
Here are six versions of the same image with the contrast set at 25, 35, and 50 percent (top row), and 65, 75, and 85 percent (bottom row).

In Figure 3.19 you can see the effect of adjusting the brightness control. The image at top left is the basic head shot at the 50 percent contrast level. The next three have brightness set for 25, 50, and 75 percent. Learn to use these controls to provide the exact look you want. Often, a 100 percent black-and-white image is not the best looking one.

Figure 3.19
Here, the brightness
has been adjusted from
25 to 75 percent.

High Contrast with Levels

You can use Photoshop's Levels dialog box to give yourself a lot more control over your high-contrast image than the Brightness/Contrast controls can offer. This can be especially important when you're working with a color image, as you can adjust the contrast of each of the three primary RGB colors separately.

The Levels dialog box, shown in Figure 3.20, provides a different way of adjusting brightness and contrast. The graph is called a histogram and is used to measure the numbers of pixels at each of 256 brightness levels. Each vertical line in the graph represents the number of pixels in the image for each brightness value, from 0 (black) on the left and 255 (white) on the right. The vertical axis measures that number of pixels at each level. There are three triangles at the bottom of the graph, representing the black point (darkest shadows), midtone point, and white point (the brightest highlights). How these are used will become clearer shortly.

Figure 3.20
The Levels dialog box is used to adjust brightness and contrast using a histogram.

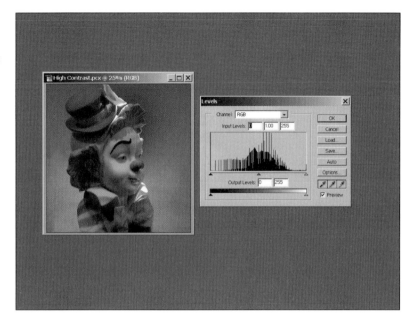

This histogram shows that most of the pixels are concentrated in the center of the histogram, with relatively few very dark pixels (on the left) or very light pixels (on the right). If we wanted to make the best use of the available tones, we'd move the black triangle on the left to a point that better represents where the darkest pixels are in the image, and the white triangle on the right to a point that represents where the image actually contains some light pixels, as shown in the upper dialog box in Figure 3.21. The result would be a "better" image, producing a histogram more like the lower one shown in the figure. Notice that the tones are spread more evenly in the graph.

CHAPTER 3

Figure 3.21
Adjusting the black, midtone, and white points distributes the tones more evenly.

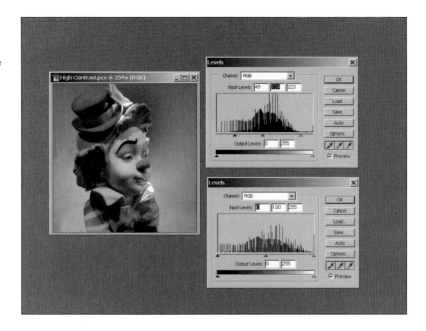

Ah, but when working with high-contrast images, the concept of "better" differs slightly from the ideal. Instead, if we pulled the three triangles together, as shown in Figure 3.22, the brightest and darkest tones in the original image are ignored, and the emphasis is placed on a narrow range of midtones, producing the results you see. Move the white, midpoint, and black sliders to experiment with different effects. Concentrating them at the left side of the histogram produces a high-contrast, very light image, while bunching them up at the right side of the histogram produces a high-contrast, dark image, as you can see in Figures 3.23 and 3.24.

Figure 3.22
Clustering the black,
midtone, and white
point triangles together
produces a high-
contrast image.

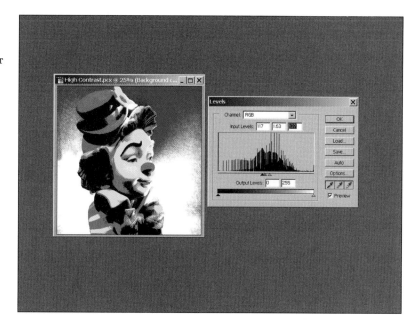

Figure 3.23
Clustering the points
on the left side
produces a high-
contrast, light image.

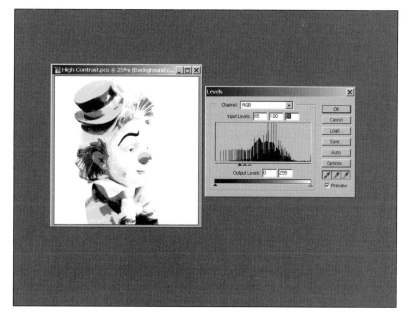

Figure 3.24
Clustering the points on the right side produces a high-contrast, dark image.

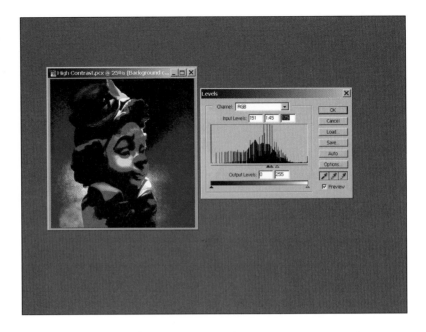

You can see that experimenting with the Levels controls can produce a wide variety of high-contrast results. You can even apply the level adjustments to each of the individual red, green, and blue color channels to create spectacular color effects even as you adjust the contrast.

WORKING WITH ADJUSTMENT LAYERS

For maximum flexibility, create an Adjustment Layer using Levels as the control (select Layer > New Adjustment Layer > Levels) to let you play with the levels without making any permanent changes in your image. The Adjustment Layer appears in the Layer palette with a special icon, shown in Figure 3.25. You can access the layer's Levels dialog box at any time by double-clicking the icon. When you're satisfied with the result, flatten the image before saving. Adjustment Layers can be used with the Curves and Brightness/Contrast controls you've also used in this chapter.

Figure 3.25
Access an Adjustment
layer by clicking
its icon in the
Layer palette.

High Contrast with Photoshop's Posterize Command

Photoshop's Posterize command can also be used to create high-contrast images. Its dialog
box (accessed by choosing Image > Adjustments > Posterize) has only one parameter: You
type in the number of different tones in your final image. In practice, once you include
more than about 16, the image tends to look like an ordinary photograph. Figure 3.26
shows our clown rendered in 4, 8, 12, and 16 different levels.

Figure 3.26
Photoshop's Posterize
command produces
effects like these at 4,
8, 12, and 16 different
levels of color.

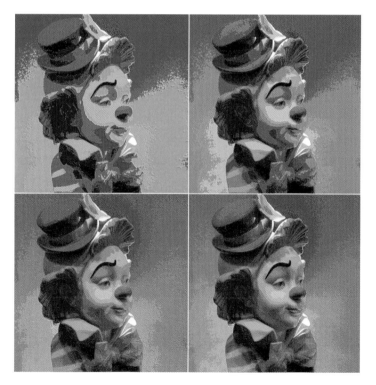

Grainy Images

Film grain is an inescapable fact of life in conventional photography, as clumps of silver grain are roughly the equivalent of the pixel in digital imaging. Generally speaking, the larger the grains of silver in a film, the more sensitive that film is to light, and the better able it is to capture images in reduced lighting or with faster shutter speeds and/or smaller lens openings. In the never-ending quest to increase the exposure "speed" of films, grain has been a frequent by-product. Given the "if you can't beat 'em, join 'em" attitude of photographers, grain itself has found a place as a creative tool. Grain can mask defects in a person's face and, like high contrast (which often goes hand in hand with grainy pictures), can reduce an image to its bare essentials.

In conventional photography, extra grain can be produced in several different ways. You can use a faster, inherently grainer film, or underexpose your film and then use longer processing times to make the grains that were exposed (usually the largest, clumpiest grains) visible. Warm developer solutions or even "grainy" overlays used to add grain to an image as it is printed are other options.

Photoshop offers several different ways of creating grain effects. Figure 3.27 shows the dialog boxes for Photoshop's Film Grain, Grain, Add Noise, and Mezzotint filters. All these work best with black-and-white images, as adding grain effects to color photos generally produces unnatural looking results.

Figure 3.27
The Film Grain, Grain, Add Noise, and Mezzotint filters each produce different grain effects.

Film Grain

This filter has three slider controls. You can adjust the amount of Grain, the size of the Highlight Area, and the Intensity of the highlights. The Grain setting controls the density

of what appear to be random little black grains that are sprinkled throughout your image. The higher the value, the more details of your image are obscured by the grain overlay. Since the Film Grain filter applies more grain to the highlights than to the shadows and midtones, the Highlight Area slider determines how many tones are considered highlights; at higher values, virtually all of the image is given the full treatment. The Intensity slider controls how strongly the grain is applied to the highlight areas.

Grain

While the Film Grain filter adjusts the amount of grain and how the granules are applied to highlights, the Grain plug-in works with contrast (the darkness of the grain in relation to the image area surrounding it) plus the shape of the granules. You can also control how much grain is added. The 10 available types of grain cover several varieties often seen in photographs, plus some new ones that offer imaginative artistic effects. You can choose from Regular, Soft, Sprinkles, Clumped, Contrasty, Enlarged, Stippled, Horizontal, Vertical, or Speckle grain patterns. It's sometimes difficult to tell the difference between some of these effects. For example, the Stippled effect uses foreground and background colors to create grain, while Sprinkles uses just the foreground color.

WHY TWO GRAIN FILTERS?

Why does Photoshop include two filters called "Film Grain" and "Grain," rather than one? In practice, each operates a little differently than the other, producing different effects, but we can thank the free enterprise system for their existence. Photoshop's current Film Grain filter was originally part of a third-party set of 16 compatible plug-ins called Aldus Gallery Effects, which sold for $199. These filters proved so successful that Aldus Corporation followed up with a second set of 16, which included the slightly different Grain filter. Soon after Aldus released the third Gallery Effects library, Adobe acquired the company (adding PageMaker to its product line along with Gallery Effects). The filters were sold by Adobe for a time, but disappeared as a separate product when they were folded into Photoshop 4.0.

Add Noise

The Add Noise filter has one slider, a pair of radio buttons, and a checkbox. You can select an Amount from 1 to 999 (the default value is 32). This value is used to determine how much the random colors added to the selection vary from the color that is already present (or from the gray tones, if you're working with a monochrome image).

Choose either Uniform or Gaussian distribution of the noise. Uniform distribution uses random numbers in the range from zero to the number you specified with the Amount slider. The random number is then added to the color value of the pixel to arrive at the noise amount for that pixel. Gaussian distribution uses a bell-shaped curve calculated from the values of the pixels in the selected area, producing a more pronounced speckling effect.

Mark the Monochromatic box to apply the noise only to the brightness/darkness elements of the image without modifying the colors themselves. This can reduce the "color specks" effect that often results from applying noise to a color image.

Mezzotint

The Mezzotint filter is another technique borrowed from traditional printing, in which a special overlay is placed on top of a photograph to add a pattern during duplication. Digital filters offer much the same effect with a little less flexibility, since the range of mezzotints you can achieve with Photoshop is fairly limited. Only dots (fine, medium, grainy, or coarse), lines, or strokes (in short, medium, and long varieties) can be applied. You can rotate your image, apply this filter, then rotate it back to the original orientation if you want to change the direction of the lines or strokes.

Figure 3.28 shows examples of grain effects produced by the Film Grain, Grain, Add Noise, and Mezzotint filters.

Figure 3.28
Various film grain effects: in the top row (left to right), the original image— Film Grain filter with Grain, Highlight Area, and Intensity all set to values of 5, and Film Grain filter with settings of 10, 5, and 7; in the bottom row (left to right), Grain filter set to Speckle, Add Noise filter, and Mezzotint filter in Fine Dots mode, then faded to reduce the effect slightly.

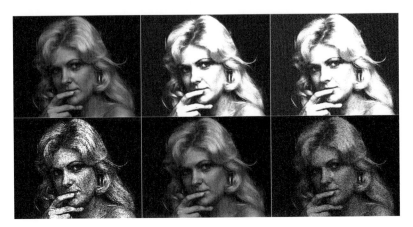

Diffuse Glow

My favorite of all Photoshop's "grain" effects is the Diffuse Glow filter, which can produce a radiant luminescence in any image. The glow seems to suffuse from the subject and fill the picture with a wonderful luster, while softening harsh details. It's great for romantic portraits, or for lending a fantasy air to landscapes. Diffuse Glow works equally well with color and black-and-white images, using the dialog box controls shown in Figure 3.29.

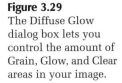

Figure 3.29
The Diffuse Glow
dialog box lets you
control the amount of
Grain, Glow, and Clear
areas in your image.

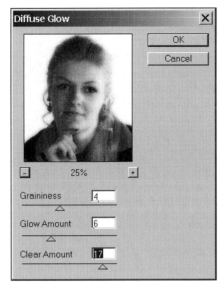

You can get a variety of effects by manipulating the filter's controls, such as in the examples shown in Figure 3.30. The Graininess slider adds or reduces the amount of grain applied to an image. A large amount obscures unwanted detail and adds to the dreamy look of the image. The Glow Amount control adjusts the strength of the glow, as if you were turning up the voltage on a light source. The higher the setting, the more glow spreads throughout your picture. The Clear Amount slider controls the size of the area in the image that is not affected by the glow. You can use this control with the Glow Amount slider to simultaneously specify how strong a glow effect is produced, as well as how much of the image is illuminated by it. The current background color becomes the color of the glow. That's an important point. Beginners sometimes forget this, and then wonder why their glow effect looks weird. If you want a glowing white effect, make sure the background color is white. Anything else tints your image. You can use this feature to good advantage, by selecting background colors with a very slight tint of yellow, gold, or red to add a sunny or warm glow to your image.

Figure 3.30
The original photo
(top left) with three
variations on the
Diffuse Glow filter.

In the examples, the portrait in the upper right has the Graininess control set to 5, the Glow Amount control set to 10, and the Clear amount set to 20. At lower right the diffusion is less obvious, and the contrast not quite as high, producing a romantic fuzziness that doesn't take over the entire picture. I used Graininess, Glow Amount, and Clear Amount settings of 1, 4, and 12, respectively. Finally, for the example in the lower right, I concentrated the attention on the model's eyes by using settings of 7, 15, and 10, and then merging the layer with a copy of the original, unmodified layer, using the Layer palette's Merge drop-down list set to Lighten. In that mode, Photoshop looks at each pixel in the two layers and uses the lightest pixel for the final image. The resulting picture is very washed out and grainy with an interesting high-contrast appearance.

Black-and-White Infrared Film

The look of black-and-white infrared films are not a darkroom effect but, instead, a result of using specialized films that are intended to capture a bit of the infrared spectrum along with the normal visible light. Despite the common misconception, widely used infrared films don't image "heat" as we think of it. Instead, they are simply more sensitive to light that's even redder than the reds we capture with ordinary films—light in the near infrared portion of the spectrum.

Because infrared films see light that the unaided eye cannot, these pictures look quite a bit different from a standard black-and-white image. Anything that reflects infrared illumination especially well, such as clouds, foliage, or human skin, appears much lighter than it does to the naked eye. Subjects that absorb infrared, such as the sky, appear much darker than normal. You can't predict ahead of time what an infrared photo will look like (because the image is affected by light you can't see), so these pictures are often surprising and mysterious looking.

Infrared film is difficult to use, too. Light meters don't accurately measure the amount of infrared light, so exposures may vary quite a bit from your meter reading. You should bracket exposures on either side of the "correct" reading to increase your odds of getting a good picture. Infrared film must be loaded and handled in total darkness, too. Fortunately, faking an infrared photo with Photoshop is simple to do.

Use the **Infrared** photo (or another color photo of your choosing) from the CD-ROM bundled with this book. Photoshop needs to see the various colors in the image, just as an infrared film does, so you must start with a color picture. Just follow these steps:

1. First select the sky area of the image. Press Q to enter Quick Mask mode, and paint around the sky area with a soft brush, as shown in Figure 3.31. Use a small brush to paint the edges of the selection around the castle and trees.

2. Press Q again to exit Quick Mask mode, then press Ctrl/Command+C to copy the sky. Then press Ctrl/Command+V to paste it down in its own layer. Double-click the layer to activate Photoshop 7's renaming mode, and name the layer Sky.

3. Press Ctrl/Command+S and save the file as infrared.psd to preserve your work so far.

4. Double-click the background layer, and name it Castle.

5. Choose Layer > New Adjustment Layer > Channel Mixer, and click OK when the New Layer dialog box appears. The Channel Mixer dialog box should pop up, as shown in Figure 3.32.

Figure 3.31
First, paint around the sky area in Quick Mask mode to select it.

Figure 3.32
Use the Channel Mixer to apply an infrared look to the greens of the image.

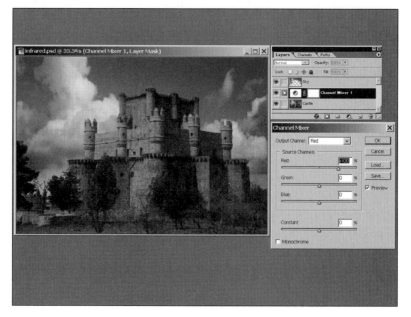

6. To mimic the infrared effect, we want everything that appears as green in the image to appear much lighter than normal (because living foliage reflects a lot of infrared light), but in black and white. Click the Monochrome button to apply the changes we're going to make to a grayscale version of the layer.

7. Lighten the green portion of the image by boosting the Green channel to 200 percent (the maximum allowed by Photoshop). Move the Green slider all the way to the right.

8. Reduce the amount of red by moving the Red slider to the left, to about −80 percent. Click OK to apply the change. The image now looks like the one shown in Figure 3.33.

9. Click the Sky layer and Choose Layer > New Adjustment Layer > Channel Mixer to create an adjustment layer for the sky.

10. Move the Red slider to the right, to about 90 percent, and then click OK to apply the change.

11. Save the image with the adjustment layers intact. You can reload the image at any time and make further modifications with the adjustment layers.

12. Flatten the image and save under a new name. Figure 3.34 shows a comparison of the original image converted to grayscale, and our "fake" infrared image.

Figure 3.33
After adjusting the Red and Green channels, the image looks like this.

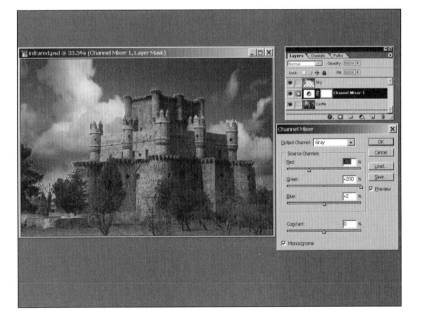

Figure 3.34
Darken the sky to complete the faux infrared look.

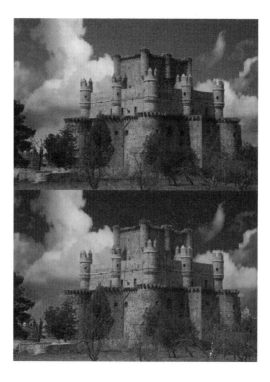

Printing Techniques

The fun doesn't stop when the film is developed and hanging from clothespins. There are many different things in the darkroom that you can do to your images while they are being printed. Those of us who rely on digital output hard copies can still enjoy the pleasure of fine-tuning pictures in the digital darkroom. Here are a few techniques to work with.

Dodging and Burning

Color and black-and-white prints are traditionally made using an enlarger, which casts an image of the film onto a photosensitive sheet of paper for a carefully calculated number of seconds. For about as long as photographers have been making prints they have also been sticking their fingers, hands, or other objects in the light path to reduce the relative exposure of one part of an image (dodging) while increasing it in another (burning). The result is either an image in which the light and dark tones in an image are more evenly balanced or, in some cases, deliberately changed to provide a different appearance (as with vignetting, discussed next).

Cupped hands with a gap between them are often used to burn parts of an image. The darkroom worker is able to keep the hands moving, varying the size and position of the opening, to blend the burned areas with their surroundings. A hand can also be used to

hold back, or dodge part of an image, but it's more common to use a home-made dodging tool (such as a piece of cardboard fastened to a length of coat hanger wire) so the adjustment can be made only to the center portion of the image.

Because the image being exposed on the paper is visible and the length of the overall exposure is known, the printer is able to adjust the tones quite precisely. For example, with a 60-second exposure, a portion of the image that needs to be lightened or darkened can be dodged or burned in roughly 5- or 10-second increments by viewing the enlarger's timer while working. The amount of dodging or burning required comes from experience, usually gained by redoing a print that hasn't been manipulated properly.

It also was widely believed that some small changes could be made in black-and-white prints by fiddling with the paper development, usually by controlling how the paper went into the developer, by rubbing portions of the paper with the fingers (to generate heat and "faster" development of that portion), as well as through mystical incantations.

Today, you can do the same magic with Photoshop. You can use the image editor's built-in dodging and burning tools, or create a selection mask and adjust the brightness using controls such as Brightness/Contrast. Open the file **Lighthouse** from the CD-ROM that accompanies this book, and follow these steps. The original image appears in Figure 3.35.

Figure 3.35
The original lighthouse
photo looks like this.

1. Use Layer > Duplicate Layer to create a copy of the background layer.

2. Choose the Burn tool from the Tool palette, and make the following adjustments in the Options bar: Choose a 65-pixel soft brush, set the Range drop-down list to Highlights, and set the Exposure slider to 15 percent. This lets you darken the brick wall in front of the lighthouse gradually by painting carefully. The low exposure setting means the changes won't be dramatic, and by choosing Highlights as the range, your darkening is applied mostly to the lightest areas of the wall. Figure 3.36 shows how your image should look before you start burning, and in Figure 3.37 you can see the results you can expect.

Figure 3.36
Darken the wall in front of the lighthouse with the Burn tool.

Figure 3.37
After burning, the wall looks like this.

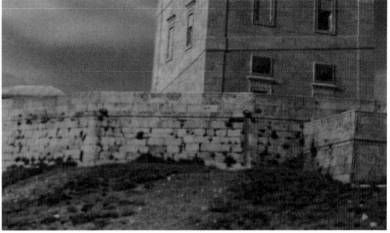

3. You can also darken by painting a selection mask in Quick Mask mode and using Photoshop's Levels or Brightness/Contrast controls on the selected portion. Press Q to enter Quick Mask mode, and paint the left side of the lighthouse.

4. Press Q again to exit Quick Mask mode.

5. Choose Image > Adjustments > Brightness/Contrast, and adjust the sliders to darken the left side of the lighthouse. Don't move the brightness slider too far to the left, or you eliminate the dramatic lighting entirely. We just want to reduce the excessive contrast. I used a value of −17 percent.

6. Use the Dodge tool to lighten the front face of the lighthouse, producing the result you see in Figure 3.38 at right. The original image is shown at left.

CHAPTER 3

Figure 3.38
After the walls of the lighthouse have been dodged and burned, the image should resemble the one at right. The original is shown at left for comparison.

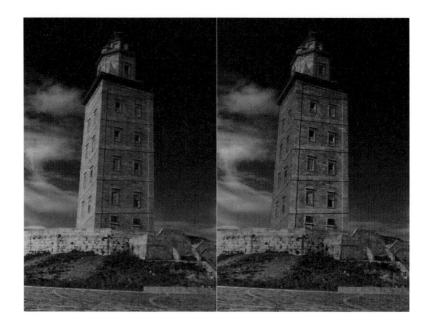

Vignetting

Here's a quickie. Vignetting, in which the corners and edges of an image are significantly darker than the center, can be produced in a number of ways outside the darkroom. A lens hood that is too small for the field of view of the lens it is used with can produce a vignette effect unintentionally. The photographer can shoot through a hole or other aperture to create a vignette, too. Or, you can dodge the image while it's being printed to achieve the same end. Photoshop is as good an option as any, and better than most, especially if you want a fine degree of control over your vignettes.

The easiest way to create a vignette in Photoshop is to use the Quick Mask tool to paint a selection mask, and then use the Brightness/Darkness controls to darken the edges. However, you can achieve a more regular, feathered mask if you use the following technique:

1. Use the file **Cathy10** on the CD-ROM, or work with a photo of your own.
2. Select the Elliptical Marquee tool and drag an oval selection like the one shown in Figure 3.39.
3. Invert the selection by pressing Shift+Ctrl/Command+I.
4. Choose Select > Feather (or press Alt/Option+Ctrl/Command+D), and type in "40" as the pixel value for feathering your selection.
5. Create one kind of vignette by filling the selection with black, or create a more 3-D vignette by first filling the selection with gray, then refilling it with black. Figure 3.40 shows both finished products.

Figure 3.39
First, drag a selection
oval to outline the
vignette boundaries.

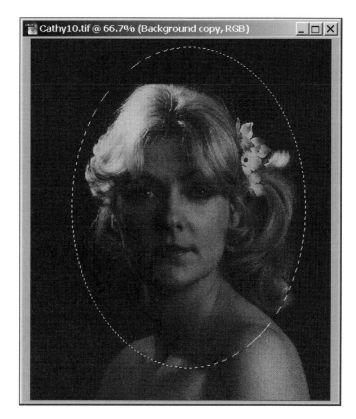

Figure 3.40
After feathering the
selection, fill it to
create the vignette look.

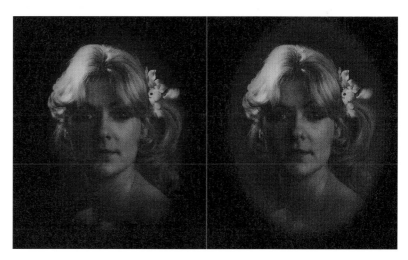

Sepia Toning

In one sense, color photography predated black-and-white photography by a number of years. Early photographic processes like the daguerreotype all had sepia or bluish tinges to them. It took some time before truly color-neutral black-and-white photography became possible. We still equate sepia toning with old-timey photography. Who hasn't donned Civil War attire to pose for a family portrait reproduced in rich browns and light tans? While in modern times it's been necessary to use special toning solutions in the darkroom to achieve a warm sepia look, Photoshop can do the same thing with very little trouble. Try out the effect using the image **Sepia** from the CD-ROM, or use your own photo. Just follow these steps:

1. Start with a black-and-white image, like the one shown in Figure 3.41. Choose Image > Adjustments > Hue/Saturation, or press Ctrl/Command+U to produce the Hue/Saturation dialog box.

2. Click the Colorize button, and then move the Hue slider to the 20 position for a sepia tone, or any other position on the scale for a blue, green, or yellow tone, as you prefer.

3. Move the Saturation slider to enrich the tone. Click OK to apply the toning effect.

4. Use Photoshop's Brightness/Contrast controls to give the image a somewhat washed-out, old-timey look if you like. The finished photo should resemble Figure 3.42.

Figure 3.41
Start with a black-and-white image, and use Photoshop's Hue/Saturation controls to add a tone.

Figure 3.42
Finish the effect with some extra contrast to give the photo an old-timey look.

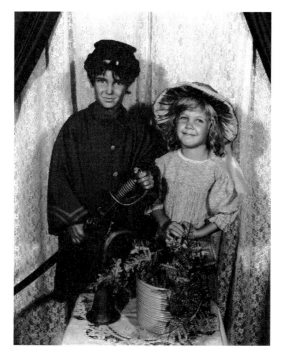

You can also get a toned effect using Photoshop's Duotone feature.

1. While in Grayscale mode, choose Image > Mode > Duotone.

2. When the Duotone Options dialog box pops up, choose Duotone from the Type drop-down list.

3. Click the colored box next to Ink 2 to select a custom color for the second shade.

4. Click the spectrum in the center of the Custom Colors dialog box to choose a particular color range, then click on the exact color swatch you want from the patches on the left side of the dialog box, as shown in Figure 3.43.

5. Click OK twice to apply the duotone.

CHAPTER 3

Figure 3.43
Duotones are another
way of creating an
interesting toned look.

Next Up

Retouching is another time-honored photographic endeavor that's part art and part craft.
Photoshop gives all of us a fighting chance to do some decent retouching, as you'll learn
in the next chapter.

4

Secrets of Retouching

For many of us, our first exposure to photo retouching came in high school, when we exchanged wallet-sized senior portraits with friends and noticed that none of our classmates looked like their pictures. Once adolescence passes, the only time you may give any serious thought to the topic of retouching is when you see your passport picture, or enlarge one of your prize photos up to 11 × 14 or larger. Either event can cause you to stop and say, "Can't we do something about this?"

With Photoshop, you can. Retouching is a common technique now, and one that's become particularly easy. I'm going to divide what you may think of as retouching into two chapters, to account for two very different kinds of picture-manipulation procedures. This chapter deals with methods for correcting defects in an image without performing major modifications; such minor corrections include eliminating dust or other artifacts, fixing small problems with your subject matter, or making minor tonal variations. More dramatic manipulations, such as adding entire objects or people, combining two images to create one, or making other major changes, are presented in the next chapter, "Compositing."

Retouching, the Old Way

Even in the pre-Photoshop, manual labor era, retouching was a lot more common than you might think. Advertising photography, for example, involved millions of dollars in fees (and still does), so a few thousand dollars for retouching was small change. An art director might have sketched a layout on a piece of translucent media placed on the focus screen of a large format camera and used by the photographer to arrange the subjects just so. Then, the finished transparency (or, more likely, a duplicate of it) might be painstakingly retouched with dyes so the colors were perfect and to remove every small defect. It's not an exaggeration to say that every important advertising still image you've seen has been retouched in some way.

Retouching has also been common in portraiture, because few faces are perfect, and even visages that *are* perfect don't necessarily photograph that way. Retouching is a convenient way to touch up portraits without resorting to irreversible camera techniques, such as using detail-obscuring filters or other tricks.

Another kind of retouching, called "spotting," is used to touch up the inevitable dust spots and other artifacts that appear in enlargements, particularly those made from small negatives. Any time you make a print larger than 5 × 7 of, say, a 35mm negative, tiny spots that were invisible on the original film loom as huge as Godzilla when blown up ten times or more. It's always a good idea to clean your film before printing it, but there's a cleanliness point of diminishing returns after which a few seconds with a spotting brush or pen can fix things quickly.

Three types of photographic media are commonly retouched: negative film, transparencies, and prints. Here's a brief description of each. I'm including more detail than you really need to know to demonstrate just how technically demanding old-fashioned retouching could be.

Retouching Negatives

With negative film, it makes sense to retouch the original before you make prints, because all the changes are reflected in each of the resulting prints. Black-and-white negatives, because they consist of a single image layer, can be retouched using etching knives, reducing chemicals, and bleaches, as well as pigments. Color negatives consist of separate layers for each color of the image, so those remedies are not practical. However, color negatives can be retouched with colored dyes, black lead, colored pencils, or a combination of dyes and pencils. Because color negs have an overall orange or red tint to them (masks which optimize color reproduction), and all negatives have their colors and tones reversed, retouchers often must make a proof print to use as a guideline. Even experienced retouchers may have to view a color negative through different colored filters to evaluate areas being retouched. I can't emphasize how much skill negative retouching requires. For example, to correct prominent veins in a portrait, the retoucher has to learn to look for yellow-orange lines on the subject's face and obscure them with cyan dye or blue pencil.

Retouching Transparencies

Color transparencies ("chromes," as the pros refer to them) are a little easier to retouch, because the image looks more like the subject it is supposed to represent. Chromes can be retouched using bleaches, dyes, or both (although, when using both, the bleaching needs to be done first). It's possible to use selective bleaching to remove one color at a time (there are special bleaches for each color). Overall bleaching reduces each of the three colors in an image by an equal amount, and total bleaching removes all the colors in an area.

Bleached areas can even be partially restored ("regenerated" is the term), which makes the process a little forgiving. Cyan, magenta, and yellow dyes can be used to retouch transparencies, too. Special dyes that match the original transparency dyes both visually and when the chrome is reproduced must be used. In days of yore, there were additional hair-raising retouching techniques that involved major surgery on the transparency (quite literally) using cutting knives and butting portions of the transparency together.

Retouching Prints

Color and black-and-white prints can be retouched, and often are, if the original negative is too small for the detailed work that must be done. Dyes, pencils, airbrushes, or any other way of applying tone can be used for retouching prints. If a pigment can stick to paper, it's probably been used to retouch prints.

Retouching has always involved a great deal of artistic skill. The retoucher painted or drew changes on the film or paper, and the training required to achieve that skill could easily be as extensive as for any other area of photography. Photoshop doesn't eliminate the need for artistic skill, but it does make any retouching changes you make more easily reversible. So, even those of us whose sketches look like we had the pencil taped to our elbows can spend as much time as we need to make our images look their best.

Retouching, the New Way

Today, virtually all the retouched images you see reproduced in advertising and magazines have been manipulated digitally. Indeed, Photoshop has become the tool of choice for virtually all retouching. The most common application for traditional retouching skills today is in the field of coloring by hand, using the venerable Marshall's Photo Coloring System of pigments, photo oils, spot colors, retouch pencils, and other products. However, Photoshop is becoming a mainstay in that arena, too.

I'm going to show you some of the most common applications for retouching, and then I'll take you through a typical project. Most images will require more than one type of retouching, so fixing several problems with a single photo is a more realistic way of demonstrating these techniques in the real world. Let's look at the most common problems, first, before moving on to the solutions. I'll use two different photos to give you a broader experience.

Figure 4.1 shows the high school senior portrait I took of my middle son (prior to his blue hair period). This is the unretouched version, and while it might look okay to you (thanks to the inevitable loss of detail wrought by the offset printing process), there were lots of things that needed to be done to it before it was ready to frame and be set on the mantel.

Figure 4.1
This basic portrait
has plenty of room
for improvement.

Dust Spots

Even the most carefully printed photos always have a few white dust spots that need touching up. If you then digitize your print using a scanner, you'll probably pick up a few dust spots from the scanner bed's glass, as well. Scanned transparencies show black spots instead of white. The dust is actually the same color in both cases, and varies only because the image is captured by reflected light in the former case and transmitted light in the latter. Digital cameras are not immune to "dust" spots, either. You may pick up artifacts in your digital image from a defect in your camera's sensor or other mysterious electronic phenomena. Figure 4.2 shows a close-up of the portrait with lots of dust showing. You probably won't have to eliminate quite so much dust, but dust spots are quite common, and they have to be dealt with.

Figure 4.2
Your photos probably
won't be this dusty,
but some photos are.

Double Catchlights

Photographers know that catchlights in the eyes are the key to making a portrait subject look vibrant and alive. It's the moisture on the cornea catching reflections from the lights that give eyes their sparkle. Without catchlights, even a smiling portrait looks wooden and unrealistic. We may not even know what's wrong until it's pointed out to us. Figure 4.3 shows our portrait with the catchlights removed. Compare it with Figure 4.1, and you'll see what I mean.

Figure 4.3
No catchlights at all
mean dead-looking
eyes and a dull
appearance.

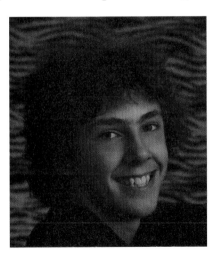

The original photo does have catchlights. The problem is it has too many of them, as you can see in Figure 4.4. Although the portrait is an informal one, it was shot in a studio, and if you look closely, you can probably make out the outlines of the two umbrella reflectors I used to light the picture. You see quite a few octagonal photo umbrellas reflected in the eyes of portrait subjects as catchlights. Sometimes the reflections are used as a creative element, showing up as a glamorous studio-oriented element in the lenses of wrap-around sunglasses.

In theory, we're most accustomed to seeing square, window-shaped catchlights in eyes, but, in practice, the round catchlights aren't especially distracting. Two catchlights do look wrong, however, so if you have a pair this obvious in your own photos, you'll want to learn how to remove them during digital retouching.

Figure 4.4
Dual catchlights are almost as bad as none at all.

Other Defects

Other common defects in photographs that are susceptible to retouching include skin blemishes (in portraits), areas that are too dark or too light, and objects that need to be removed. Many photos have many or all of these. Indeed, it's common to mark up a proof print with a pencil, as shown in Figure 4.5, so the retoucher knows exactly what needs to be done.

Figure 4.5
You may want to mark up a proof print to make sure you don't miss any area that needs retouching.

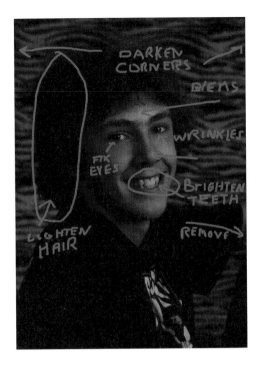

The finished, retouched portrait looks like Figure 4.6, with all the suggested fixes applied. It's not perfect (I still wish I'd used a touch of a hair light and some background lighting when I took the picture), but it's a great improvement.

Tackling a Retouching Project

I'm going to show you how to retouch a typical picture, using a different photograph, which is included on the CD-ROM bundled with this book. You can use my image, **Mardi Gras**, or one of your own, if you like. You'll be spotting dust, removing objects, and performing other retouching magic in no time. But first, you learn how to save yourself some time.

Figure 4.6
After retouching, the
portrait looks like this.

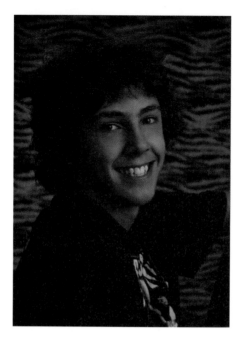

Avoiding Retouching

The best martial arts choreographer and philosopher of my generation, Li Jun Fan (known to American cinema-goers as Bruce Lee), espoused the "art of fighting without fighting." Bruce Lee's approach works equally well in the photographic realm. The most effective way to retouch an image is to avoid the need for it in the first place. Here are some tips to help you minimize your retouching efforts.

▶ Work with "clean" images. Use your digital camera's best resolution and optimum ISO speed setting to produce images with the least amount of noise and artifacts that will need to be cleaned up. If you're working from conventional photographic images, use a lab that won't add dust to your negs or slides. If you have your lab convert your images to digital format, let them do the scan on the first visit, before your film has had a chance to pick up dust and dirt. If you scan your images yourself, clean off the print or film before scanning, and make sure your scanner glass is clean.

▶ Watch your lighting when you take a photo. High-contrast lighting accentuates defects in your subject, as does light that comes from the side. You may not always want to use soft, front lighting for your images, because of creative reasons, but keep in mind that high-contrast effects can mean extra retouching later.

► Check out your background and other parts of the picture before you shoot. One of the most frequent needs for retouching arises from "mergers," where a tree or some other object appears to grow out of the top of someone's head.

► Double-check your composition. If you have everything arranged the way you want, you won't need to move things around in Photoshop.

Many of the things we'll work on with our Mardi Gras picture could have been avoided if the photographer hadn't been looking specifically for a bad photo to use as a "before" picture for this book. The original image is shown in Figure 4.7. There is an entire panoply of things to fix in this picture, most of them easily discerned by the unaided eye. We'll tackle them one at a time.

Figure 4.7
A bad background is only one of the problems with this photo.

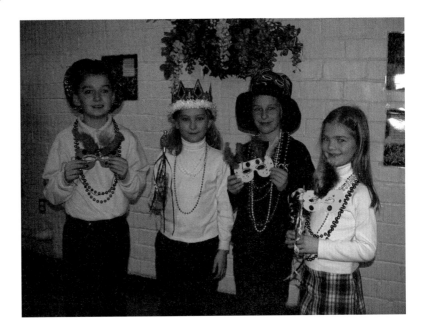

Cropping

The first thing to do is crop the photo a little better to remove some of the extraneous stuff on all four sides of the photo. Although you can simply make a rectangular selection with the Rectangular Marquee tool and then choose Image > Crop, there's a better, more flexible way. Just follow these steps:

1. Choose the Crop tool from the Tool palette (or press C to switch to it).

2. Place the cursor in one corner of the image where you'd like to start cropping, and drag to the opposite diagonal corner. When you release the mouse button, a selection rectangle with handles in each of the four corners and

midpoints of the selection lines appears, as you can see in Figure 4.8. The area outside the rectangle is darkened to make it easier to see what your composition will look like cropped.

3. To fine-tune your cropping, drag the handles in any direction to enlarge or reduce the size of the cropped area.

4. When you're ready to apply the cropped area, press Enter.

Figure 4.8
The Crop tool helps you visualize how your trimmed image will look.

Removing Dust

Photoshop includes several ways to remove dust spots and other artifacts from an image. Two of them, the Despeckle and Dust & Scratches filters, don't lend themselves to this particular image, so I'll describe them and get them out of the way first.

Despeckle

Despeckle is a clever filter that examines the pixels in your image, looking for areas with a great deal of contrast between them. In an image, such areas generally mark the boundaries of edges. When the Despeckle filter finds these edges, it leaves them alone and, instead, blurs other parts of the image. That produces lower overall sharpness in most of your image (the non-edge parts), which tends to blur any speckled areas so the speckles blend in. However, because the edges remain sharp, your image still may look acceptable. The Despeckle filter is a quick way to mask a lot of dust in images that contain many different spots. It works best in images that are fairly sharp to begin with, especially those that may have a bit of noise that can benefit from the blurring. It works worst with images that are not very sharp, because the blur effect can be objectionable.

This filter has no controls to adjust. Simply select it from the Filter > Noise menu and see if it does the job. If not, choose Edit > Undo, or Edit > Fade to fully or partially reverse Despeckle's effects.

Dust & Scratches

The Dust & Scratches filter is a smarter tool that actively seeks out areas of your image that contain spots and scratches. Photoshop performs this magic by looking at each pixel in the image, then radially moving out from that pixel, searching for abrupt transitions in tone that might indicate a dust spot on the image. If a spot is found, only that area is blurred to minimize the appearance of the defect. This filter has two controls, shown in Figure 4.9.

The Radius slider adjusts the size of the area searched for the abrupt transition, measured in pixels. You can select from one to sixteen pixels. If your image is full of dust spots, you might find a value of about four pixels useful, but for most pictures either a one- or two-pixel radius should be sufficient. The larger the radius you select, the greater the blurring effect on your image, so you should use the smallest radius you can. The Threshold slider tells the filter just how extreme a transition must be before it should be considered a defect. Set the radius slider to the lowest setting that eliminates the spots in the Preview Window, and then adjust the Threshold slider up from zero until defects begin to reappear. The idea is to eliminate dust and scratches without adding too much blur to your image.

Figure 4.9
The Dust & Scratches filter dialog box has two sliders and a preview window.

Using the Clone Stamp

Our sample picture was taken with a digital camera and doesn't have dust spots. It does have some white spots that were possibly caused by some bad pixels in the sensor. We can erase these just as if they were dust spots; the same technique applies to both kinds of defects. With conventional photography, dust spots are covered up with spotting brushes or pens, and if the

pen happens to match the color of the background, then the process can be quick and easy. With Photoshop, the process is even easier, because the Clone Stamp can be used to create a pen that automatically matches the color and texture surrounding the spot you are removing. That's because the Clone Stamp paints copies of those actual pixels. The Healing Brush tool, discussed next, does an even better job, but the Clone Stamp is fine for the following task, because it works much faster.

1. Use the Zoom tool (press Z to activate it), and zoom in on the image so you can see the spots well enough to work on them.

2. Next, choose the Clone Stamp tool (press S). Make sure the Aligned box is checked in the Option bar, and then choose a 13-pixel soft brush from the drop-down Brush menu, as shown in Figure 4.10.

Figure 4.10
Choose a 13-pixel soft brush from the drop-down menu.

3. Place the cursor near a spot that contains some image area with the same tone and texture as the area surrounding the spot, and click while holding down the Alt/Option key. Photoshop uses the point where you clicked as the "source" for its cloning action.

4. Paint with the Clone Stamp's brush until you've covered up the spots, as shown in Figure 4.11.

Figure 4.11
A few brushes with the Clone Stamp and most of the spots are invisible—a few more dabs, and the last of them will vanish.

MEET THE NEW HEALING AND PATCH TOOLS OF PHOTOSHOP 7

We're concentrating on the Clone Stamp tool in this chapter, because it is a basic, versatile tool that's quick to learn and easy to use, and you should be comfortable with it. However, Photoshop 7 introduced two new related tools, the Healing Brush and Patch tool, which are both more sophisticated and more difficult to master. The advantage of the Healing Brush is that it takes into account the lighting, texture, and other aspects of an image when you clone from one layer to another within or between images or parts of images. That simplifies repairing defects without totally masking the underlying area. Where the Healing tool works like a brush, the Patch tool uses parts of the image that you select to fix areas while preserving as much of the underlying detail as possible.

Fixing Dual Catchlights

Here are those dual catchlights again, as shown in Figure 4.12. The brightest catchlight was caused by the electronic flash used to take the picture. The secondary catchlight can be blamed on a bright window behind the photographer.

Figure 4.12
These dual catchlights reflected in the eyes need to be removed.

It's sometimes difficult to visualize a picture well enough to realize that double catchlights are going to result (the main catchlight doesn't appear until the flash goes off, for example). The easiest solution is simply to remove one of the reflections in Photoshop. Again, for a simple fix like this, the Clone Stamp is the best choice, because the Healing Brush uses complex algorithms to perform its magic, and that sort of effort is not needed for this simple task. All we need to do is blot out the offending reflection. Follow these steps:

1. Press S to select the Clone Stamp tool.
2. Set the brush size to the smallest fuzzy brush (the 5-pixel model), set Opacity to 66 percent, and make sure the Aligned box is marked.
3. Choose an origin point somewhere below the second reflection and Alt/Option click it.
4. Paint out the redundant catchlight. Because Opacity has been set to 66 percent, you can blend the pixels in smoothly so the cloning is not so obvious.
5. Repeat with all four kids to remove all their catchlights. Their eyes should look something like Figure 4.13.

Figure 4.13
With the dual
catchlights removed,
the eyes look more
normal and lifelike.

CHAPTER 4

ALIGNED/UNALIGNED

When the Aligned box is marked, Photoshop copies pixels from the point that you first marked as the source (by pressing Alt/Option when you clicked) to the point in the image where you begin cloning. Then, as you move away from that point, Photoshop uses the distance and direction the cursor moves from the cloning point to determine which pixels to copy. For example, if you move 1/4 inch up and to the left of the first point where you start painting, the Clone tool will copy pixels that are 1/4 inch up and to the left of the origin point. It doesn't matter if you stop painting and start again, unless you Alt/Option click again somewhere else, the origin point is used as the reference point. When the Aligned box is not checked, each time you begin painting again, the origin point is used in the new location. Figure 4.14 shows what happens. In both cases, I clicked on the girl's shoe to set the origin point, and then began painting at a point above her knee. Then, I stopped painting, and resumed cloning at a point a little to the left. With the Aligned box checked, the soccer ball, located to the left of the girl's foot at the origin point, is cloned. With the Aligned box not checked, the Clone stamp begins painting her foot again.

Figure 4.14
You can see the difference between Aligned and Unaligned cloning.

begin painting here

resume painting here

Alt/Option+click here

Removing Unwanted Objects

I chose the best background that was available when I snapped this picture. I was even smart enough to ask my subjects to step three feet away from the painted brick wall, so the shadows from the flash would fall on the floor instead of the wall itself. However, there are still some objects in the picture that should be removed. The Clone Stamp can help by painting parts of the wall, or other subject matter, over the portions we want to remove or hide. Follow these steps to learn how to remove your ex-brother-in-law from those family reunion photos, or in this case, delete a picture that was securely taped to the wall.

1. Press Z to choose the Zoom tool, then zoom in on the boy's face with the picture on the wall behind him, as shown in Figure 4.15.

2. Press Q to activate Quick Mask mode, and then B to choose the Paintbrush tool. Use the hard-edged, 19-inch brush, and paint a mask around the edge of the boy's hat, as you can see in Figure 4.16. This protects the hat from accidentally being cloned over.

3. Press Q again to exit Quick Mask mode. If you have Photoshop set to paint a selection while in Quick Mask mode, press Shift+Ctrl/Command+I to invert the selection so that everything is selected *except* the area of the hat that you painted.

4. Press S to choose the Clone Stamp tool, and then Alt/Option click some-where in the area of the wall to the right of the boy's head. Make sure the Aligned box is checked. You should have Opacity set to 100 percent.

5. Use a soft-edged brush to paint the blank wall area into the part of the image occupied by the picture on the wall. Your image should begin to look like Figure 4.17. Try to choose your origin point and the spot where you begin painting so the lines on the wall line up properly in the cloned area.

6. When you're finished, remove the other extraneous objects from the image, using this same technique, as indicated in Figure 4.18. Figure 4.19 shows the finished image with the extra image area cloned out. The instructions to lighten parts of the image are handled in the next section.

Figure 4.15
Zoom in on the image area you are going to work on.

Figure 4.16
Paint a mask to protect the hat from the cloning operation.

Figure 4.17
Clone the blank wall
over the area where
the picture on the
wall resides.

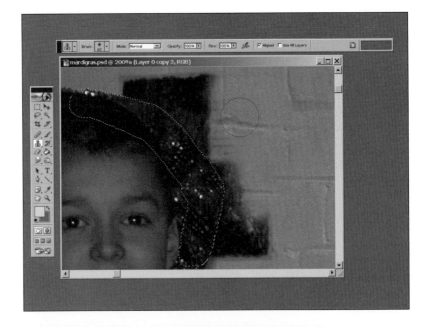

Figure 4.18
Here are some other
extraneous objects to
be removed.

remove picture

remove flower

lighten faces

remove reflection on lip

delete pipe and wall outlet

remove feather from face

darken shirt

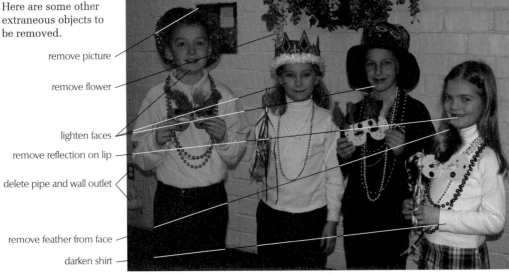

Figure 4.19
The retouched image looks like this, with the extra objects removed.

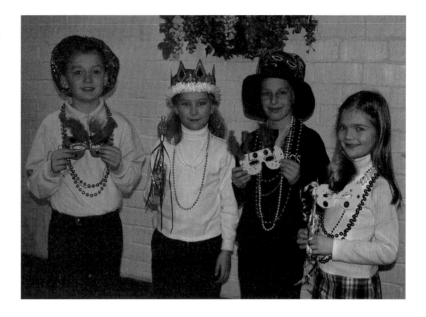

Darkening and Lightening

Only a couple of fixes remain, and they don't require a great deal of instructions. To lighten the faces, all you need to do is enter Quick Mask mode, paint a selection over each of the three faces on the left and the shirt of the girl on the right, then exit Quick Mask and use Photoshop's Brighten/Contrast controls to lighten the three faces on the left to match that of the girl on the right. Figure 4.21 shows the final image with the brightness/contrast adjustments, plus the final movement of the boy on the left, as described below.

Moving Boy Over

It's difficult to get your models to stand exactly where you want them. The most frequent error amateur photographers make in group shots like this is to fail to have the subjects standing close enough together. Even seasoned pros can fall victim, especially when the subjects include a lively quartet of second graders in which one or more of the boys does-n't especially want to *touch* one of the girls. Luckily, Photoshop makes it easy to move our subjects closer together, as I did in this case.

1. Use the Lasso selection tool to create a selection around the boy at the left. Select some of the wall area behind him, to make it easier to blend the boy back into the picture.

2. Press Ctrl/Command+C to copy the boy's figure, then press Ctrl/Command+V to paste him down in a new layer.

3. Press E to select the Eraser tool, and then remove part of the area surrounding the boy. Use a soft-edged eraser brush on the wall area at the right side of his head, and a harder-edged brush to erase his sleeve, so he can overlap the girl. Figure 4.20 shows what the partially erased layer should look like.

4. Use the cursor arrow keys to nudge the boy closer to the girl.

5. Flatten the image when you're satisfied, producing the final image shown in Figure 4.21.

Figure 4.20
After pasting the boy into his own layer, erase the area around him so he blends in.

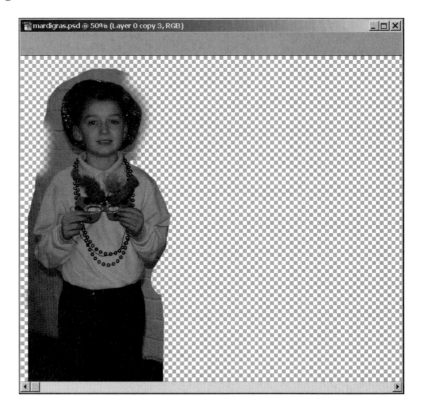

Figure 4.21
The final image looks
like this.

Repairing Images with the Healing Brush and Patch Tool

You're going to love the Healing Brush and the Patch tool. Trust me. Maybe not today, or tomorrow, but when they get these innovative new implements perfected you're going to love them. Even though they're still a work in progress, both can do some things very quickly that you'd spend ten times as much time doing using the Clone Stamp or other methods.

The chief drawback to the Clone Stamp is that it's "dumb." The Clone brush ignores the pixels you're painting over, and covers them completely with the pixels you're copying from another location. That means you must be fairly clever about where you Alt/Option click to create an origin point for the Clone Stamp. Ideally, you should select an area that is fairly close to the destination pixels in color, tone, and texture. If you can't do that, there are various work-arounds, such as changing the opacity of the Clone brush to less than 100 percent to allow some of the underlying pixels to show through. You can also clone onto a new, empty layer and merge that with the original image pixels using one of Photoshop's cryptic blending modes.

The Healing Brush and Patch tool perform all those calculations for you automatically. When you use either one, they copy pixels from the location you specify to the destination you indicate. But, before the pixels are merged, Photoshop examines the texture, lighting, and shading of the destination pixels and matches the copied pixels to them. As a result, the new pixels merge more smoothly with the old, avoiding the complete obliteration of the detail that was originally there. These implements are very smart, and they do a good job.

The only problem at this time is that both tools are very slow. With any PC faster than about 800 MHz or any G3 or G4 Macintosh faster than 400 MHz, as long as you have 256MB or more of memory, virtually all Photoshop "painting" operations take place in real time, even those that involve sharpening, smudging, or other fairly complex tasks. With the Healing Brush and Patch tool, many users notice a measurable time lag while the tools' algorithms calculate the merge and apply it. That is, you paint an area, then pause for a second or two (or much longer if the area is large) until the new pixels appear. It's not an excessive wait, and it's actually sort of cool to watch Photoshop do its stuff as the "healed" pixels appear apparently out of thin air. Rumor has it that Adobe intends to fine-tune the algorithms for the next release of Photoshop and, of course, many rabid Photoshop users constantly update their computers to the latest and fastest processors. While the Healing Brush and Patch tool are usable now, they should really sing by the time Photoshop 7.5 or 8.0 appears.

Both tools are best applied to subjects that truly need "healing" of small areas that need to be blended in with the areas around them. Figure 4.22 shows the kind of situation in which you would *not* want to use either one. In this case, I applied a patch of wall over the picture taped to the wall. The Patch tool used the underlying pixels in the original picture and modified the patch so that it blends with the picture, rather than obscures it.

Figure 4.22
The Patch Tool doesn't lend itself to patching large areas with very different textures.

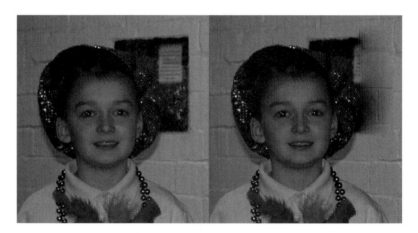

A better choice is the image shown in Figure 4.23. It was scanned from a 35mm slide, and, as a result, has a few black spots from the dust that wasn't removed from the transparency. In addition, the model has an unfortunate scar on her forehead and some minor skin problems that the Healing Brush is perfect for. If you'd like to work on this image yourself, locate the **Cathy11** image on the CD-ROM bundled with this book and follow along with the steps that follow.

1. Zoom into the forehead area of the image.
2. Click the Healing Brush tool in the Tool palette (or press J to activate it). Unlike the most common Photoshop brush tools, the Healing Brush doesn't have a selection of preset brushes from which to choose. In fact, the Brush palette is deactivated while the Healing Brush is in use.

3. Set your brush characteristics from the drop-down dialog box available in the Options bar, as seen in Figure 4.24. You can choose the brush size, hardness (how hard or fuzzy the brush is), brush shape, and other parameters. Choose a 27-pixel brush, and leave the hardness set at 0, producing a medium-size soft brush.

Figure 4.23
This photo has many small defects that can be fixed with the Healing Brush or Patch tool.

Figure 4.24
Set the Healing Brush characteristics from the drop-down dialog box.

4. Make sure the Source box is checked. That tells Photoshop to use the area where you Alt/Option click as the source for the cloned pixels. If you mark the Pattern box instead, you can heal an area with a pattern of your choice.

5. Alt/Option click in the area of the forehead to the left of the scar, and paint over the blemish with the Healing Brush. The defect vanishes, as shown in Figure 4.25.

6. Use the drop-down dialog box to reduce the size of the Healing Brush to about 15 pixels, and repeat the operation on each dust spot, wrinkle, or other defect you see. The result should look something like Figure 4.26.

Figure 4.25
Painting over the defect with the Healing Brush blends it in with the surrounding area.

Figure 4.26
Additional wrinkles, dust spots, and defects are easy to remove with the Healing Brush.

The Patch tool works in a similar way, except that you make a selection in your image of an area to be used as a patch, and then apply the patch to the destination area of the image. Scroll down to the right cheek area (your right, not the model's) and zoom in. Then, follow these steps:

1. Activate the Patch tool from the Tool palette. Mark the Destination box in the Options bar. This indicates that you are selecting an area that will be used as a patch. You'll see exactly how this works, shortly.

2. The tool cursor turns into a crosshair, which you can drag to define the area to be used as a patch, shown in Figure 4.27.

3. Once you've defined the patch, place the cursor inside it and drag to the area you'd like patched. The patch blends in with the area smoothly, as you can see in Figure 4.28.

4. Use either the Patch tool or Healing Brush to fix the other dust spots and problem areas in the image.

With a photo that has many defects, like this one, these two new tools can be slow going, but they certainly take a lot of the work and planning out of this kind of common retouching task.

Figure 4.27
Define the area of the patch first, then drag it to the area to be patched.

CHAPTER 4

Figure 4.28
After patching, the
image looks like this.

PATCHING IN A DIFFERENT ORDER

You can also reverse the order of the patching process by defining the area you
want to fix first as a selection, then dragging that area to the source for the pixels
to be used for the patch. Just click the Source button instead of the Destination
button in the Options bar. How do you decide which way is better? If you think
you'll have a problem creating a patch that fits exactly over the problem area,
define the problem area as a selection first with the Source button marked. If
you'd rather select the area used as a patch first and aren't fussy about the area
you're patching, mark the Destination button and define the patch area instead.

Next Up

In the next chapter, we're going to explore compositing, which is a much more complex
type of retouching that involves combining pieces of images into one whole work of art.
You get to use most of what you know about working with Photoshop Layers, Selections,
and then some.

5

Compositing

Combining several pictures into one new image or moving around objects within a single photograph is a time-honored photography technique. Photographers have been compositing images for as long as there have been negatives and prints that made such combinations possible. The process can be as simple as sandwiching two negatives together and printing the result, or as sophisticated as using digital techniques to nudge two pyramids closer together, as *National Geographic* did for its controversial February, 1982, cover story on Egypt. In either case, the result is the same: an image that never existed in real life.

Now that "photoshop" (lowercase) has become a verb, manipulating photographs in this way has become extremely common. Tabloid magazines regularly picture Hollywood celebrities out on "dates" when, in fact, they may never have met, and even more legitimate magazines, like the late *Picture Week*, managed to picture Nancy Reagan and Raisa Gorbachev having a friendly chat that never took place. Journalists have some serious ethical considerations when creating composited images (Robert Gilka, former director of photography at *National Geographic* magazine, says that significantly manipulating images is an oxymoron on the order of "limited nuclear warfare"). The rest of us, however, can happily modify and combine images to our heart's content, as long as we're not attempting to defraud anyone.

This chapter concentrates on the tools and techniques you need to create composites. Sometimes, your goal may be to create realistic images; other times you may simply want to combine several pictures in interesting ways, even if the end result is obviously a fantasy.

Your Compositing Toolkit

Ads for photographic-oriented products like image editors and printers are one venue where creating outlandish image combinations is definitely okay. In fact, if you look closely at some of the ads for Photoshop or Epson printers in the past few years, you'd think that high-end image editing programs and photo-quality printers are used primarily to transplant the Eiffel Tower to Sunset Boulevard or print images of trees made out of human bodies.

However, compositing also has more mundane applications that involve nothing more than blending several photos with no overt intention to deceive. The goal here is to combine the best features of four or five flawed images to produce a post-card quality photo that doesn't scream *fake* until you look at it very closely. To make this chapter even more interesting, we're going to work with some outtake photos. Some of them were extremely dark, blurry, or otherwise defective in ways that would ordinarily send them to the shoe box. I kept these rejects for the same reason the miser kept a box carefully labeled, "Pieces of string not worth saving." You never know when an odd image can come in handy!

Figure 5.1 shows four vacation photos that range from okay to boring. Only the mountain scenic shot at upper right might be worth putting on display. In Figure 5.2, I moved the mountains to the shore of the Mediterranean Sea, changed the sea from green to blue, transplanted several windmills, and added a cathedral and some craggy rocks from the coast of Ireland. This obvious fantasy photo might even look realistic until you examine it closely. I'm going to show you how to do better.

Figure 5.1
These four photos were barely good enough to throw in a shoe box.

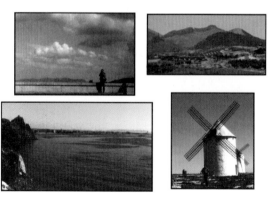

Figure 5.2
Combining them
produced an image that
doesn't exist in real life.

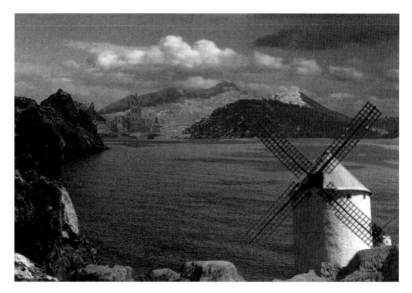

First, let's look at exactly what you need to know to do effective compositing. The main tool you need to master are the selection tools. If you've been working with Photoshop for a while, you've already used the selection tools extensively. To grab portions of an image for realistic compositing, you need to be able to precisely select the object or area that you need. Because the ability to make selections is so crucial, I'm going to spend some time reviewing the key tools before we begin actually butchering a few photos.

Selection Refresher Course

In order to facilitate making changes or to copy only part of an image, Photoshop allows you to make selections. A selection is the part of the image inside the crawling selection border (called marching ants and various other names) when you define an area with one of the selection tools. Once you've created a selection, you can do the following things with the selected area:

> ▶ Copy the area to the Clipboard and paste it down in a new layer of its own, surrounded by transparency.

▶ Paint or fill selected areas with color or pattern using all the painting tools in any of the available modes.

▶ Fill selections with the contents of other selected areas (e.g., pasting one image on to another).

▶ Mask selected areas to prevent them from being changed.

▶ Apply a filter to a selected area.

▶ Edit a selection: Scale its size, skew or distort its shape, change its perspective, flip it horizontally or vertically, rotate it, add to or subtract from it, and combine it with another selection.

▶ Save selections in channels or layers for later use.

▶ Convert selections to vector-oriented paths that you can manipulate using the Pen tool.

When you create a selection in Photoshop, you are essentially doing what airbrush artists do when they cut masks out of film: You define an area in which painting (or another process) can take place. Photoshop allows you to make masks with three kinds of edges: anti-aliased (smoothed), feathered (fading out gradually), and nonanti-aliased (jagged edged). In addition, masks can be opaque, semitransparent, or graduated in transparency. You can use Photoshop's selection tools, described next, or actually "paint" a selection using Quick Mask mode, which we've already worked with earlier in this book (so I won't be reviewing it in this chapter).

Making Rectangular, Square, Oval, and Circular Selections

The easiest way to make rectangular, square, oval, and circular selections is with the Rectangular and Elliptical Marquee tools. To make such a rectangular selection, just choose the tool (press M to select it), then drag across your image, releasing the mouse when the selection is the right size. To deselect any selection at any time, press Ctrl/Command+D or click anywhere on the screen with a selection tool outside of the selection border. If you click outside the border with another tool, this shortcut does not work. Hide a selection by pressing Ctrl/Command+H. Here are some of the options you should learn when using the selection tools:

▶ Click at the point where you want the rectangle or ellipse to begin, and then drag in any direction. The selection grows from that point in the direction you drag.

▶ Hold down the Alt/Option key and click a point, then drag in any direction. The selection radiates outward, with that point as its center.

▶ To draw a perfect square or circle, click and hold down the Shift key while you drag. Hold down both the Shift and Alt/Option keys when you first click, and the selection radiates from the centerpoint where you clicked.

▶ Choose Fixed Aspect Ratio from the Style drop-down list in the Option bar, shown in Figure 5.3. Leave the Width and Height values at their default 1, and forget about holding down the Shift key. You'll draw only perfect squares or circles every time you click and drag when this option is active.

▶ Type other values into the Width and Height boxes to create selections with other proportions. For example, using 8 and 1, respectively, forces the Marquee tool to create only selections that are eight times as wide as they are tall.

▶ Choose Fixed Size from the Style drop-down list in the Option bar and type in dimensions in pixels for your selection. Say you had an image that was 800×600 pixels and you wanted to grab a 640×480 pixel chunk of it. Once you've typed the target dimensions into the Width and Height boxes, clicking with the Rectangular Marquee produces a selection just that size that you can drag around the screen to the part of the image where you want it to be.

Figure 5.3
Choose Selection options from the Option bar.

CHAPTER 5

Creating Single-Row and Single-Column Selections

Choose the single-row and single-column selection tools. Position the mouse pointer in the window, then click and drag. You will select a single line, which extends across the entire window. If you had chosen the single-column option, you would have drawn a single vertical line. These lines, horizontal and vertical, have properties of selections and therefore can be filled with paint, rotated, and manipulated in many other ways.

Making Freehand Selections with the Lasso Tool

With the Lasso tool you can make freehand selections of a part of an image. Select the tool and drag around the outline of the area you want to select. This tool has three modes. The default mode draws a selection as if you were sketching it with a pencil. The Polygonal Lasso tool lets you create selections in straight lines by clicking, dragging to the next point and clicking again, and then repeating this process until you click back at the origin

point to close the selection. The Magnetic Lasso tool examines the image area as you drag and attempts to "hug" the edges of the area as closely as possible, using parameters you type into the Option bar. These include:

▶ Detection Width, which is an area, measured in pixels, that the tool uses to search for high-contrast areas in the path of the selection border to "hug."

▶ Edge Contrast, which is the amount of contrast required in the area (from 0 to 100 percent) to qualify as an "edge."

▶ Frequency, which is the spacing between magnetized points. The higher the number (from 0 to 100), the more frequently Photoshop adds points.

▶ Pen Pressure, which allows drawing thicker lines when you press harder with a stylus on a pressure-sensitive tablet.

Use large width and higher-edge contrast settings with a higher frequency to create a selection that has well-defined images. Use a smaller width, reduced contrast settings, and a lower frequency to trace a softer-edged selection. Figure 5.4 shows the Option bar with the Magnetic Lasso options available.

Figure 5.4
These options are
available when using
the Magnetic Lasso.

Other Selection Tips

Here are some more tips that apply to the selection tools:

▶ When any selection tool is active, you can drag a selection anywhere on the screen.

▶ Mark the Anti-aliased box in the Option bar to smooth the edges of an elliptical or freehand selection. Rectangles don't need anti-aliasing, so this option is grayed out when the Rectangular Marquee tool is active.

▶ Type a value into the Feather box in the Option bar to create a selection that fades out gradually over a range of the number of pixels you specify.

Adding, Subtracting, or Combining Selections

Once you've made a selection, you can modify it by adding, subtracting, or combining. Here's a refresher of the options at your command:

▶ Choose a selection tool and add to an existing selection by holding the Shift key while you drag. You can also click the Add To Selection icon in the Option bar to temporarily make adding to the selection the default action.

▶ Choose a selection tool and subtract from an existing selection by holding the Alt/Option key while dragging. Or, you can click the Subtract from Selection icon in the Option bar.

▶ Click the Intersect with Selection icon in the Option bar, then create a selection that overlaps the original selection. Only the portion that overlaps the two is selected. This useful technique can help you do things such as create a particularly shaped selection. Figures 5.5, 5.6, and 5.7 show the results of adding, subtracting, and intersecting selections.

Figure 5.5
Adding to a selection.

Figure 5.6
Subtracting from a selection.

Figure 5.7
Intersecting two selections.

Other Selection Tools

There are other tools you can use to make selections within Photoshop. Here is a brief refresher for those tools.

Magic Wand

The Magic Wand selects all pixels that are similar in hue and value to the pixel you first clicked on. Originally, the Magic Wand would select only the pixels that touched each other (were contiguous), but now this capability is an option (albeit, the default). If you turn off the contiguous parameter in the Option bar, the Magic Wand selects all the pixels in an image that are similar in hue and value to the first pixel.

You tell the wand how choosy to be by setting its tolerance, from 0 to 255. Based on the tolerance set, the wand extends the selection outward until it finds no more pixels with the color values within the limits you've specified. For example, if the tolerance is set to 40 and you click with the wand on a pixel that has a value of 100, the Magic Wand

selects all pixels with values between 60 and 140. (Both hue and luminance are figured into a special equation as the wand decides which pixels it can and cannot select.) A high tolerance selects a wider range of pixels. A low tolerance selects a very narrow range of pixels.

If you want to select a wide range of a color, from bright to dark, set the tolerance higher than the default (32), and click the wand in the middle of the range of color values. If you click in an area of the color that is very dark or very light, you are giving the wand less latitude. (Remember, color values can range from 0 to 255.)

The Magic Wand's selections can be smooth (anti-aliased) or rough, depending on whether you've marked the Anti-alias box in the Option bar, and you can also check the Use All Layers box, in which case the Magic Wand selects pixels based on color information in all the layers of your image, rather than simply from the active layer. Figure 5.8 shows a selection made with Tolerance set to 12 (at top) and at 32 (at bottom).

Figure 5.8
The Magic Wand's Tolerance control was set to 12 at top and 32 at bottom.

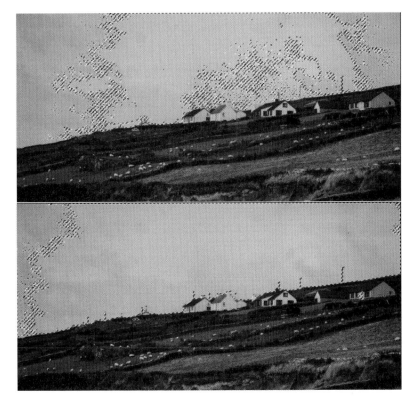

The Select Menu

You can change a selection using choices from the Select Menu.

▶ Select All (everything in an image; also Ctrl/Command+A), Deselect (cancel all selections; also Ctrl/Command+D); Reselect (the last selection made; also Shift+Ctrl/Command+D); and Inverse (reverse the selection; also Shift+Ctrl/Command+I).

▶ Select Color Range: Using the dialog box shown in Figure 5.9, make a selection based on colors you specify using the eyedropper tool.

▶ Feather (fade out a selection; also Alt/Option+Ctrl+D). Type in a pixel value for the desired width of the fade zone.

▶ Modify: Change the selection boundary to a border of a pixel width you specify; smooth the rough edges of the selection border; expand the selection border outward by the number of pixels you specify; contract the selection border inward by the number of pixels you specify.

▶ Grow: Adds adjacent pixels that fall into the brightness range specified by the Magic Wand tool's options.

▶ Select Similar: Adds pixels anywhere in the image that fall within the Magic Wand tool's tolerance setting.

▶ Transform Selection. Produces a set of handles you can use to modify the selection using Photoshop's transformation tools. Right/Control click the selection to choose one of the transformation options, such as Scale, Rotate, Skew, and so forth.

▶ Load/Save Selection. Allows you to save the current selection, or load one you've previously saved.

Figure 5.9
Selecting Color Range lets you create a selection based on hues in your image.

Making Selections with the Paths Palette

If you have used an object-oriented illustration program, you will recognize the Pen tool as a Bézier (Bez-ee-ay) curve drawing device. With the Pen tool you can create lines and shapes that can be fine-tuned, saved as paths, filled with color or outlined (stroked), and used as the basis for selections. Conversely, you can change selections into paths and edit them with the tools on the Paths palette. The smallest part of a path is a segment—the line connecting two anchor points. Several segments, linked, make a subpath, and subpaths combine to form paths. A path can be either a line, a closed shape, a series of lines, a series of shapes, or a combination of lines and shapes. You can stroke and fill subpaths as well as paths. Importantly, paths can be converted to selections, which is useful when you want to select an area of an image that can be closely approximated by a path.

Here's a quick refresher on the Pen tool. Open an empty document and try out the individual tools and options to make sure you're up to speed. There are considerably more options and techniques for using the Pen tool and Freehand Pen tool than I've outlined here. If you find the Pen especially useful for making selections, you'll want to brush up on them.

Drawing Straight Lines

Here's how to draw straight lines:

1. Select the Pen tool. Click in the window to set an anchor point. It is called an anchor point because it anchors one end of a line. Release the mouse button. Click again a distance away to create a second anchor point; a line is drawn between the two.

 Notice that a new anchor point is darkened as it is created, indicating that it is selected. At the same time, the previous anchor point lightens, meaning that it is deselected, as shown in Figure 5.10. Release the mouse button and click to create a third anchor point and second line.

2. Release the mouse button and move the pen on top of the first anchor point. A small loop appears to the side of the Pen tool icon, letting you know that clicking will close the path. Click on the first anchor point to close the triangle. Photoshop creates this new shape in its own shape layer, called Shape 1, by default. Each new object you create with the Pen tool is created in its own layer, too.

Be certain that you do not drag the mouse as you create any of these lines. If you do, you will create curved lines, not straight-edged ones. Press Delete twice to eliminate all lines before going on to the next part of the exercise.

Hold down the Shift key to constrain the placement of an anchor point to a 45 degree angle or a multiple of 45 degree, such as a 90 degree angle. This also works to constrain the angle of a direction line to 45 degree or a multiple thereof. Both constraints are helpful for drawing some geometric shapes.

Figure 5.10
The dark anchor point is the one that is currently selected.

Drawing Curves

Here's how to draw curves:

1. Click the pen once in the window to create an anchor point in a new shape layer and, holding down the mouse button, drag at an angle to form the first part of a curve. As soon as you begin dragging, the pen turns into an arrow.

 The lines that emerge as you drag are called direction lines. The slope of the curve is the same as the slope of its direction lines, and the height of the direction lines determine the height of the curve. There are two dark dots at the end of each direction line. These are direction points.

2. Release the mouse button to finish drawing the first part of the curve.

3. Position the pen a short distance from the first point. Click, keeping the mouse button held down. A slightly curved line forms between the two anchor points.

4. Still keeping the mouse button down, drag in the direction away from the first anchor point. This action shapes the curve connecting the two anchor points, making it more exaggerated, as shown in Figure 5.11.

5. Release the mouse button and click again in line with the first two anchor points and drag in the direction away from the second anchor point. Another curve is formed. You can continue in this way, building a gently curved line.

Figure 5.11
Drawing curves with
the Pen tool.

PREVIEWING YOUR CURVE

Before you add an anchor point, you may want to preview the curve it will be making. This is especially helpful when you're outlining an image. To use this preview option, click the down-pointing arrow in the Option bar and mark the Rubber Band checkbox. Thereafter, when you release the mouse button, but move the pen to set your second anchor point, a curved line follows it. You can use this feature to assist you with anchor point placement as you outline an object.

Moving an Anchor Point or Direction Point to Change the Shape of a Curve

You can change the shape of a curve by following these steps:

1. Draw a simple path with the pen: one anchor point with direction lines, connected by a curve to a second anchor point.

2. Select the arrow from the palette and place it on the first anchor point. Click on the point and drag it. The shape of the curve changes as you do.

3. Now place the arrow on one of the direction points (at the end of a direction line), and drag it back and forth. This is another way to change the shape of a curve. When you select the pen again, you can continue drawing from where you left off.

Making a Selection from a Pen Tool Path

Here's how to transform your path into a selection:

1. Select the path you want to transform by making its layer active.

2. Right/Control click the path and choose Make Selection from the pop-up menu, as shown in Figure 5.12.

3. In the Make Selection dialog box, you can set the feather radius for the selection border, and you can choose the Anti-aliased option if you wish.

4. Choose whether you want a new selection, or add, subtract, or intersect a current selection.

5. Click OK to change the path to a selection.

Figure 5.12

Change a path to a selection.

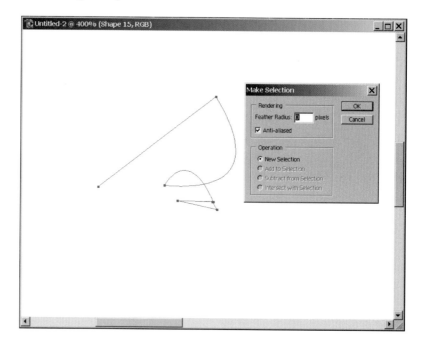

Creating A Simple Composite

Now it's time to use your selection skills plus some other techniques we'll pick up as we go along to create a simple composite. This section helps you learn not only the Photoshop tools you need to create realistic composites, but some of the visual considerations. You can follow along using the **Soccer Ball** and **Soccer Kick** images from the CD bundled with this book, or work with a similar photo of your own. The techniques can be applied broadly.

Figure 5.13 shows the original photo we'll work with. It's not razor sharp, but it's not a bad action photo, particularly if you happen to be the parent of one of the players pictured. The chief problem is that the soccer ball is all washed out and excessively blurry, and, unfortunately, merges with a bit of light-colored background showing through the trees behind, making it look like the ball has a knob growing out of the bottom. A simple composite can improve this photo while offering the opportunity to make other changes, as well. Follow these steps to create the transformation:

1. The first thing we can do is make the picture more dramatic by raising the young girl an extra two or three feet off the ground. Use the Lasso to select her, and paste her down onto a new layer. Then use the Move tool to nudge her up higher in the picture, as shown in Figure 5.14. (I've dimmed the original image background to make the pasted selection more obvious.)

2. Use a soft eraser brush to erase around the edges of the figure on the new layer so she'll blend in with the background.

3. Go back to the original background layer and use the Clone Stamp to remove the extra shadow that appears under the player's feet, leaving only the original shadow beneath her. Use the Clone tool to put part of the background image on any portions of the original player figure that show through. The image should look like Figure 5.15. (The background is no longer dimmed, so you can see how smoothly the background and pasted image merge.)

CHAPTER 5

Figure 5.13
This action photo can be improved, a lot.

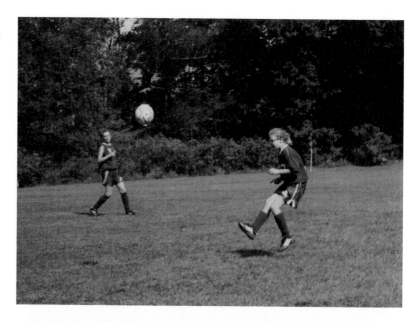

Figure 5.14
Give the young soccer player a lift to add to the excitement.

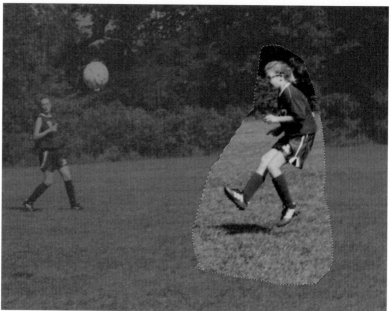

Figure 5.15
Blend the elevated portion of the image so it merges smoothly with the background.

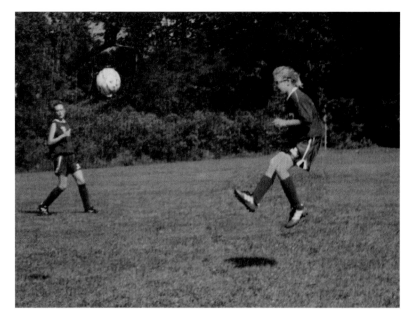

4. Next, load the **Soccer Ball** photo, and use the Elliptical Marquee tool to select it. You can hold the Shift and Alt/Option keys, click the approximate center of the ball, and drag to create a perfect circle with the ball centered in the selection. If necessary, nudge the selection and/or expand or contract the selection (as you learned to do earlier in this chapter) until only the ball is selected, as shown in Figure 5.16.

Figure 5.16
Select only the soccer ball from the second photo.

5. Copy the ball and paste it down in the original photo.

6. Resize the ball in its new layer so it's exactly the size of the ball it replaces.

7. Use the Clone Stamp tool to erase the original ball from the background image.

8. Make the replacement ball match the photo a little more closely by performing these modifications:

 —Use Image > Transform > Rotate to rotate the ball a little counterclockwise so its brightest surface is upwards, matching the direction of the sunlight in the original photo (almost exactly overhead, but a little to the right).

 —Use the Burn tool with a soft brush to darken the underside of the soccer ball.

 —Use Image > Adjustments > Brightness/Contrast to adjust the brightness and contrast of the ball so it looks more natural in the image. You need to judge the amount of brightness and contrast to apply visually. Just move the sliders until the ball looks "best."

 —Use the Filter > Blur > Motion Blur filter, with the Distance setting at 11 pixels to give the ball a little blur.

The finished photo should look like Figure 5.17. In Chapters 8 and 9 you learn how to do other interesting things with photos like these, such as add motion blur streaks to the players themselves.

Figure 5.17
The finished photo is
a lot more interesting
with the new,
composited elements
and added blur.

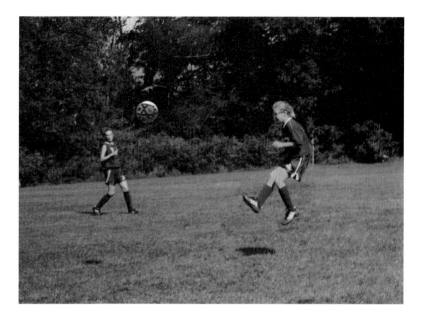

Stitching Two Photos Together

Ordinary panoramic pictures are the penultimate wide-angle photograph (the ultimate being either a 360-degree panorama or, perhaps, a picture that would encompass a complete sphere, with the camera at the center). In practice, 100 to 120 degree panoramas are easier to achieve simply by taking multiple pictures and stitching them together with Photoshop. This next project shows you how to do it. But first, a little background.

Traditionally, panorama photos have been produced using several different methods. One elegant solution has been a special panorama camera, which uses a lens that rotates from left to right in concert with a moving shutter, thus exposing a long strip of negative with a very wide-angle view of the subject, something like the one shown in Figure 5.18. Such cameras tend to be expensive and require working with a tripod for best results.

Figure 5.18
Special panorama cameras expose a wide image on a long strip of film.

Another solution is the one used by current APS (Advanced Photo System) cameras, which let you switch back and forth between three different aspect ratios, including a panorama view. This system works by taking an ordinary frame and simply ignoring the top and bottom portions, enlarging a thin strip in the middle of the frame to create a panorama. There are advantages and disadvantages to this approach. One advantage is that you don't need a tripod; any picture you care to take can be transformed into a panorama by flipping a switch on the camera. The most important plus to this system is that photofinishers are set up to handle such panorama photos automatically. The APS camera marks the film's magnetic strip with a code that labels a panorama picture as such. The photolab's automated printing equipment reads this code and prints out your wide photos using the panorama area previewed in the camera's viewfinder. The chief disadvantage is that such panoramas don't use all the available film area: You get a wide-angle shot by enlarging only a center strip of the film. Your 4×10-inch panorama picture is actually just an 8×10 with two inches trimmed from the top and bottom. That's cheaper and faster than snipping an 8×10-inch print yourself, but you're not getting the sharpest possible picture. Figure 5.19 shows how such a panorama might be derived from a full-frame photograph.

A third way to create panoramas is to take several full-frame photos and then stitch them together to create one very wide photo. Such photos have been pasted together in the past, and then rephotographed and printed, but Photoshop makes it easy to mate a series of photos digitally. The advantage of this method is that each picture contains the maximum resolution possible with a full-frame digital or film camera image. Another plus is that it's not necessary to shoot with a wide-angle lens, which tends to load the image up with foreground and sky, while pushing the important subject matter way, way back. You can move to a good vantage point and take your set of pictures with a normal lens or telephoto, then join them to create one seamless image. The chief disadvantage of this method is that it's tricky to produce the original images, and it's time-consuming to join them.

Figure 5.19
Another way to create a panorama is simply to crop the top and bottom from a negative or slide.

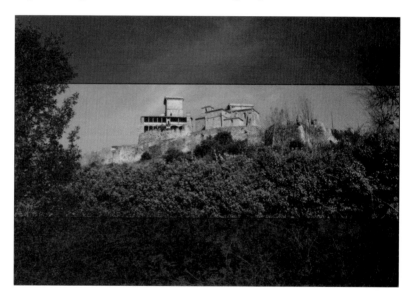

However, if you plan your panorama out as you shoot, you can avoid many of the problems. Here are some tips for shooting good panoramas.

> ▶ Minimize the number of photos you take to reduce the number of images you have to stitch together. If you really, really want a 360 degree panorama you can take one, but plan on spending a lot of time combining images.

CHAPTER 5

▶ There are specialized software programs you can buy that do what you can do with Photoshop for free if you plan on taking many panoramas. I recommend seeing how well Photoshop works for you before buying one of these, however.

▶ Use a tripod with a panning head as a way to keep all your images level. Adjust the tripod (use an actual level if necessary) and swivel through your panorama to make sure the transitions will be smooth before taking the first photo. Some panheads have markings in degrees to help you align the camera.

▶ Try to keep exposures, including lens opening and shutter speed, the same between pictures so they'll match more easily.

▶ Remember to overlap your images slightly so you'll be able to blend each photo into the next.

▶ You should know that, technically, the camera should rotate around the optical center of the *lens*, not the center of the *camera body* to produce the most realistic perspective. Some panorama attachments for tripods include a plate that includes a tripod mount out under the lens center, rather than in the usual location under the camera body. Figure 5.20 shows the right and wrong locations for your center of rotation.

Figure 5.20
Ideally, a camera should swivel around the optical center of the lens when creating a panorama.

This next exercise introduces you to the basics of stitching, using only two pictures to start. Load the **Toledo Left** and **Toledo Right** photos from the CD-ROM. These two pictures were taken on a hill outside Toledo, Spain, at the exact spot where the artist El Greco stood in the sixteenth century to craft his immortal painting *View of Toledo*. Unfortunately, the location is so far from the town that a wide-angle picture of the entire panorama displays more hillside and sky than actual town. Reaching out with a telephoto lens to grab the medieval city on its perch above the Tagus river yields a minimum of two pictures, shown in Figures 5.21 and 5.22.

Figure 5.21
The left side of a panorama.

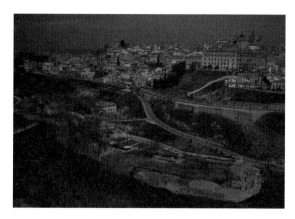

Figure 5.22
The right side of the panorama.

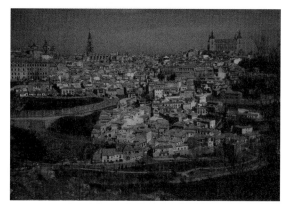

1. Create a large, empty document, approximately 3000 pixels by 1500 pixels, then copy and paste the left and right versions of the Toledo picture into the new document.

2. Try to align them so they overlap. You see that the right picture is rotated slightly relative to the left picture, and offset vertically. That's because these photos were taken without benefit of a tripod. You can see the ill fit in Figure 5.23.

Figure 5.23
Unfortunately, the pictures don't fit exactly together, even though they overlap.

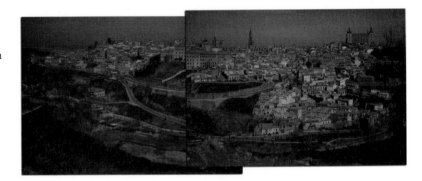

3. Rotating the right photo clockwise, as shown in Figure 5.24, lines the photos up better. Focus your attention on the building that overlaps both photos at the edge, rotating until left and right sides of the building are lined up. Figure 5.25 shows how the two pictures will be oriented when you've finished rotating them.

Figure 5.24
Rotate the right photo
clockwise to line up
the pictures.

Figure 5.25
Now the images match
more closely.

CHAPTER 5

4. If you like, you can use the Clone Stamp to copy some of the sky in to the area above the image. Or, you can copy sky sections and paste them in, as you can see in Figure 5.26. This lets you crop the picture a little "taller" once you've merged the photos.

5. Using a soft brush eraser, erase some of the overlapped area from the right-side image, which you should have placed on top of the left-side image. The image will begin to blend seamlessly.

Figure 5.26
Paste or clone some sky area to fill in empty portions of the photos.

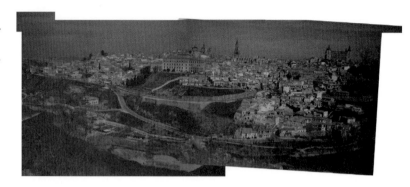

6. Finally, use the Brightness/Contrast controls (if necessary) to blend the two images together. Use the Clone Stamp tool to copy parts of the sky over the edges of the sky portions you've added.

7. Flatten the image, which should look like Figure 5.27.

Figure 5.27
Flattened and cleaned up, the finished panorama looks like this.

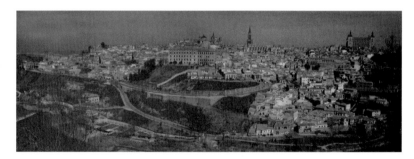

Creating a Fantasy Landscape

By now you should be ready to tackle a major project. We're going to create a fantasy landscape similar to the one in Figure 5.2, only better. We'll use a stack of photos, each with various defects, and combine them into one over-the-top composite.

You'll be using various skills that have already been exercised in previous projects, so I won't provide detailed step-by-step instructions for everything. Instead, I explain in general terms what needs to be done, focusing on any new or difficult tasks.

We start with the photo shown in Figure 5.28, and we end up with one that looks like Figure 5.29. The major center of interest was supposed to be the medieval castle perched at the top of the darker green mountain in the middle of the photo. Unfortunately, the castle is too far away to show up well, and the cluttered foreground includes an automobile tire retailer, some electrical poles, and a group of nonmedieval homes and other structures. The plain blue sky is a little bland, too. We can fix all of that.

In this exercise, you learn all the different things that must "match" for a composite image to look realistic. These include:

▶ Lighting: In general, all the illumination must appear to come from the same general area. In the finished composite, the "sun" is high in the sky, just above the upper-right corner of the picture, so most of the shadows are cast towards us. I took some liberties with the mountain picture, in which the illumination is coming from the upper-left corner, instead, because the mountains looked better lit that way, and we tend not to notice lighting discrepancies for objects located that far in the distance.

▶ Color: The colors should match in hue and degree of saturation. I took a cue from the overall blue cast of the mountains and made sure everything else in the picture had a slight blue or blue-green cast to it, rather than an overpowering warm look.

▶ Brightness/Contrast: Objects should be plausibly close in contrast. Objects in the distance can be lower in contrast because they are masked by haze, but your foreground objects should all display the same contrast you'd expect from objects lit by the same illumination.

CHAPTER 5

▶ Texture/Sharpness: It's difficult to make a good composite if one or more objects is decidedly sharper or has a different texture than the other objects in the image. For this project, most of the items dropped into the picture were close enough in sharpness to make a good match. The mountains, because they were off in the distance, didn't need to be as sharp as the components in the foreground. When you're creating your own composites, you may need to use Photoshop's Gaussian Blur or Add Noise filters to blend items carefully. Adjust contrast after blurring, if necessary, to keep your objects matched. Although you can sharpen a soft component to match the rest of an image, Photoshop's Sharpen filters add contrast that's difficult to compensate for.

▶ Scale: Unless you're creating a complete fantasy image, you want composited components to be realistically scaled in relation to their surrounding objects. Remember that things closer to us appear larger, so as you move an object farther back in your composition, you need to reduce its size.

▶ Relationships: Objects in a composited picture must relate in ways that we expect in real life. An object placed between a light source and another object should cast a shadow on the second object. Objects located next to water or a shiny surface should have a reflection. Two objects of known size should be proportionate not only to the rest of the image, but to each other. If there are two moving objects in an image and one of them has motion blur, the other one should, too.

▶ Transitions: The transition between one object and another should be smooth, or, at least, as smooth as we might expect from an image of that sort.

▶ Viewing Angle: If your angle is high above most of the objects in the composite, you shouldn't include an object shot from down low. Viewers may not notice the discrepancy at first, but the picture won't "look" right.

Keep these things in mind as you work on the next project. You can break a few of the rules I just outlined, but not too many. Start by loading the **Mountains** photo from the CD-ROM bundled with this book.

Figure 5.28
The mountains look
nice, but we can add
some new elements
to the image.

Figure 5.29
The finished version
looks like this.

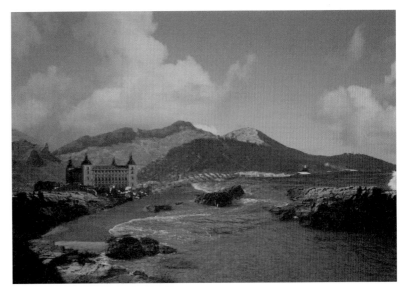

Adding Clouds

The first step is to select the sky area so substitute clouds can be dropped in. Luckily, the sky in this photo is a fairly uniform blue, so the Magic Wand is a good tool for selecting it.

1. Use the Magic Wand with Tolerance set to 20 and click in the center of the sky. This grabs most of the sky, as shown in Figure 5.30.

2. Use Select > Similar to capture virtually all of the rest of the sky. If you see any nonselected areas (they will "sparkle" with the selection border around them), press Q to jump to Quick Mask mode and paint in the small dots that remain unselected.

3. Choose Selection > Save Selection to save your sky mask.

4. Next, load the **Sky** photo from the CD-ROM. Copy the image by pressing Ctrl+V, and, with your sky selection in the mountain photo still active, choose Edit > Paste Into (or press Shift+Ctrl/Command+V) to insert the new clouds into the photo.

5. Use Edit > Transform > Scale to resize the clouds so they fit in the available area. Notice that you don't have to resize the image proportionately. You can stretch in one direction or another to make the clouds fit. The "distortion" isn't apparent because clouds are just clouds and have no natural proportions.

6. Next, adjust the opacity of the new cloud layer in the Layer palette. One key to making composites is not having one object stick out because it is overly bright, overly sharp, or overly dramatic. By reducing the opacity of the cloud layer, the clouds blend in with the plain, blue sky underneath. I reduced the clouds to 44 percent opacity, and they blended in just fine.

7. You may make one final modification. I returned to the original mountain layer, loaded the sky selection, then inverted it (press Shift+Ctrl/Command+I) to select the mountains and foreground. I then copied that selection and pasted it down on a new layer above the clouds. Then, I used the Smudge tool to lightly smudge the edges of the mountains, removing any sharp line between the mountains and the sky. The image so far is shown in Figure 5.31.

Figure 5.30
Grab most of the sky
using the Magic Wand.

Figure 5.31
Once the sky has been
merged, the image
looks like this.

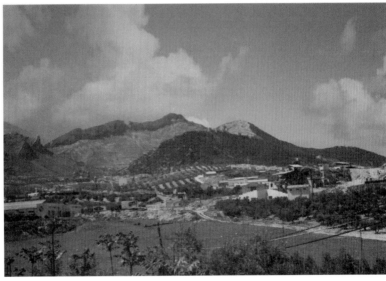

Bringing the Seashore Inland

Next, we add an interesting shoreline to the photo, neatly covering up those houses and electric poles. Use the **Inlet** picture from the CD-ROM. The original photo is shown in Figure 5.32.

1. Simply select the whole thing, and paste it down in the mountain photo.
2. Make all the background layers transparent by adjusting the Opacity sliders for those layers. This lets you see the seashore layer more clearly, as shown in Figure 5.33.
3. With the shore layer active, use a soft eraser brush to remove the portion of the inlet that obscures the mountains and part of the valley on the left. The image should look like Figure 5.34.

Figure 5.32
This seashore can be transplanted a few hundred miles inland.

Figure 5.33
Make the background layers transparent so you can see to edit the seashore layer.

Figure 5.34
Remove parts of the seashore to reveal the mountains and valley.

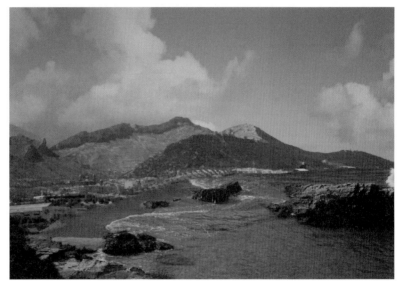

CHAPTER 5

Adding a Castle

Next, take the **Alcazar** photo from the CD-ROM, shown in Figure 5.35. The image happens to be a famous fortress almost completely destroyed during the Spanish Civil War, and then later rebuilt.

1. Select only the castle using your favorite method. The Magnetic Lasso, used in Figure 5.36, works well for selecting the towers, which are clearly differentiated from the background, but the Polygonal Lasso can also be used.

Figure 5.35
This rebuilt castle can add some interest.

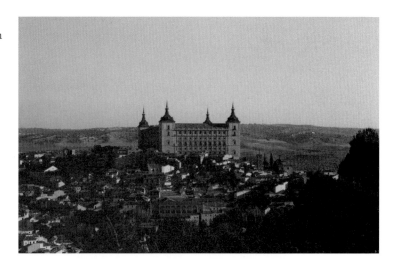

Figure 5.36
Use the Magnetic Lasso to select the towers.

2. Once you've isolated the castle, copy it and paste into the landscape as shown in Figure 5.37. I've made the underlying layers partially transparent so you can see clearly how the Alcazar image fits in.

Figure 5.37
Paste the castle onto the landscape.

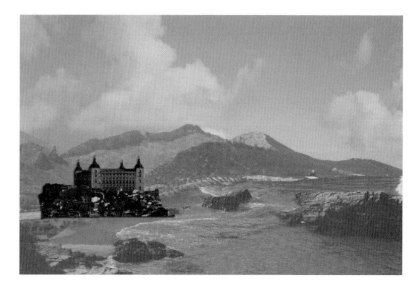

3. The transition between the castle and the surrounding countryside isn't smooth. I fixed this by copying the rock that juts up from the right side of the inlet, pasting it down into a layer of its own, and reversing it left to right.

4. Next, use Edit > Transform > Scale to widen the rock slightly to fit and make it look a little different from its twin. A touch of the Clone stamp tool to copy some texture from one place on the rock to another also differentiates the two.

The finished image is shown in Figure 5.28.

CHAPTER 5

Compositing Close Up

It's one thing to create a composite image of distant objects with edges that can be blurred, as we did with the fantasy landscape. Assembling a collage of images that are closer to the camera, sharper, and easier to examine closely is more of a challenge. For this next project, we move a kitten from a deck railing to a Chinese desk and do all we can to make the combination look realistic. Start with the **Kitten** image from the CD-ROM, shown in Figure 5.38, and follow along with these steps. As with the last project, I'm not going to describe every single procedure in exhausting detail, except when we work with a new feature, such as the Extract command in the next section.

Figure 5.38
Crouching kitten,
hidden background.

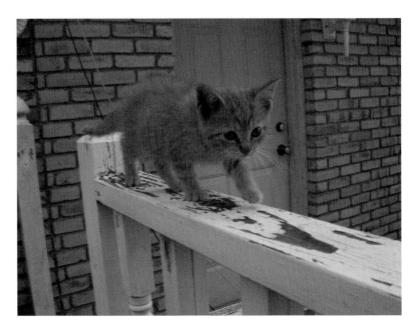

Extracting the Kitten

Photoshop includes several tools specifically designed to help you isolate parts of an image from their backgrounds. These include the Background Eraser and the Extract command. The Background Eraser is the simpler of the two: It's nothing more than an eraser with a circular cursor similar to that used by the Magnetic Lasso, discussed earlier in this chapter. Set a Tolerance level in the Option bar, choose a size for the eraser, and use the Background Eraser to remove pixels that don't closely match the pixels in your main subject. This tool is useful for objects that have a fairly hard edge and a distinct background and, in such situations, offers little advantage over selection tools, such as the Magic Wand.

The Extract command, moved from the Image menu to the Filter menu in Photoshop 7, provides much more sophisticated removal of surrounding areas. You can carefully paint a mask around the edges of your object, adjust the borders, and preview your result before extracting the object. Extract works very well with wispy or hairy objects. Follow these steps:

1. The Extract command works best with images that are sharp, so the first thing to do is sharpen the kitten image using Filter > Sharpen > Unsharp Mask. Use a setting of 100 percent or more to make every hair on the kitten's body stand out.

2. Activate the Extract command by choosing Filter > Extract, or by pressing Alt/Option+Ctrl/Command+X. The dialog box shown in Figure 5.39 appears.

3. Zoom in on the portion of the image you want to extract. In this case, focus on the upper edge of the kitten. Zooming within the Extract dialog box is done in exactly the same way as within Photoshop. Use the Zoom tool (available from the dialog box's tool palette at the left edge) or simply press Ctrl/Command+spacebar to zoom in or Alt/Option+spacebar to zoom out.

4. Click the edge highlighter/marker tool at the top of the tool palette. Choose a brush size of 20 from the Tool Options area on the right side of the dialog box.

CHAPTER 5

5. Paint the edges of the kitten with the marker. Use the Eraser tool to remove markings you may have applied by mistake, or press Ctrl/Command+Z to undo any highlighting you've drawn since you last clicked the mouse. The Hand tool can be used to slide the image area within the preview window.

6. When you've finished outlining the kitten, click the Paint Bucket tool and fill the area you want to preserve.

7. Click the Preview button to see what the kitten will look like when extracted, as shown in Figure 5.40.

8. If necessary, use the Cleanup tool (press C to activate it) to subtract opacity from any areas you may have erased too enthusiastically. This returns some of the texture of the kitten's fur along the edge. Hold down the Alt/Option key while using the Cleanup tool to make an area more opaque.

9. Use the Edge Touchup tool (press T to activate it) to sharpen edges.

10. Click the OK button when satisfied to apply the extraction to the kitten.

Figure 5.39
The Extract command lets you remove objects from their backgrounds.

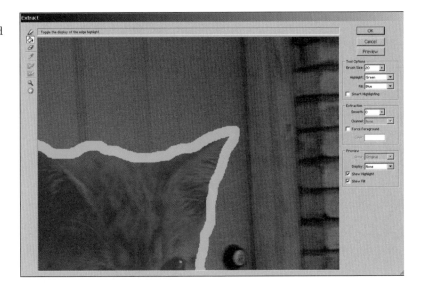

Figure 5.40
Preview your
extraction before
applying the effect.

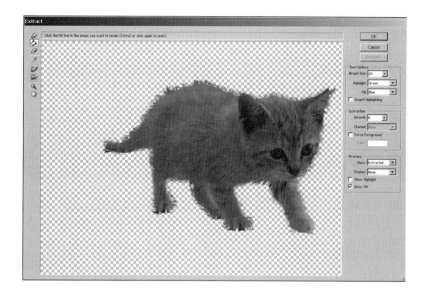

Load the **Chinese Desk** image, shown in Figure 5.41, from the CD-ROM as we begin to
give the kitten a new home. Follow these steps to deposit her on the shiny black surface.

Figure 5.41
This Chinese desk
makes an interesting
background for our
crouching tiger kitten.

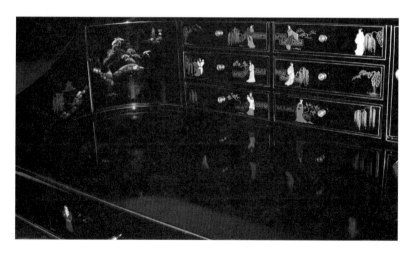

CHAPTER 5

1. Select the kitten from the original image, and paste her down into the Chinese desk photo. Use Edit > Transform > Scale to adjust her size to one that's realistic for the desktop.

2. Use Image > Adjustments > Brightness/Contrast to boost the contrast of the kitten to match the harder lighting of the desk surface.

3. Press Q to enter Quick Mask mode and, using a fairly large, soft-edged brush, paint the undersides of the kitten's feet, body, and tail. Press Q again to exit Quick Mask mode and use the brightness/contrast controls again to darken these under-surfaces.

4. Press Ctrl/Command+D to deselect everything in the image, then use Quick Mask mode to paint a selection that encompasses the kitten's eyes. Exit Quick Mask and use brightness/contrast to lighten the eyes dramatically and give them much more contrast. Your image should now look like the one shown in Figure 5.42.

Figure 5.42
Darken the underside
of the kitten, and
lighten her eyes.

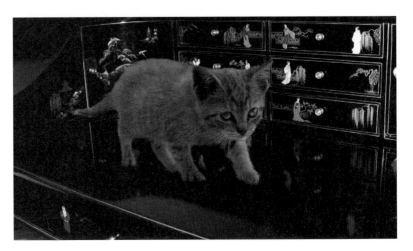

Creating a Reflection

Notice that parts of the desk are reflected in the shiny black surface. The kitten needs a realistic reflection of her own. Here's how to do it.

1. Choose Layer > Duplicate to duplicate the kitten layer.

2. Select Edit > Transform > Flip Vertical to produce a mirror image of the kitten.

3. Use Edit > Transform > Rotate to rotate the mirror image counterclockwise so it appears at the side of the kitten, rather than in front of it.

4. Reduce the opacity of the reflection to about 30 percent, using the slider in the Layers palette.

5. Here's the sneaky part: Adjust the way the reflection merges with the shiny desktop by selecting Difference as the merging mode in the Layers palette. This ensures that darker parts of the reflection merge with the desktop, while letting the lighter parts show through. This produces a more realistic reflection than one in which the reflection layer completely overlays the desktop layer.

6. You can optionally apply some Gaussian blur to the reflection to soften it, or leave the reflection sharp to give the desk top a shinier appearance. I didn't use blur in the image shown in Figure 5.43, but you might want to.

7. Create a new transparent layer and, using a two-pixel white brush, paint in some whiskers on the right side of the kitten. The whiskers typically are too wispy to extract well, so I usually allow them to be erased and then replace them later.

8. Set the opacity of the whiskers layer to about 60 percent and apply Gaussian blur to them until they match the kitten's other whiskers fairly well.

CHAPTER 5

Figure 5.43
Add a reflection and
some whiskers.

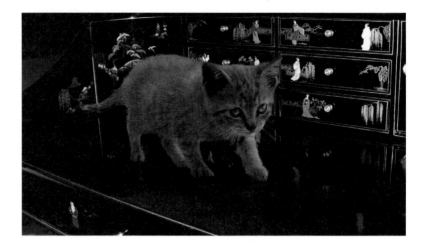

More than One Way to Skin a Cat

You can colorize the kitten (or any other object you care to) in a realistic way using the
following trick. I wanted to make this cat a little more tiger-like, so I enhanced its color-
ing a little with some bright orange-yellow. That's not as simple as you might think. If
you color the cat using the Hue/Saturation controls, you apply color to all of it, losing
some of the subtle color in its eyes. Follow these steps, instead:

1. Duplicate the kitten's layer using Layer > Duplicate.

2. Choose Image > Adjustments > Hue/Saturation, and move the Hue and
 Saturation controls until you get the color you want. Click OK to apply the
 modification to the duplicate of the kitten layer.

3. Choose the Overlay merging mode in the Layers palette to merge the col-
 orized layer with the original kitten in the layer underneath. This technique
 lets other colors show through, smoothly merging the new color with the
 original image.

4. Use the brightness/contrast controls on the colorized layer to get the color
 exactly the way you like. Usually, it's best to reduce the contrast a little and
 add some brightness, as I did for the final image, shown in Figure 5.44.

Figure 5.44
A slick colorizing
trick gives the kitten
a tiger's pelt.

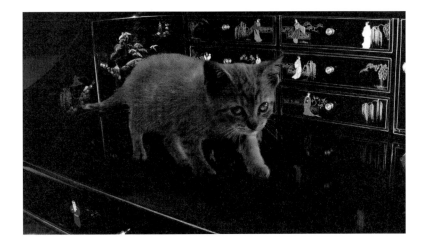

Next Up

Color correction is another important image editing technique you'll want to master as you learn to enhance your photos. In the next chapter, I'm going to show you at least four ways to improve colors of any image and how to modify them to create some special effects.

6

Correcting Your Colors

Color is cool. Color is hot. Photographers know that color is a powerful tool that can grab the eye, lead our attention to specific areas of an image, and, through some unknown process, generate feelings that run the emotional color gamut from ardor to anger. Conversely, *bad* color can ruin an image.

The most interesting thing of all is that the concept of good and bad color can vary by the image, the photographer's intent, and the purpose of the finished photograph. The weird colors of a cross-processed image are very bad if they show up in your vacation pictures, but wonderfully evocative in a fashion shoot. A photo that has a vivid red cast may look terrible as a straight portrait but turn interesting as a glamour shot taken by the glowing embers of a fireplace.

Strictly speaking, you don't have to understand how color works to use it to make corrections or generate striking effects. It's entirely possible to use trial and error to arrive at the results you want. However, just as you don't need an electrical engineering degree to operate a toaster, it's good to know a little something about electricity before you go poking around inside with a fork.

This chapter provides a gentle introduction to the color theories that photographers work with everyday—they become even more useful when you begin working with Photoshop. You'll learn about the most frequently used color models and the differences between the way color is viewed in the real world, the way it is captured by a film or digital camera, and how it is displayed on your monitor or produced by your printer. I spare you the hypertechnical details of working with color curves. If you need to fine-tune color that precisely, you need a prepress guide like Dan Margulis' *Professional Photoshop*.

All the color correction tools in this chapter are easy to use. Even so, you'll be able to work with them effectively because, before we ever touch a slider, I'm going to give you enough background about color that correction will become almost second nature to you.

CHAPTER 6

Wonderful World of Color

In a sense, color is an optical illusion. Human perception of color is a strange and wonderful thing, created in our brains from the variation of the wavelengths of light that reach our eyes. If you remained awake during high school science class, you will recall that the retina of the eye contains rod cells (which are used for detail and black-and-white vision when there is not much light) and three types of cone cells, which respond to different wavelengths of light, all in the 400 nanometer (violet) to 700 nanometer (red) range of what we call the color spectrum.

All the colors we could see (if our eyes were constructed that way) would reside in that continuous color spectrum, like the one shown in Figure 6.1. However, we can't directly sense each of those individual colors. Instead, each of the three kinds of cone cells in our eyes "sees" a different set of frequencies, which happen to correspond to what we call red, green, and blue. Our brains process this RGB information and translates it into a distinct color that we perceive.

Figure 6.1
Our eyes don't perceive the full spectrum of color, but instead capture hues through three different kinds of cone cells in the retina.

Color films use a minimum of three different layers of photosensitive emulsion, each one being sensitive to red, green, or blue light. Digital cameras have three sets of color sensors, and scanners use three light sources—three arrays of sensors, or filters, to capture red, green, and blue information. Finally, when digital information is seen on computer monitors, the same three colors (in the form of LCD pixels or CRT phosphors) complete the circle by displaying the color information for our eyes to view again.

This process is significant for an important reason. *None* of the systems used to capture or view color are sensitive to red, green, and blue light in exactly the same way. And it gets worse: The models used to represent those colors in the computer also treat colors in a slightly different way. That's why an image you see in real life may not look exactly the same in a color slide, a color print, a scanned image, on your screen, or when reproduced by a color printer or printing press. Simply converting an image from RGB to CMYK (more on that later) can change the colors significantly. The concept of the range and type of colors that can be captured, manipulated, and reproduced by a given device or system—its color gamut—is an important one for photographers working in Photoshop.

Color Models

Artificial color systems, which include computer scanners, monitors, printers, and other peripherals, attempt to reproduce, or model, the colors that we see using various sets of components of color. If the model is a good one, all the colors we are capable of detecting are defined by the parameters of the model. The colors within the definition of each model are termed its *color space*. Because nearly all color spaces use three different parameters such as colors (red, green, and blue, for example) or qualities (as in hue, saturation, and brightness), we can plot them as x, y, and z coordinates to produce a three-dimensional shape that represents the color gamut of the model.

The international standard for specifying color was defined in 1931 by the Commission Internationale L'Eclairage (CIE); it is a scientific color model that can be used to define all the colors that humans can see. However, computer color systems are based on one of three or four other color models, which are more practical because they are derived from the actual hardware systems used to reproduce those colors.

None of these systems can generate all the colors in the full range of human perception, but they are the models with which we must work. There have been some efforts to define new color working spaces, such as sRGB, but so far nothing has appeared that can completely take over the photography and computer graphics industries. Indeed, learning to work with Photoshop's sRGB setting was one of the most popular topics among puzzled users when Photoshop 6 was introduced. Your best bet is to learn something about all color working spaces, since image editors like Photoshop support several different color models.

Of the three most common models, the ones based on the hue-lightness-saturation (HLS) and hue-saturation-value (HSV) of colors are the most natural for us to visualize, because they deal with a continuous range of colors that may vary in brightness or richness. You use this type of model when you adjust colors with the Hue/Saturation dialog boxes.

Two other models, called additive color and subtractive color, are easier for computers to handle, because the individual components are nothing more than three basic colors of light. Throughout this book, I've referred to these models as RGB and CMY (or CMYK).

Additive color is commonly used in computer display monitors, while subtractive color is used for output devices such as printers. Since you need to understand how color works with these peripherals, I explain the additive and subtractive models first.

Additive Color

Color monitors produce color by aiming three electronic guns at sets of red, green, and blue phosphors (compounds which give off photons when struck by beams of electrons), coated on the screen of your display. LCD and LED monitors use sets of red, green, and blue pixels to represent each picture element of an image that are switched on or off, as required. If none of the colors are displayed, we see a black pixel. If all three glow in equal proportions, we see a neutral color—gray or white, depending on the intensity.

CHAPTER 6

Such a color system uses the additive color model—so called because the colors are added together, as you can see in Figure 6.2. A huge selection of colors can be produced by varying the combinations of light. In addition to pure red, green, and blue, we can also produce cyan (green and blue together), magenta (red and blue), yellow (red and green), and all the colors in between. As with grayscale data, the number of bits used to store color information determines the number of different tones that can be reproduced.

Figure 6.2
The additive color system uses beams of light in red, green, and blue hues.

Figure 6.2 shows one way of thinking about additive color, in a two-dimensional color space. The largest circles represent beams of light in red, green, and blue. Where the beams overlap, they produce other colors. For example, red and green combine to produce yellow. Red and blue add up to magenta, and green and blue produce cyan. The center portion, in which all three colors overlap, is white. If the idea that overlapping produces *no* color, rather than some combined color, seems confusing, remember that the illumination is being added together, and combining all three of the component colors of light produces a neutral white with equal amounts of each.

However, this two-dimensional model doesn't account for the lightness or darkness of a color—the amount of white or black. That added dimension is dealt with in the model shown in Figure 6.3.

The figure shows red, green, and blue colors positioned at opposite corners of the cube, with their complementary colors arranged between them. White and black are located opposite one another, as well. Any shade that can be produced by adding red, green, and blue together can be represented by a position within the cube.

Figure 6.3
The RGB color space can be better represented by a three dimensional cube, simplified to corners and edges in this illustration.

No display device available today produces pure red, green, or blue light. Only lasers, which output at one single frequency of light, generate absolutely pure colors, and they can't be used for display devices. We see images through the glow of phosphors, LEDs, or LCD pixels, and the ability of these to generate absolutely pure colors is limited. Color representations on a display differ from brand to brand and even from one display to another within the same brand.

Moreover, the characteristics of a given display can change as the monitor ages and the color-producing elements wear out. Some phosphors, particularly blue ones, change in intensity because they age at a different rate than others. So, identical signals rarely produce identical images on displays, regardless of how closely the devices are matched in type, age, and other factors.

In practice, most displays show far fewer colors than the total of which they are theoretically capable. Actually, the number of different colors a display can show at one time is limited to the number of individual pixels. At 1024 × 768 resolution, there are only 786,432 different pixels. Even if each one were a different color, you'd view, at most, only around three-quarters of a million colors at once. The reason your digital camera, scanner, display, and Photoshop itself need to be 24-bit compatible is so the *right* 786,432 pixels (or whichever number is actually required) can be selected from the available colors that can be reproduced by a particular color model's gamut.

As you know from working with Photoshop, the number of theoretical colors that can be represented is measured in bit depth. For example, 4-bit color can represent the total number of colors possible using four bits of binary information (0000 to 1111), or 16 colors. Similarly, 8-bit color can represent 256 different colors or grayscale tones, while "high color" 15- or 16-bit displays can represent 32,767 or 65,535 colors (which you sometimes need when displaying at very high resolutions using video cards which don't have enough memory for 24-bit color at that resolution). The standard today is for 24-bit full color, which can represent 16.8 million different hues. Scanners and some high-end digital cameras can even capture 36-bits or 48-bits, for a staggering billions and billions of hue. When using Photoshop, so-called 32-bit color usually refers to an extra eight bits that are used to store grayscale alpha channel information.

Subtractive Color

There is a second way of producing color that is familiar to computer users, and it, too, has a color model that represents a color gamut. When we represent colors in hard copy form, the light source by which we view comes not from the image itself, as it does with a computer display. Instead, hard copies are viewed by light that strikes the paper or other substrate, is filtered by the image on the paper, and then gets reflected back to our eyes.

This light starts out with equal quantities of red, green, and blue light and looks white to our eyes. The pigments the light passes through before bouncing off the substrate absorb part of this light, subtracting it from the spectrum. The light that remains reaches our eyes and is interpreted as color. Because various components of light are subtracted from white to produce color, this color model is known as the subtractive system.

The three primary subtractive colors are cyan, magenta, and yellow, and the model is usually known as the CMY model. When black is added, it becomes the CMYK model (black is represented by its terminal character, k, rather than b to avoid confusion with the additive primary blue). Figure 6.4 shows the subtractive color model in a fanciful representation (you can't just overlap filters to produce the colors shown, although you could print with inks to create them).

Figure 6.4
The subtractive color system uses cyan, magenta, and yellow colors.

In subtractive output devices, cyan, magenta, yellow, and, usually, black pigments (for detail) are used to represent the gamut of colors. It's obvious why additive colors won't work for hard copies: It is possible to produce red, green, and blue pigments, of course, and we could print red, green, and blue colors that way (that's exactly what is done for spot color). However, there would be no way to produce any of the other colors with the additive primaries. Red pigment reflects only red light; green pigment reflects only green. When they overlap, the red pigment absorbs the green, and the green absorbs the red, so no light is reflected and we see black.

Cyan pigment, on the other hand, absorbs only red light (well, it is supposed to). It reflects both blue and green (theoretically), producing the blue-green shade we see as cyan. Yellow pigment absorbs only blue light, reflecting red and green, while magenta pigment absorbs only green, reflecting red and blue. When we overlap two of the subtractive primaries, some of at least one color still reflects. Magenta (red-blue) and yellow (red-green) together produce red, because the magenta pigment absorbs green and the yellow pigment absorbs blue. Their common color, red, is the only one remaining. Of course, each of the subtractive primaries can be present in various intensities or percentages, from zero to 100 percent. The remainder is represented by white, which reflects all colors in equal amounts.

So, in our example above, if the magenta pigment were only 50 percent present and the yellow represented at 100 percent, then only half of the green would be absorbed, while 100 percent of the blue would be soaked up. Our red would appear to be an intermediate color, orange. By varying the percentages of the subtractive primaries, we can produce a full range of colors.

Well, theoretically we could. You recall that RGB displays aren't perfect because the colors aren't pure. So, too, it is impossible to design pigments that reflect absolutely pure colors. Equal amounts of cyan, magenta, and yellow pigment *should* produce black. More

often, what you get is a muddy brown. When daily newspapers first began their changeover to color printing in the 1970s, many of them used this three-color system, with mixed results.

However, better results can be obtained by adding black as a fourth color. Black can fill in areas that are supposed to be black and add detail to other areas of an image. While the fourth color does complicate the process a bit, the actual cost in applications like offset printing is minimal. Black ink is used to print text anyway, so there is no additional press run for black. Moreover, black ink is cheaper than critical process color inks, so it's possible to save money by using black instead of laying on three subtractive primaries extra thick. A typical image separated into its component colors for printing is shown in Figure 6.5

Figure 6.5
Full-color images are separated into cyan, magenta, yellow, and black components for printing.

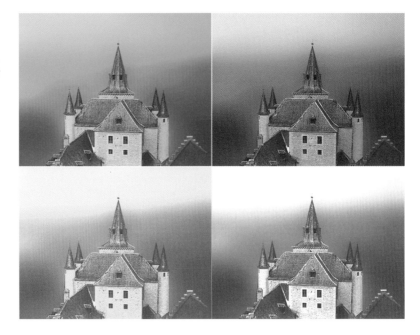

The output systems you use to print hard copies of color images use the subtractive color system in one way or another. Most of them are unable to print varying percentages of each of the primary colors. Inkjet printers, color laser printers, and thermal wax transfer printers (all discussed in Chapter 10) are examples of these. All these systems must simulate other colors by dithering, which is similar to the halftoning system discussed earlier. A few printers can vary the amount of pigment laid down over a broader range. Thermal dye sublimation printers are an example of this type. These printers can print a full range of tones, up to the 16.8 million colors possible with 24-bit systems.

The subtractive color system can also be represented in three dimensions, as I've done in Figure 6.6. In this illustration, the positions of the red, green, and blue colors have been replaced by cyan, magenta, and yellow, and the other hues rearranged accordingly. In fact, if you mentally rotate and reverse this figure, you see that it is otherwise identical to the one in Figure 6.3; RGB and CMYK are in this sense two sides of the same coin. However, don't make the mistake of thinking their color spaces are identical. There are colors that can be displayed in RGB that can't be printed using CMYK.

Figure 6.6
The subtractive color model can also be represented by a 3-D cube.

When you view color images on your display during image editing with Photoshop, the colors in the image file are always converted to additive (RGB) colors for display—regardless of the color model used to represent the actual image. However—and this is important—the color model used for the actual file remains the same, unless you change modes and then save the file. In truth, Photoshop uses another color model, called Lab (discussed below), as an intermediate step when converting from one color to another.

For example, if you load a file that has been saved using the CMYK color model, a program like Photoshop lets you work on it in CMYK mode, even though the colors must be converted to RGB for viewing. In general, CMYK colors seem less saturated and duller than RGB colors. That's because RGB colors can be made brighter by pumping more light through the device you're using to view them. CMYK colors are limited by the brightness of the substrate (a whiter paper reflects more light and brighter colors) and the amount of ink used.

Within Photoshop, you don't actually lose any colors unless you physically convert the file from one mode to the other. If you do convert from CMYK to RGB mode, and back again, because CMYK can represent some colors that are outside the RGB gamut—and vice versa—you lose some hues each time. Stick with CMYK if that's the mode in which your file was created, especially if you are outputting to a printer or color separation system that expects to work with CMYK colors. That way, you avoid creating RGB colors which cannot be reproduced by the CMYK output system. Photoshop handles your file in Lab mode and protects your colors.

Lab color was developed by the CIE as a device-independent international standard. Lab consists of three components, a luminance channel, plus a* and b* channels that represent green to magenta and blue to yellow, respectively. Because CIELab can represent all the colors found in both RGB and CMYK, it serves as a perfect intermediate format for Photoshop. There are some highly technical operations that can be carried out in Lab mode. In addition, Lab colors more closely reflect how humans perceive color, so if there is a difference in color in CIELab mode, humans can probably perceive a difference, too. That's not always the case with RGB and CMYK modes.

Other Color Models

The hue-saturation-brightness color model, also known as HSB or HLS (for hue-lightness-saturation), is a convenient way to manage color for some operations. For example, if you want to adjust the saturation of a color without modifying its hue or brightness, HSB mode (using Image > Adjustments > Hue/Saturation) is the way to go. In this model, individual colors, called hues, are represented as they are in a rainbow, as a continuous spectrum, arranged in a hexagon like that shown in Figure 6.7. The full color space is represented as a double hexcone that extends upwards and downwards from the hexagon, as shown in Figure 6.8. The top of the axis drawn through the center of the cones represents pure white, while the bottom point represents black. Moving higher in the cone produces lighter colors, and lower in the bottom cone, darker colors. Saturation is represented by movement in a third direction, outward from the center axis. The center represents a desaturated color, the outer edges fully saturated hues.

Figure 6.7
The hue/saturation/
brightness color model
starts with a color
circle or hexagon like
this one.

Figure 6.8
The full color space is
represented by two
hexagonal cones—the
center outward
produces more
saturated colors;
moving up or down the
axis of the cones
darkens or lightens
the color.

whiter

increase in saturation

blacker

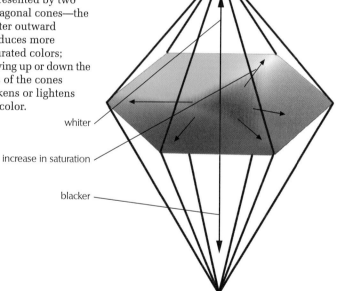

All colors can be represented by three parameters in this model. The hue is the particular position of a color in the color wheel. Hues are often represented by angles, beginning with red at 0 degrees and progressing around in a counterclockwise direction to magenta at 60 degrees, blue at 120 degrees, and so forth. The saturation of the color is the degree to which that color is diluted with white. A hue with a great deal of white is muted; a red becomes a pink, for example. A hue with very little or no white is vivid and saturated. Brightness can be thought of as the degree to which a color is diluted with black. Add black to our desaturated red (pink), and you'll get a very dark pink. Various combinations of hue, saturation, and brightness can be used to produce just about any color we can see. Individual hues can be found along the edges of the hexagon. Moving from that edge toward the center within the same plane indicates a color that is less saturated. The center of the hexagon represents zero saturation. The axis extending through the center of the hexcones represents lightness and darkness, with white at the top and black at the bottom of the line.

Capturing Color Images

Today we have several options for capturing images for manipulation in Photoshop. Color scanners have been around the longest, for around 50 years, in fact. The first ones I saw early in my career cost more than a million dollars when you included the computer equipment needed to drive them, and they were intended only for professional graphics applications at service bureaus and large publications. Today, color scanners, like the one shown in Figure 6.9, can cost less than $100 and are affordable by anyone.

Figure 6.9
Modern color scanners
can cost $100 or less.

Color scanners are nothing more than a system for capturing the proper amount of each of the primary colors of light in a given image. These scanners use three different light sources—one each of red, green, and blue—to scan a color image. To do so, some older

scanners actually made three passes over the image—once for each color. More recent scanners use multiple light sources, or "rotate" their illumination, using red, green, and blue light in succession to capture an image in a single pass.

The amount of light reflected by the artwork for each color varies according to the color of the pigments in the original. Cyan pigment, for example, absorbs red light and reflects blue and green. So, when a cyan area is illuminated by the red fluorescent light in a scanner, relatively little light is reflected. Most of the light produced by the blue and green fluorescents is reflected. Your scanner software records that area of the original as cyan. A similar process captures the other colors in your subject during the scan. Even if you don't use a scanner yourself, you may work with scanned images that are captured by your photofinisher when converting your color slides or prints to digital form for distribution online or as a photo CD.

Digital cameras cut out the middle step by creating color images directly. Where scanners use a linear array that grabs an image one line at a time, digital cameras use a two-dimensional array that grabs a complete bitmap in one instant. Today, digital cameras with 3.3 to 6 megapixels (or more) of resolution can capture images that are virtually indistinguishable from those grabbed on film when reproduced or enlarged to $8" \times 10"$ or less.

Color Calibration and Gamma Curves

Conventional film is well-known for having color reproduction characteristics that vary over a considerable range. Some films are prized for their vivid, saturated colors and are used to make product shots exciting or to brighten an overcast day. Other films are chosen for their neutrality or realistic flesh tones. Digital color offers new capabilities, but carries with it the same color reproduction concerns that film has long displayed. Whether you're shooting film or pixels, in most cases you want your image to closely approximate the original. Neither color display systems nor color hard copy output devices are consistent or particularly accurate. The best you can do is calibrate your peripherals so that there is a relationship between the colors in the original, what you see, and what you get as output.

The process is complicated by two facts. First, the response of any color system is rarely linear. And, to make things worse, it's difficult to describe a color in such a way that it means exactly the same thing to everyone. Assume for a moment a 24-bit system with 256 different tones of each color. A value of zero for a particular color should represent no color; a value of 255 should represent the maximum intensity of that color. On a linear scale, 64 would represent about 25 percent intensity, 128 would be 50 percent, and so on. Yet, in real applications, an intensity of 64 is not half that of 128. It corresponds to some other percentage, depending on the characteristics of the device being used. The relationship of the actual representation to the ideal is known as a gamma curve.

Scanners do happen to conform to the ideal rather closely, but computer displays and printers tend to vary greatly. If you know the gamma curve of a particular device, however, you can correct it. For example, if you know that, with a certain device, a value of

64 produces an intensity that is only 90 percent of what it should be to be linear, you can boost that value by an appropriate amount whenever it occurs.

This is done by building a gamma correction table using the tools supplied by your scanner vendor. The table includes a value for each of the levels used in a system. The correction values can be automatically substituted by your software for the default values, theoretically producing a perfect, 45 degree gamma curve. Many vendors provide device characterization files for their products. You can find instructions for using the Adobe Gamma application to profile your monitor at the end of this chapter.

Color Correction

Sometimes a horrid looking image may have nothing more wrong with it than an imbalance of colors used to represent the image. Other times, the balance may be okay, but you'd like to make the colors look horrid to produce a desired special effect in your image.

Color balance is the relationship between the three colors used to produce your image, most often red, green, and blue. You need to worry only about three different factors.

▶ **Amount of Red, Green, and Blue:** If you have too much red, the image appears too red. If you have too much green, it looks too green. Extra blue makes an image look as if it just came out of the deep freeze. Other color casts are produced by too much of two of the primary colors, when compared to the remaining hue. That is, too much red and green produce a yellowish cast; red and blue tilt things toward magenta, and blue and green create a cyan bias.

▶ **Saturation:** Determines how much of the hue is composed of the pure color itself, and how much is diluted by a neutral color, such as white or black.

▶ **Brightness/contrast:** Brightness and contrast refer to the relative lightness or darkness of each color channel and the number of different tones available. If, say, there are only 12 different red tones in an image, ranging from very light to very dark, with only a few tones in between, then the red portion of the image can be said to have a high contrast. The brightness is determined by whether the available tones are clustered at the denser or lighter areas of the image. Pros use something called a histogram to represent these relationships, but you don't need to bother with that for now.

You may wonder what causes bad color in the first place. Indeed, knowing the sources of bad color can help you avoid the need for much color correction. Unfortunately, there are many culprits, whether you're using color negative film or slides, a scanner, or a digital camera. Here are the major sources of bad color.

Problem: Wrong Light Source

Reason: All color films are standardized, or balanced, for a particular "color" of light, and digital cameras default to a particular "white balance." Both are measured using a scale called *color temperature*. Color temperatures were assigned by heating a mythical "black body radiator" and recording the spectrum of light it emitted at a given temperature in degrees Kelvin. So, daylight at noon has a color temperature in the 5500 degrees to 6000 degrees range. Indoor illumination is around 3400 degrees. Hotter temperatures produce bluer images (think blue-white hot) while cooler temperatures produce redder images (think of a dull-red glowing ember). Because of human nature, though, bluer images are called "cool" and redder images are called "warm," even though their color temperatures are actually reversed.

If a photograph is exposed indoors under warm illumination using film balanced for cooler daylight, the image will appear much too reddish. If you were using a slide film, you would get reddish slides. Your photo processing lab can add some blue while making prints from "daylight balanced" color negatives exposed under this warm light, giving you reasonably well-balanced prints. Some professional films are balanced for interior ("tungsten") illumination. If one of these is exposed under daylight, it appears too blue. Again, prints made from tungsten-balanced color negatives can be corrected at the lab.

At the same time, your digital camera expects to see illumination of a certain color temperature by default. Under bright lighting conditions, it may assume the light source is daylight and balance the picture accordingly. In dimmer light, the camera's electronics may assume that the illumination is tungsten, and color balance for that. This may be what happens when your digital camera's white balance control is set to Auto. Figure 6.10 shows an image exposed under tungsten illumination with a daylight white balance.

Figure 6.10
Exposing daylight film
under tungsten
illumination or taking
a digital picture with a
daylight white balance
setting produces a
reddish image.

Solution: You can often make corrections for this type of defect digitally in Photoshop. However, to avoid the need entirely, use the correct film, or use a filter over the camera lens to compensate for the incorrect light source. You may not need to bother with color negative films, but you certainly want to do something in the case of slide films. Note: The light a filter removes must be compensated for by increasing the exposure in the camera.

With a digital camera, set the white balance manually using your camera's controls. Your camera probably has a setting that allows you to point the lens at a white object and let it use that as its white point. Or, your camera may have some built-in white balance settings for tungsten, fluorescents, daylight, and other sources.

Problem: Fluorescent Light Source

Reason: The chief difference between tungsten and daylight sources is nothing more than the proportion of red and blue light. The spectrum of colors is continuous, but it's biased toward one end or the other. However, some types of fluorescent lights produce illumination that has a severe deficit in certain colors, such as only particular shades of red. If you looked at the spectrum or rainbow of colors encompassed by such a light source, it would

have black bands in it, representing particular wavelengths of light. You can't compensate for this deficiency by adding all tones of red, either digitally or with a filter that is not designed specifically for that type of fluorescent light. Figure 6.11 shows an image that was exposed under fluorescent lights using a tungsten light balance.

Figure 6.11
Some fluorescent lights can produce a greenish image.

Solution: Your camera retailer can provide you with color filters recommended for particular kinds of fluorescent lamps. These filters are designed to "add" only the amounts and types of colors needed. Since it's difficult to correct for fluorescent lights digitally, you want to investigate this option if you shoot many pictures under fluorescents and are getting greenish results.

Problem: Incorrect Photofinishing

Reason: Here's one that digital photographers don't have to worry about. Equipment that makes prints from color negatives is highly automated and can usually differentiate between indoor and outdoor pictures, or those that have a large amount of one color. Sometimes the sensors are fooled and you end up with off-color prints or those that are too light or dark. The processing of color slides won't usually have any effect on the color balance or density of the transparencies, unless something is way out of whack, so you are usually concerned only about the color balance of prints.

Solution: Change finishers if it happens often. Ask that your prints be reprinted. If you'd rather not bother, you can often make corrections digitally after you've scanned the prints.

Problem: Mistreatment of Original Film

Reason: Your digital film cards won't deteriorate if you expose them to harsh environments briefly, but the same is not true for film. If you regularly store a camera in the hot glove compartment of your car, or take a year or more to finish a roll of film, you can end up with color prints that are off-color, sometimes by quite a bit. If your prints have a

nasty purple cast, or even some rainbow-hued flares in them, your negatives probably suffered this indignity.

Solution: Usually, film that has been "fogged" by heat or latent image-keeping effects cannot be corrected. If it hurts when you do that, don't do that. Figure 6.12 shows an image faded by heat and light.

Figure 6.12
Leave your camera in the trunk for too long, and you may end up with a fogged image like this one.

Problem: Mixed Light Sources

Reason: You bounced your flash off a surface such as a colored wall or ceiling, and the pictures picked up the color of that surface. Or, you took an indoor picture with plenty of tungsten light, but the subject is near a window and is partially illuminated by daylight.

Solution: Avoid these situations. If some of your image is illuminated by the colored bounce flash, or daylight streaming in through a window, and other portions by another light source, you'll find it very difficult to make corrections. Investigate turning that picture into an "arty" shot.

Problem: Faded Colors

Reason: The dyes in color prints and slides are not stable, and they change when exposed to strong light or heat for long periods (one to five years), or with no further impetus even if kept in the dark for much longer periods (five to twenty years, and up).

Solution: In the case of color prints, you can sometimes make a new print from the original negative if you can find the negative, and it was kept in a cool, dark place. Faded color prints and original slides can often be corrected digitally after scanning, because the color changes tend to take place faster in one color layer than another. You may be able to add missing colors by reducing the amount of the other colors in the photograph.

Problem: Unexpected Blue Cast in Flash Photographs

Reason: Certain fabrics, particularly whites, reflect a huge amount of ultraviolet light, making that neutral white garment turn a horrid blue. Because our eyes can't perceive ultraviolet light (except in the form of a brighter, whiter wash), but film can, we don't see this bluish cast as dramatically as the film does. Wedding photographers in particular have to deal with this.

Solution: Warming filters can cope with this, but you can often fix the problem in Photoshop by adding a little red to your photo. Human faces tend to accommodate a bit of extra warmth, as you can see in Figure 6.13.

Figure 6.13
Extra ultraviolet reflection from white fabrics can produce bluish pictures like the one at top; fortunately, Photoshop can correct for this error.

There are other reasons why you can end up with poorly balanced images, but this section has covered the ones you can do something about. Now, let's look at some ways to color correct these images.

Color Correction Made Easy

Entire books have been written on sophisticated color correction techniques, but I'm going to make the process fairly easy. I start out with several traditional ways to correct color in images, and move on to some newer, easier alternatives. You can select the

method you're most comfortable with: hands-on, seat-of-the-pants correction, or the simple, automated alternatives provided by Photoshop.

Just keep in mind that as you try to improve the color balance, brightness/contrast, and other attributes of photographs, that none of the following methods can add detail or color that isn't there. All techniques work well with photographs that have, say, all the colors somewhere, but with too much of one hue or another. The extra color can be removed, leaving a well-balanced picture behind. Or, you can beef up the other colors, so they are in balance once again. Photoshop can do that by changing some pixels that are relatively close to the color you want to increase to that exact color.

But, remember that removing one color, or changing some colors to another color, doesn't add any color to your image: Either way, you're taking color out. So, if you have a photograph that is hopelessly and overpoweringly green, you're out of luck. When you remove all the green, there may be no color left behind. Or, you can add magenta until your subject's face turns purple, and all you'll end up with is a darker photo. You must start with a reasonable image; color correction is better suited for fine-tuning than major overhaul.

Using Color Balance Controls

The first way we'll color correct an image is by using the color balance controls that virtually every image editing program has. This method is oriented more towards brute force, and it may be a little complicated for the neophyte. Stick with me, though. I have two alternatives for you later in the chapter that are a breeze to master. This section lays down some principles you can use to create wild color effects, even if you decide to perform normal color corrections by one of the other methods.

In Photoshop, you can find the color balance controls under Image > Adjustments > Color Balance, or just press Ctrl/Command+B if you're in a hurry. The dialog box looks like Figure 6.14. Note that Photoshop lets you set color balance separately for shadows, midtones, and highlights. What we're interested in at this point are the color sliders.

Figure 6.14
Photoshop's Color Balance controls let you increase or decrease any color.

These sliders let you adjust the proportions of a particular color from 0 percent to 100 percent. You can either add one color or subtract its two component colors. For example, moving the Cyan/Red slider to +20 (sliding it toward the red end), has the exact same effect as moving the Magenta/Green and Yellow/Red sliders both to the −20 position (towards the left).

Which should you choose? If you want to add pure red (or green, or blue), you can move the relevant control to the right. If your needs lean a little more toward one of the component colors than the other, move those sliders to the left, instead. The example below shows what I mean.

Figure 6.15 shows a scenic photo of a mountain view. Unfortunately, the original print was over 20 years old, and it took on a strong reddish cast as it faded. I could have removed this red tone by simply sliding the Cyan/Red control towards the Cyan, which is the opposite, or complementary color of red. Because Photoshop lets you preview the results, it would have been just a matter of subtracting red (adding cyan) until the picture "looked" right. In this case, a value of −36 applied only to the middle tones of the photo (those other than the highlights or shadows) would have been about perfect. In most cases, that's all you need to get the result shown in Figure 6.16.

Figure 6.15
This photo has a
distinct reddish cast.

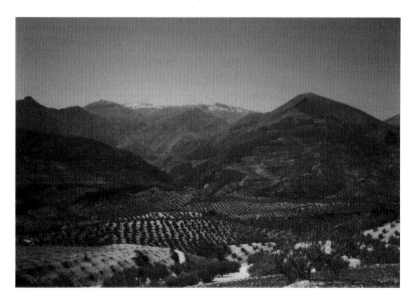

Figure 6.16
Adding cyan removes
the cast.

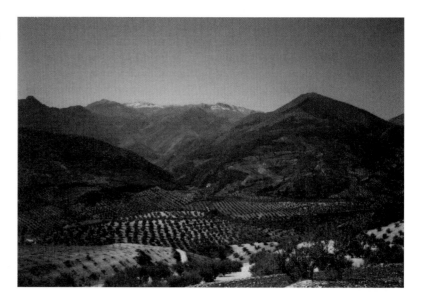

So, you can see that it is possible to remove red in one of two ways:

▶ Add cyan (thereby subtracting red)

▶ Add green and blue (thereby subtracting magenta and yellow)

I know it's a little confusing without looking at the color wheel, but the basic rules are simple. Reduce a color cast by:

▶ Adding the color opposite it on the color wheel

▶ Subtracting the color itself

▶ Subtracting equal amounts of the adjacent colors on the color wheel

▶ Adding equal amounts of the other two colors on its color wheel triangle

If you keep the color wheel in mind, you won't find it difficult to know how to add or subtract one color from an image, whether you are working with red-green-blue or cyan-magenta-yellow color models.

The biggest challenge is deciding in exactly which direction you need to add or subtract color. Magenta may look a lot like red, and it's difficult to tell cyan from green. You may need some correction of both red and magenta, or be working with a slightly cyan-tinted green. Your photo retailer has color printing guidebooks published by Kodak and others which contain red, green, blue, cyan, magenta, and yellow viewing filters. Use them to view your image until you find the right combination of colors.

Adjusting Hue/Saturation/Brightness

You may encounter images that can be improved by changing the hue, saturation, or brightness of one color only. Photoshop lets you work with the HSB color model through the Image > Adjustments > Hue/Saturation dialog box, shown in Figure 6.17. This control lets you adjust these individual values for each color channel.

Figure 6.17
Photoshop's
Hue/Saturation dialog
box lets you work with
hue, saturation, and
brightness (or
lightness) components
separately.

For example, you might have a holiday picture that needs to have its reds and greens enriched, but the blues need to be muted. Perhaps the green grass and foliage in another color have picked up an undesirable color cast, and you want to shift all the green values one way or another to improve the color. Or, you may want to darken or lighten just one color in an image (rather than all of them, which is done through the conventional Lighten/Darken controls). Any of these are possible with the Hue/Saturation dialog box. Just select the color channel with which you want to work, and move the sliders to get the effects you want. Figure 6.18 shows an Irish landscape that has been made considerably greener using this dialog box.

Figure 6.18
Photoshop's
Hue/Saturation control
brightened the foliage
in this picture.

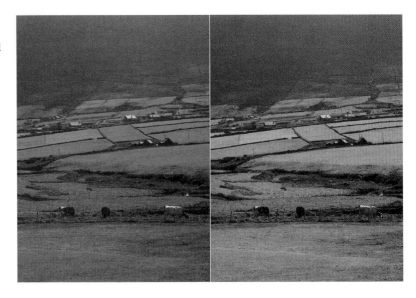

Using Color Ring Arounds and Variations

Color labs that deal primarily with professional photographers charge a lot more for the same size print as, say, an amateur-oriented photofinisher. Instead of a dollar or two for a photofinisher's 8″×10″ print, you can pay $10.00 to $20.00 and up (way up) for the same size print from a professional lab. Why the difference?

Both amateur and pro labs can produce automated (or machine) prints, although the equipment may be very different. The pro lab also offers handmade, or custom, prints, produced one at a time with an enlarger and painstaking manual techniques. The exact color balance of a custom print is often crucial, so a pro lab may produce five or six variations and let the client choose the preferred example. That's why custom prints are worth the extra money: You're paying not only for the handwork, but for the ability to choose from among several different prints. It's faster and more efficient for the lab to produce the variations all at once than to go back and make tiny corrections over and over until the exact version you want is produced.

The same logic holds true in the digital world. You can play with the color balance of an image for hours at a time, never quite achieving what you are looking for. There's no guarantee that, after a lot of work, you might decide that an earlier version really did look better, after all.

Photoshop was one of the first image editors to jump on the "color ring around" or "variations" bandwagon. In this mode, the software itself generates several versions of an image, arranged in a circle or other array so you can view a small copy of each one and compare them. Photoshop's Variations mode is especially useful, so I use it to illustrate a third way to color correct problem photos.

Working with Photoshop's Variations Option

For this exercise, we're going to use a typical color portrait that has been goofed up big-time. It's been printed quite a bit too dark, with plenty of extra red. Yet, hiding underneath this disaster is a good photo. We can use Photoshop's Variations to fix this image. Just follow these steps:

1. If you want to follow along, you can load the **Close-up** image from the CD-ROM bundled with this book. Otherwise, experiment with a photo image of your own. The principles are exactly the same.

2. With Photoshop, you can generate a color ring around by choosing the Image > Adjustments > Variations. The Variations dialog box is shown in Figure 6.19.

Figure 6.19
Photoshop's Variations dialog lets you compare alternate versions of an image.

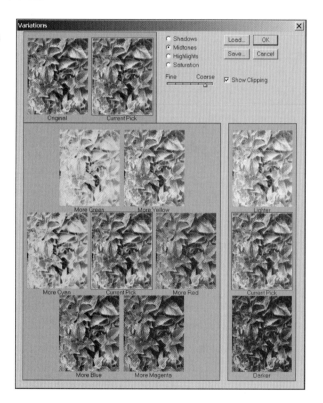

There are several components in this window:

—In the upper-left corner, you find thumbnail images of your original image paired with a preview of the changes you've made. As you apply corrections, the Current Pick thumbnail changes.

—Immediately underneath is another panel with the current pick surrounded by six different versions, each biased toward a different color: green, yellow, red, magenta, blue, and cyan. These show what your current pick would look like with that type of correction added. You can click on any of them to apply that correction to the current pick.

—To the right of this ring around is a panel with three sample images: the current pick in the center with a lighter version above and a darker version below.

—In the upper-right corner of this window is a group of controls that modify how the other samples are displayed. I'll describe these controls shortly.

3. If the Midtone button is not selected, click on it. You also want the pointer in the Fine...Coarse scale to be in the middle, and the Show Clipping button selected. The purpose of each of these controls is as follows:

—The radio buttons determine whether the correction options are applied to the shadows, midtones, or highlights of the image, or only to saturation characteristics. You may make adjustments for each of these separately.

—The Fine...Coarse scale determines the increment used for the each of the variations displayed in the two lower panels. If you select a finer increment, the differences between the current pick and each of the options is much smaller. A coarser increment provides much grosser changes with each variation. You may need these to correct an original that is badly off-color. Since fine increments are difficult to detect on the screen, and coarse increments are often too drastic for tight control, I recommend keeping the pointer in the center of the scale.

—The Show Clipping box tells the program to show you in neon colors which areas will be converted to pure white or pure black if you apply a particular adjustment to highlight or shadow areas (midtones aren't clipped).

—You may Load or Save the adjustments you've made in a session so they can be applied to the image at any later time. You can use this option to create a file of settings that can be used with several similarly balanced images, thereby correcting all of them efficiently.

4. Our image is too cyan, so the More Red thumbnail looks better. Click on it to apply that correction to the current pick. In fact, we need to click twice, since the original image is very cyan.

5. The image is also too light. Click on the Darker thumbnail.

6. Click on the OK button in the upper right of the dialog box when finished.

In this example, we worked only with the midtones. In most cases, the shadows, midtones, and highlights need roughly the same amount of correction. In others, though, the shadows or highlights may have picked up a color cast of their own (say, reflected from an object off-camera). Variations lets you correct these separately if you need to.

More often, though, you use the shadow-midtone-highlights option to improve the appearance of images that have shadows that are too dark or highlights that are washed out. Where any image editor's brightness/contrast control generally affects all the colors equally, this procedure lets you lighten shadows (bringing out more detail) or darken highlights (keeping them from becoming washed out) without affecting other portions of the image. The technique also lets you avoid nasty histograms and gamma curves.

Calibrating Your Monitor

While color corrections are something you're likely to do every day, setting up your computer for color management is something you are likely to do when you first install Photoshop, and then at intervals later on as your needs or equipment change. This section outlines the use of the Adobe Gamma control for your monitor. Adobe Gamma works with both the Windows and Macintosh operating systems' own internal color management systems to create an ICC profile for your display. Just follow these steps to get set up:

1. Open the Adobe Gamma application. In Windows, you find it under Control Panel (Start > Settings > Control Panel). Under Mac OS, you can find the Adobe Gamma application in your System folder in the Control Panels folder. The first window you see looks like Figure 6.20.

Figure 6.20
First choose whether to use the Assistant/ Wizard or work directly with the control panel.

2. You are given a choice of using a step-by-step, wizard approach, or going directly to the control panel itself. The wizard merely presents the choices provided in the control panel one at a time. If this is the first time you've used Adobe Gamma, you want to work with the parameters one at a time.

Click the Step by Step (Assistant) button (on the Mac) or the Step by Step (Wizard) button on the PC, and click Next.

3. In the next dialog box, shown in Figure 6.21, you are invited to assign a unique name for the profile you're creating. If you've previously saved a profile and want to edit that, you can click the Load button and locate the profile on your hard disk. For example, you may have a monitor profile provided by the vendor of your particular display (if not, check their Web site). Click Next to move to the next dialog box.

Figure 6.21
Assign a name to your new profile.

4. You should see a white box, with two darker boxes inside it (the center box may be difficult to see, as it is a very dark gray). Follow the instructions shown in the dialog box in Figure 6.22, and set your monitor's contrast control to its highest setting. Then adjust the brightness control to make the center box dark, but not totally black. Then, click Next to move to the next dialog box.

Figure 6.22
Set your monitor's brightness to its highest setting, then adjust the brightness control until the center box is dark.

5. In the dialog box shown in Figure 6.23, you need to select the type of phosphors that your monitor uses. You may want to check the manual that came with your monitor to see if the phosphors indicated match anything on the list. If you're working with a profile provided by your monitor vendor, the type of phosphors is already correct. Click the Next button to proceed.

Figure 6.23
Choose the type of phosphors used in your monitor.

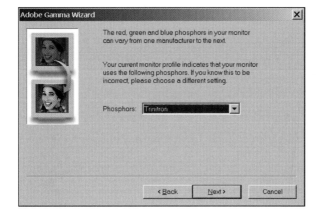

6. Choose the target gamma for your system from the drop-down list. Macintosh OS uses a gamma setting of 1.8, while the Windows default is 2.20. When the target is chosen, move the slider shown in Figure 6.24 until the gray center box merges with the surrounding gray frame. Then, click Next to move on.

Figure 6.24
Merge the center gray box with the surrounding gray frame.

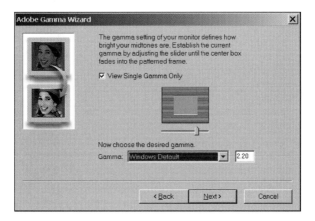

7. Next, you should set the color temperature of your monitor. In most cases, the default value of 6500K, shown in Figure 6.25, works fine. Change this setting only if your monitor manufacturer recommends it.

Figure 6.25
Choose a color
temperature for
your display.

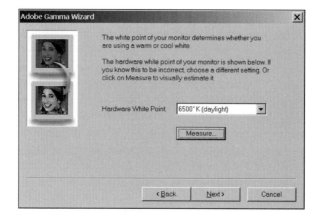

8. If you're curious, you can "measure" your monitor's color temperature visually. Turn down the ambient light in your work area, and click the Measure button in the dialog box. The Adobe Gamma tool shows you three gray squares against a black screen. Click the left square to make them all cooler, or the right square to make them warmer. When you are satisfied that you have a neutral gray, click the center square or press Enter to create your Custom hardware white point. If you change your mind, you can still select 6500K or another color temperature from the drop-down list.

9. Click Next to proceed to the dialog box shown in Figure 6.26. There, you can choose to work at a different white point from the one you've just set for your hardware. You rarely need to change this. Click Next again to move to the final dialog box.

Figure 6.26
Normally, you
wouldn't make any
changes in this
dialog box.

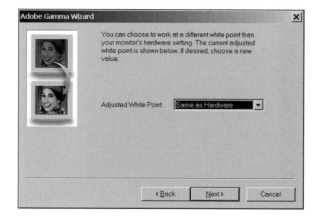

10. You're done. The dialog box shown in Figure 6.27 allows you to compare your original monitor setting with the new one. Click Finish to save the profile and exit the Adobe Gamma application.

Figure 6.27
Compare your new setting with your previous one, and then save your profile.

Next Up

After all this work with color images, you may be ready to work with grayscale photos for a while. The next chapter not only shows you how easy it is to convert a good color picture to a bad black-and-white rendition, but it also provides the tools you need to create great grayscale images instead.

7

Beyond Black and White

There's a lot more to black and white than a song by Michael Jackson or Paul McCartney's duet with Stevie Wonder. We've all heard phrases like "The world is not black and white" (Graham Greene), "The wings of Time are black and white" (Emerson), or even "Let me explain it to you in black and white" (every frustrated parent). The concept of monochrome represents simplicity, purity, or even polar opposites.

There are lots of reasons to use black and white, even with a full-color image editor like Photoshop and even if you have a full-color printer available to make a hard copy. This chapter explores how photographers who value what black-and-white imagery is able to do can get what they need—and beyond—from our favorite image editor. You'll learn some of the reasons why you *need* to use grayscale images and how to create better conversions from color than Photoshop normally provides on its own, plus you'll glean a few tips on reproducing some of the looks that b&w can give you.

Why Black and White?

Most photos today are taken in color, but that wasn't always the case. While I'm fond of pointing out that daguerreotypes were actually color photos (in the sense that they had overall tones and were not true black and white), color photography was a long time in arriving after the first photographic images were made by Nicephore Niepce in 1826 and Henry Fox Talbot in 1835. Some early attempts at color still photography were made by Scottish physicist James Clerk Maxell, who understood that red, green, and blue were the primary colors of light. In 1861, he photographed the same scene in black and white through a set of red, green, and blue filters; by projecting the three images on a screen with appropriately colored lamps, he reproduced the image of a tartan ribbon.

However, color imaging didn't really catch on until Kodachrome slide film was introduced in 1935 and, in 1942, Kodacolor film for prints. Black-and-white images were still favored by amateurs and professionals through the '50s and most of the '60s. Amateurs

liked B/W because it was less expensive than making color prints and more convenient than showing color slides.

Professionals often used monochrome for a variety of reasons. Perhaps the publications they worked for didn't publish color; black-and-white photos were standard in many magazines until the late '60s. Pros also used black-and-white images for creative reasons. Color can be distracting or destroy the mood of certain kinds of photos. Professional photographers even had cost considerations when their clients were unable to pay the tariff for full color. In the early '60s, for example, a color wedding album had to be priced much, much higher than the black-and-white version (sometimes with hand-colored images) that had been the standard for decades.

Color photography began to nudge black-and-white imaging out of the picture in the '70s, when instant-loading cameras and automated processing made color prints virtually as inexpensive as black and white (or, today, even cheaper). Affordable laser scanners at newspapers and magazines made full-color photography more practical for publications. More recently, digital tools like Photoshop, desktop scanners, and photo CDs have removed the last vestiges of barriers to color photography. Today color is king.

So, why are we talking about black and white? There are dozens of valid reasons for working in black and white. Here are some of them:

▶ Your destination for the image will display it only in black and white, and you want a fairly accurate preview of what the photo will look like. For example, you may have a photo that will be printed in black and white in a magazine, or included in a laser-printed newsletter. Two hues that are distinct in color may appear to be the same in black and white, providing an undesirable merger. If you know the image will be viewed in monochrome, you want to work with it in that mode.

▶ You don't know how your photo will be used, but you want to cover all the bases. I submit two or three photos a month to our local newspaper. I give them color 5×7 prints because they publish them in color about 25 percent of the time. But, I also preview the photo in black and white to see what it looks like in that mode. Given the vagaries of reproduction on newsprint, this is a very good idea.

▶ The picture you are working with originated as a black-and-white photo.

▶ Color is distracting. A big red or yellow blob in the upper right corner of a photograph may command our attention, especially when our intended subject is a muted pastel. Our eye is attracted to color first, and then to brightness. In Figure 7.1, the big red whatsit at the top of the frame grabs our attention, and it's hard to look away. In black and white, however, as on the right, the whatsit becomes just a framing element that surrounds the water and shore.

Figure 7.1
The red object at the top of the frame grabs our attention, but becomes just another framing device in black and white.

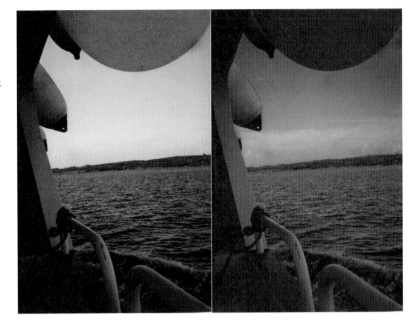

▶ Color destroys the atmosphere. Moody pictures, high-contrast photos, documentary photos with a gritty feel, and many other subjects may all look better in black and white. Would Dorothea Lange's immortal photo, "Migrant Mother," have been as effective in color? The cracked and lined face of the destitute mother of seven (who was, in fact, only 32-years old) was more powerful because it was shown in stark black and white.

▶ Color changes the emphasis. For example, you've probably seen figure studies in which close-ups of some body part, such as the curve of a shoulder, are made to represent something else, such as a desert landscape. The converse is also true: Edward Weston's famous still life, "Pepper #30," is said to resemble the musculature of a man kneeling. In color, it would simply be a very interesting picture of a pepper, just as the "landscape" photo would be transformed into a photo of a shoulder.

▶ You want to combine several color images that have widely varying color balances and have no time or inclination to make them match, or one or more of them are so off-color that you'd never be able to make them look anything other than patched together. If a color picture isn't an overriding concern, converting everything to black and white before compositing them together may be a satisfactory alternative.

▶ You want a historical look. A full-color photo of a Civil War reenactment is realistic, but it won't look like it was taken during the Civil War. Figure 7.2 wasn't really taken 150 years ago, but at least a full-color image didn't tip us off.

Figure 7.2
Sometimes monochrome can provide an historical look to an image.

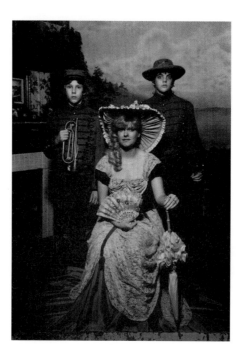

Converting Color to Black and White

Photoshop makes it very, very easy to convert a good color photo into a bad black-and-white image. All you need to do is select Image > Mode > Grayscale from the menu bar, and, presto, your color image has been converted to an inaccurate black-and-white rendition. Or, perhaps, you decide to use Image > Adjustments > Desaturate, which does much the same thing, but only operates on a particular layer or selection.

Of course, images converted this way always seem to have low contrast. So, your next step would probably be to use Image > Adjustments > Brightness/Contrast to boost the contrast a bit. In a process that took only a few seconds, you've managed to convert a good color image into a black-and-white photo with excessive contrast that doesn't necessarily offer a good representation of the original. What happened? You've fallen for the same trap that has snared photographers for decades. It has long been common to increase contrast when making a black-and-white print from a color negative, and the practice has become standard operating procedure in the digital world, too.

The fallacy lies in the fact that in a black-and-white photo, the contrast, or apparent differences between objects in an image that makes them distinct, is determined solely by the relationship between the light and dark tones. In a color photo, however, *three* separate factors determine true contrast: hue (the various colors of the image), saturation (how rich they are), and brightness (the lightness or darkness of a tone). I see this glossed over in most books about Photoshop, so I'm going to take the time to clarify the inherent problems

behind color to black-and-white conversions. Understanding the problems helps you avoid them.

The following illustrations should make the situation abundantly clear. I'll use the image shown in Figure 7.3, a landscape photo of a barren dirt field with mountains and sky in the background (**Landscape** on the CD-Rom). When converted to grayscale using Photoshop's Mode changing operation, the image looks like Figure 7.4.

Figure 7.3
The various components of this photo are easy to discern in full color.

Figure 7.4
Converting to grayscale using Photoshop's default methods tends to blend many of the colors together as similar tones.

You can see that the conversion to black and white is less than satisfactory. The browns and blues that were distinct in the original image have all turned into similar shades of gray. The typical solution is to adjust the contrast of the grayscale image, creating a result such as the one shown in Figure 7.5.

However, as I said, color images consist of three components: hue, saturation, and brightness. Look what happens when we first change some of the color photo's characteristics and then see what Photoshop can do.

Figure 7.5
The knee-jerk response to a low-contrast grayscale conversion is to increase the contrast and/or brightness—bad plan, as you can see in this example.

Hue

One of the ways our eyes see contrast between objects in a photo is through the differences in color. Figure 7.6 shows the same image with the colors all skewed (I used Photoshop's Image > Adjustments > Hue/Saturation control and adjusted the Hue slider). It's easy to differentiate between the green sky and magenta field, isn't it? However, when this garish image is converted to grayscale, the image shown in Figure 7.7 results. It's identical to Figure 7.4. Photoshop ignores the color differences in making the conversion, as long as the colors maintain their relationships.

Moving the Hue slider rotates all the colors in an image simultaneously in one direction or another around an imaginary color wheel. That's why the Hue slider begins in a neutral middle position and can move 180 increments (degrees) positive (clockwise) to the opposite side of the color wheel, or a negative 180 degrees counterclockwise to the same position on the wheel. All the colors move equal amounts, so as far as Photoshop is concerned, their relationships haven't changed and the results are the same after the image is converted to grayscale.

Figure 7.6
Changing an image to a garish color scheme doesn't affect the grayscale conversion one whit.

Figure 7.7
Because all colors were changed equal amounts, the grayscale version looks exactly the same.

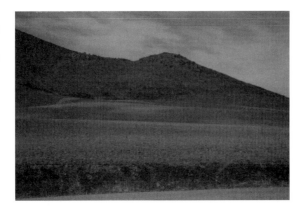

Saturation

Saturation is another way of creating contrast between objects in a color image. You can think of saturation as a way of measuring how pure colors are. Imagine a can of pure red paint. It would produce a color like the one shown at left in Figure 7.8. Add some white paint to the can, and you get a less saturated red, eventually arriving at a totally desaturated white (if you added an overwhelming amount of white paint), as shown in the squares in the top row of the figure. If you added black paint instead, you end up with a darker, but also less saturated, red, finally ending up with black, as you can see in the bottom row.

Figure 7.8
Add white or black to red, and all you get is a desaturated red that is lighter or darker than the original color.

This analogy isn't perfect, however, because the white paint is lighter than the red paint, and the black paint is darker, so, in terms of gray scales, the various degrees of saturation could still be told apart in a black-and-white version of the image, like the one in Figure 7.9.

However, if parts of an image were exactly the same color and brightness, and varied only in the degree of saturation, they'd look precisely the same when converted to grayscale. Figure 7.10 shows at the top a gradient consisting of a single color, with the saturation carefully controlled to blend from the pure color (at the left side of the image) to the same color completely desaturated (at the right side of the image). When this saturation gradient is converted to grayscale, the completely uniform gray tone shown at the bottom of the figure results.

Figure 7.9
After the saturation has been adjusted, converting the colors to gray doesn't provide an accurate image.

Figure 7.10
At top is a smooth blend in which only the degree of saturation of the color changes; at the bottom, you can see Photoshop has converted the blend to a uniform gray.

CREATING A SATURATION GRADIENT

Still skeptical and want to try this for yourself? Just follow these steps:

1. Fill a rectangular image or selection with a color of your choice.

2. Choose Layer > New Adjustment Layer > Hue/Saturation to create a spanking new adjustment layer that lets you modify the saturation of your color with great precision.

3. Click OK in the New Layer box that pops up, and then click OK in the Hue/Saturation dialog box that appears. You're not going to use the sliders to adjust the saturation just yet.

4. You see two thumbnails in the Hue/Saturation adjustment layer in the Layers palette, as shown in Figure 7.11. Click the box on the right, the Layer Mask thumbnail.

5. Choose the Gradient tool from the Tool palette, and choose the foreground/background linear gradient from the Options toolbar.

6. Place the cursor at the left side of the image and, with the Shift key held down (to produce a straight line), drag to the right. The gradient is applied to the Layer Mask, so that any changes to the saturation that you make are least at the left side (where the gradient is darkest in the Layer Mask) and most significant on the right side (where the Layer mask is lightest).

7. Double-click the Layer thumbnail (to the left of the Layer Mask thumbnail) to produce the Hue/Saturation dialog box. Drag the Saturation slider all the way to the left. Photoshop applies the saturation gradient, as shown in Figure 7.12.

8. Convert the image to gray and watch it turn into a single strip of exactly the same shade.

Continued

Figure 7.11
Create a layer mask to
a Saturation
Adjustment Layer to
create your own blend.

Figure 7.12
You end up with a
blend like this one,
which you can convert
to a uniform gray.

In a real-world image, some colors may indeed have exactly the same brightness and
color, and vary only in their degree of saturation. In such cases, we still have no difficulty
differentiating the objects in the image, as you can see in the worst-case example shown
in Figure 7.13. This image contains only white and "red" in various degrees of saturation,
using the colors in the strip at the bottom of the figure. It's possible to make out the
shapes of the objects (in this case leaves) when the only difference between them is the

amount of saturation. Figure 7.14 shows the same image with all the "reds" converted to gray. It's just a big blob of gray, just like the bottom row of Figure 7.10.

Figure 7.13
This is a simplified real-world image of some leaves, posterized so only four colors remain, all the same shade of red at different levels of saturation.

Figure 7.14
Converted to gray by Photoshop, all the various reds merge into a uniform gray again.

Getting back to our landscape photo, Figure 7.15 shows the image with the saturation boosted considerably. It's easy to differentiate the blue sky from the green mountains and brown field. However, converted to grayscale, it looks precisely like Figure 7.4. (Trust me, or try it yourself; we don't need yet another identical figure to prove this point.) When

images that have objects that differ from others in the picture chiefly through saturation or color, that information is lost when the photo is converted to grayscale.

Figure 7.15
Even boosting the color saturation of the image makes no difference—the grayscale conversion looks exactly the same as Figure 7.4.

Brightness

Brightness is the third clue we use to differentiate between objects in an image. A closely related factor is contrast, which is a way of comparing the number of different tones in an image. When you adjust the brightness of an image, you're increasing (or decreasing) the lightness of every pixel in an image equally, over a range of 0 (black) to 256 (white). When you modify the contrast, you're changing the number of tones at individual brightness levels: If all 256 tones are distributed equally from black to white, the image has relatively low contrast. If there are only a few different tones, the image has high contrast.

The most important thing to know is that, with a grayscale image, brightness and contrast are the only tools you have left to differentiate among objects. If, in the original image, it was the color or saturation components that made elements stand out, you no longer have control over those factors once the image is converted to black and white. You need to make any adjustments you need to apply *before* the image is converted. That's an important point. Too often, Photoshop users blithely convert a color image to grayscale using Photoshop's default settings, and then try to adjust the brightness/contrast. At that point, you're trying to restore a distinction between objects that no longer exists.

The other important thing to keep in mind is that Photoshop does not consider hue or saturation when converting an image from color to black and white using the Mode > Grayscale or Desaturate functions. Instead, it uses an algorithm calculated to provide the best compromise, which uses approximately 60 percent of the green component of your image, 30 percent of the red, and 10 percent of the blue. However, as you've seen in the previous examples, this algorithm provides results that are often acceptable, but which are not necessarily accurate, particularly with images in which the colors or saturation provide the most important visual cues.

We can do better.

Converting to Grayscale with Channels

Let's start with an image that has lots of colors, good saturation, and plenty of contrast with which to work, like the one shown in Figure 7.16 on the left. It's stored on the CD-ROM bundled with this book as **Castle Garden**. The version on the right has been converted to grayscale using Photoshop's default Image > Mode > Grayscale feature. Knowing what you've learned about how Photoshop performs this conversion, you can probably guess what's wrong, especially with the opportunity to compare them side by side. Notice how the red flowers, in particular, tend to blend in with the rest of the blossoms, how the green grass appears to be too light, and the sky is nowhere near as dramatic as it was in the original image.

Figure 7.16
The original image is shown at left; at right, a grayscale conversion using Photoshop's default tool.

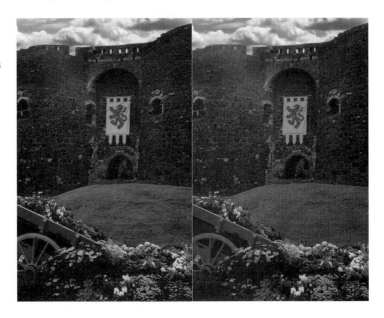

You'll find that working in CMYK mode is the easiest way to separate all the colors with which you want to work. Follow these steps to explore some of your color-to-grayscale conversion options:

1. Choose Image > Mode > CMYK to convert the RGB image to cyan, magenta, yellow, and black channels. These correspond to the printing plates that would be used to print this image on a press, or the colors used by your printer to produce a hard copy.

2. Switch to the Channels palette to access each of these color layers individually, as shown in Figure 7.17.

Figure 7.17
Using the Channels palette, you can view each of the cyan, magenta, yellow, and black "plates" of a CMYK image.

You can examine each of the individual plates, as you can see in Figure 7.18. Sometimes you find that one of them provides a pleasing, although inaccurate, rendition. For example, the magenta channel provides a splendid rendition of the castle walls and appears to differentiate among the individual flowers. However, the grass is much too light, and the sky not as dramatic as before.

The cyan plate shows off the sky and clouds, but most of the rest of the image is muddy. The yellow plate renders the grass as almost black and offers little detail elsewhere in the picture. The black plate is what is called a "skeleton" black, reproducing nothing more than the fine detail in the shadows of the wall and darker foliage (as it's supposed to), leaving all the color information for the cyan, magenta, and yellow channels.

If you see a channel you want to use, continue on with these steps:

3. Choose Layer > New Adjustment Layer > Channel Mixer. Click OK in the New Layer dialog box that pops up to create the Channel Mixer adjustment layer.

4. Click the Monochrome box in the Channel Mixer dialog box to direct your changes to a gray channel.

Figure 7.18
The top row shows the cyan and magenta color channels (left to right) while the bottom row shows the yellow and black channels (left to right).

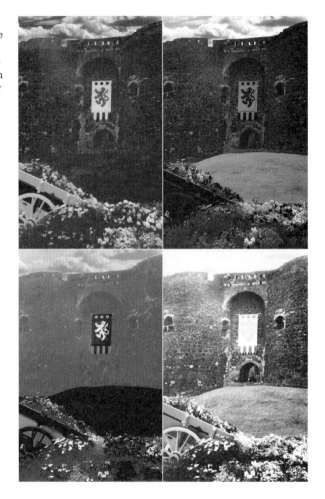

5. Move all the sliders to the 0 center point except for the channel with which you want to work. In this case, I moved the Magenta slider to the right until I got a black-and-white image I liked, as shown in Figure 7.19.

6. Click OK to apply the change.

7. Flatten the image (use Layer > Flatten) to create your grayscale image.

Figure 7.19
Here's a grayscale
rendition using the
Magenta channel.

What if you want to emphasize some other tones? You can do that, too, with the Channel Mixer. Continue with these steps.

8. Chose Image > Undo to cancel the image flattening you performed in Step 7.

9. Create a duplicate of the background layer (use Layer > Duplicate Layer) and move it above the first Channel Mixer adjustment layer.

10. Select Layer > New Adjustment Layer > Channel Mixer, and click OK to create a second adjustment layer.

11. Click the Monochrome box as before in the mixer dialog box, and then move the Yellow slider to the right while keeping the other sliders at the center point. This emphasizes the blue of the sky, as you can see in Figure 7.20.

12. Merge the two image layers with their respective adjustment layers.

13. Use an eraser to remove everything in the sky-emphasized layer except for the sky itself.

14. Flatten the image. Compare the results of the original, default grayscale conversion at left in Figure 7.21 with the results using channel manipulations, shown at right.

Figure 7.20
Create a second layer
with the sky
emphasized.

Figure 7.21
The finished image
looks like the one on
the right—compare it
with Photoshop's
default grayscale
conversion on the left.

Other Grayscale Effects

Here are some other easy grayscale effects you can do. You can create an antique photo or orthochromatic look. Check out Chapter 3 if you want to see how to duplicate an infrared film image.

Antique Photograph

It's fairly easy to recreate the look of an antique photograph from the early twentieth century, late nineteenth century, or even earlier. While the goal earlier in the chapter was to create the best possible grayscale conversion of a color image, some really bad conversions can look interesting, too. First, let's work on a fully saturated, fairly decent color image, using the original, unmodified version of our Castle Garden photo. Just follow these steps:

1. Choose Image > Calculations to access the dialog box shown in Figure 7.22. This is the Channel Calculations dialog box, which allows us to choose a channel from any layer of any image, which becomes the *base* channel, and merge it with a channel from any other layer, which becomes the *blend* channel. It's a powerful feature, indeed. This exercise shows a little of how it works.

Figure 7.22
The Calculations dialog box lets you merge channels from one or more images.

2. In the Source 1 and Source 2 areas, make sure the Background layer from the Castle Garden photo is selected. Unless you've added layers to the image, this is your only choice, in fact.

3. For Channel in Source 1, select the Red channel. We'll be using it as the base channel for the merger.

4. For the Channel in Source 2, select the Green channel, making it the blend channel.

5. For Blending, choose Exclusion from the drop-down list. I explain why shortly.

6. For Opacity, choose 50 percent. This blends the Red and Green channels evenly, using the rules of the Exclusion blending mode.

7. In the Result box, choose New Document from the drop-down list. This creates a new image containing the blended photo.

8. Click OK to create the new document, which should look like Figure 7.23.

9. Photoshop recognizes that the new document is simply a channel rather than a document in its own right (so far), so it's stored in Multichannel mode. You convert it to a grayscale document by choosing Image > Mode > Grayscale to create a valid document.

10. Save your file, then read on to see what happened.

Figure 7.23
This "antique" photo has a faded look, created by merging Red and Green channels of a full-color image.

CHAPTER 7

SOME EXOTIC BLENDING MODES

Photoshop's blending modes combine layers or channels in sophisticated ways, as you've learned earlier in this book. In this most recent case, we used the Exclusion mode to produce a weathered, old-timey look to the photograph, taking advantage of the way Exclusion combines pixels.

Exclusion mode is closely related to Difference mode. The latter examines the brightness information of each channel, and subtracts one from the other, depending on whichever is brighter. That sounds confusing, but it's not difficult to understand if you narrow it down to individual pixels.

Consider the following cases:

If a pixel in the Source 1 or Source 2 channel has a value of 200 and the same pixel in the other channel has a value of 100, the result is a new pixel with a value of 100. It doesn't matter where each pixel resides; the result is always the difference between the two.

If a pixel in either channel has a value of 255 (white), the result is always a pixel that has the opposite value of the pixel in the remaining channel. A dark pixel with a value of, say, 55, ends up as the equivalent light pixel with a value of 200 (255 − 55). A light pixel with a value of 200 ends up as a dark pixel (255 − 200) with a value of 55.

Conversely, if a pixel in either channel has a value of 0 (black), the composite pixel remains exactly the same as the value of the pixel in the remaining channel. Say, the other pixel has a value of 200; the composite pixel is 200 − 0, or 200.

Exclusion works similarly to Difference mode, *except* that it converts any midtone pixels to gray, creating a lower-contrast version that has the aged, faded, and slightly washed-out look as seen in Figure 7.23.

The same techniques also work on photos that aren't so good. As an experiment, I scanned a 30-year-old photo of a Roman bridge; the photo had faded quite badly from exposure to sunlight while it was displayed on a wall. The dye layers had faded enough that I wasn't going to be able to salvage the photo in full color anyway; any corrections would have just made the image grayer. So, I applied the same Exclusion blending mode as described above. Then I added sepia toning as described in Chapter 4. The result is shown in Figure 7.24.

Orthochromatic Film

It wasn't so long ago that black-and-white films incorporated the term "pan" in their nomenclature. Tri-X Pan, Verichrome Pan, Plus-X Pan, or even Panchromatic-X were the names of films I used early in my career. The term "pan" stood for panchromatic (all colors), and was important because it meant that these black-and-white films were roughly sensitive to red, blue, and green light in equal amounts. As odd as it might seem, that wasn't always the case. In the '40s and '50s, black-and-white films were notorious for being most strongly sensitive to blue, green, and yellow light, with red showing up much darker than it ordinarily would. That explains all the "black lipstick" photos you may recall from that era. It also explains why red safelights can be used for developing these red-insensitive, "orthochromatic" films.

Figure 7.24
A faded photo of an old Roman bridge was salvaged by combining channels and applying a sepia tone.

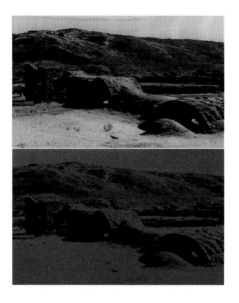

Once panchromatic films became available, ortho films lived on as a graphic arts tool, used to emphasize reds and de-emphasize other colors, and for scientific and medical applications. Ortho films aren't used for conventional photography, except as a creative tool. Here's how to approximate the effect in Photoshop.

1. Start with a photo that has plenty of reds, greens, and blues, like the one shown in Figure 7.25 (**Frutto** on the CD-Rom).

2. Choose Image > Adjustments > Channel Mixer to summon the Channel Mixer dialog box.

3. Select the Monochrome box.

4. De-emphasize all the red in the photo by moving the Red slider to the left to approximately − 76 percent.

5. Increase the blue and green sensitivity by moving the Blue and Green sliders to the right until the image has the ortho look you want. Don't be afraid to move past the 100 percent point. I used 180 percent and 144 percent for the green and blue, respectively, as shown in Figure 7.26.

6. Click OK to apply your ortho effect.

CHAPTER 7

Figure 7.25
This photo has
plenty of reds and
other colors.

Figure 7.26
In the ortho view, all
the reds have become
darker, and the other
colors are lighter.

Next Up

Filters have been used on conventional cameras for more than 150 years, producing effects that enhance an image or add some creative flair. Photoshop has more than 100 filters of its own built in, and there are hundreds more available from third parties such as Andromeda. In the next chapter, I concentrate on the filters that are most like their conventional camera counterparts. You'll learn how to recreate filter effects, and apply some that aren't even possible outside the digital realm.

8

Using Photoshop's Filters

In the realm of conventional photography, filters have long been an important corrective and creative tool. The same is true in the digital domain. Filters created for Photoshop can fix bad images, add artistic flair, or transform a shoe box reject into a triumphant prizewinner.

Anyone serious about photography comes to depend on their kit of filter attachments that fit in front of (or sometimes inside) their lens. Glass or gelatin filters can correct for improper lighting conditions, add a romantic fuzzy glow to an image, or provide incredible multi-image effects. Indeed, products like the versatile Cokin Filter System have generated sub genres of photographic techniques on their own; there are entire books written on the use of Cokin filters, and a large number of unofficial Web sites are dedicated to their use.

As you might guess, having ventured so deeply into this book, Photoshop can duplicate many of these effects through its built-in capabilities. For example, all the capabilities of color balancing filters can be mimicked using Photoshop's color correction features, as you learned in Chapter 6. Many of the special effects possible with Cokin and other filter sets can be achieved using the more than one hundred filters included with Photoshop. These filters and their abilities are addressed in this chapter. Many more traditional and nontraditional photographic effects can be created using third-party filters such as the Andromeda products featured in Chapter 9.

What Are Filters?

With traditional photography, filters are typically circles of glass that fit in front of a lens and change or attenuate the light passing through in some way. A few lenses with very large front diameters accept filters in a slot at the rear of the lens, to reduce the expense. My old fisheye lens has a few filters built in which can be changed by rotating a wheel. Filters are also available as inexpensive square sheets of gelatin that fit in holders that attach to the front of the lens.

They all work in much the same way. Some have a tint and partially or completely block light of other colors, as when a red filter is used with black-and-white film to darken the blue of the sky and the green of foliage. Other filters may remove certain types of light to reduce glare, or break up an image into multiple fragments, as if your subject were viewed through an insect's eye. Filters can blur parts of your photo, or add starlike twinkles to bright highlights. Figure 8.1 shows a popular effect that can be achieved with a split filter with orange on top and blue on the bottom.

Figure 8.1
A split filter produces one color on top, and another color on the bottom.

In Photoshop, filters can perform even more amazing magic tricks with your images. They can transform a dull image into an old masters painting with delicate brush strokes, or create stunning, garish color variations in a mundane photograph. Blast apart your images into a cascade of sparkling pixels, or simply add some subtle sharpness or contrast to dull or blurred areas. Plug-in image-processing accessories have the power to affect a complete makeover on all or parts of a scanned photo or bitmap painting you created from scratch. You can also use these add-ons to produce undetectable changes that make a good image even better.

Figure 8.2 shows a variation on the flag picture used in Chapter 1. There, the intent was to show how Photoshop could duplicate traditional photographic effects. In this illustration, however, you can see what the same image looks like with six different filters applied in a deliberate attempt to create a more highly processed appearance. While Photoshop can duplicate many traditional camera effects, it can go far beyond them, too.

Photoshop-compatible plug-in filters are actually miniature programs in their own right, designed in such a way that they can be accessed from within an image editing application to manipulate the pixels of a file that is open in the parent application. Some plug-ins can load files on their own, too, without resorting to Photoshop at all.

Figure 8.2
Six different filters
were applied to this
image to create a
combination of effects.

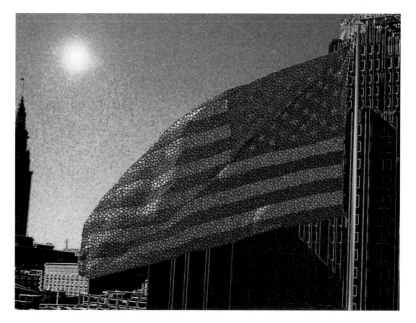

These plug-ins are called filters because, in the most general sense, they function much like filters you're familiar with in the real world. Like photographic filters, Photoshop's plug-ins can modify the bits of light, or pixels, that pass through them.

For example, one of the simplest filters of all isn't even found in Photoshop's Filter menu. The Image > Adjustments > Invert feature of Photoshop is part of the program's basic capabilities and doesn't "plug-in" at all, but it acts in exactly the same manner as other filters.

The Invert command looks at each pixel in your image in turn and simply "flips" it to the exact opposite value. That is, a pure white or light gray pixel is changed to pure black or dark gray. The color value of the pixel is changed to the color opposite on the color wheel. A dark blue pixel becomes light yellow; a light cyan pixel becomes a dark red pixel, and so forth. Figure 8.3 shows some color chips representing an array of pixels. At top are two rows of pixels in their original colors; the set at the bottom shows the same two rows that have been flipped to their opposite color and brightness value by the Invert function.

Figure 8.3
The top two rows of
color patches are
converted to the colors
shown in the bottom
two rows when
inverted.

This is the simplest kind of filtering possible, because the values being modified are
already stored as numbers, from 0 to 255, for each of the three color channels, plus gray.
A single mathematical algorithm can be applied to each pixel to produce the filtered
image. If you want an inside look at how filters work, check out Figure 8.4, Photoshop's
"blank" filter, which goes by the name Custom, and is located in the Other submenu of
the Filter menu.

Figure 8.4
Photoshop's Custom
filter shows how filters
look at individual
pixels in an image.

The center box represents the pixel being examined. When processing an image or selection,
Photoshop looks at each pixel in turn, then adjusts the values of the pixels that surround it,
based on the numbers in the boxes that ring the target pixel. That part is simple. Knowing
what numbers to plug in to achieve a particular effect is difficult. Fortunately, unless you're a
filter fanatic, you rarely have to resort to that (although the Custom filter is fun to play with).
Instead, you can put Photoshop's built-in filters to work to achieve the looks you want.

Some filters may remove pixels entirely, change their contrast (thus blurring or sharpen-
ing an image), or shift them around in an image in relation to others that remain in place,
creating some degree of distortion. The programs that make up filters can be very simple

or extremely complex; they can require no user input or bristle with dialog boxes, slider controls, buttons, preview windows, and other features.

What makes Photoshop's filters so versatile is the fact that they don't have to be part of Photoshop's basic code. Photoshop includes a programming interface that lets it talk to external programs such as filters, which need only to plug in at the appropriate places in the interface. Plug-ins are a brilliant concept, even if the idea was not original to Adobe, having been adapted from a facility in the Digital Darkroom program marketed by Silicon Beach. All Adobe had to do to provide the same capabilities was build certain "hooks" into Photoshop, bits of program code that allowed Photoshop to temporarily turn over control to an outside module, which could then work with and manipulate the pixels within currently open images.

Upgrading, adding, or removing a filter is as easy as deleting the old filter file and dragging a new one into the Plug-Ins folder of your application. The next time you start Photoshop or another image editor, the application "builds" itself by looking for available modules, such as filters. Any suitable plug-ins are added to the Filters or File > Import menus automatically.

What Kinds of Filters Are Available?

The plug-ins available for Photoshop fall into several broad categories:

▶ **Image Enhancement filters**: I use this term for filters that improve the appearance of images without making basic changes in the content of the images. You have to apply the term "basic changes" loosely, since some of these can make dramatic modifications. Sharpen, Unsharp Mask, Dust and Scratches, and similar filters are all image enhancement plug-ins. Blur filters are also image enhancement filters; there are many images that can be improved through a little judicious blurring. This kind of filter can be applied to an entire image, or just a portion that you have selected.

▶ **Attenuating filters**: I borrowed this word from the photographic world to describe filters that act like a piece of glass or other material placed between the image and your eye, superimposing the texture or surface of the material on your picture. Think of a piece of frosted glass, a translucent scrap of canvas fabric, or a grainy sheet of photographic film. These, or any of dozens of other filters, including most noise and texturizing filters, can add a texture or distort your image in predictable ways. Attenuating filters may be applied to a whole image, or just a selection.

▶ **Distortion filters**: These filters actually move pixels from one place in an image to another, providing mild to severe distortion. Filters that map your image to a sphere, immerse it in a whirlpool, or pinch, ripple, twirl, or shear bits here and there can provide distortion to some or all of an image.

▶ **Pixelation filters**: Adobe's own terminology is good enough for me to use in referring to a group of filters that add texture or surface changes, much like attenuating filters, but take into account the size, color, contrast, or other characteristic of the pixels underneath. These include Photoshop's own Crystallize, Color Halftone, Fragment, and Mezzotint filters. The Pointillize or Facet filters, for example, don't simply overlay a particular texture—the appearance of each altered pixel incorporates the underlying image.

▶ **Rendering filters**: Again, Adobe's terminology is a good way to describe filters that create something out of nothing, in the way that a 3-D rendering program creates a shaded model of an object from a wire frame skeleton. These filters may or may not use part of the underlying image in working their magic. Photoshop's Clouds filter creates random puffy clouds in the selected area, while Difference Clouds inverts part of the image to produce a similar effect. Lens Flare and Lighting Effects generate lighting out of thin air, while the Chrome filter produces Terminator 2-like surfaces.

▶ **Contrast-enhancing filters**: Many filters operate on the differences in contrast that exist at the boundary of two colors in an image. Sharpening and blurring filters are types of filters that do this, but I've lumped them into the Image Enhancement category. Other contrast-enhancing filters are used to produce special effects. By increasing the brightness of the lighter color or tone, and decreasing the brightness of the darker color or tone, the contrast is increased. Since these boundaries mark some sort of edge in the image, contrast-enhancing filters tend to make edges sharper. The effect is different from pure sharpening filters, which also use contrast enhancement. Filters in this category include all varieties of filters with names like Find Edges, Glowing Edges, Accented Edges, Poster Edges, Ink Outlines, and even most Emboss and Bas Relief filters.

▶ **Other filters and plug-ins**: You'll find many more add-ons that don't fit exactly into one of the categories above, or which overlap several of them.

▶ The About Plug-in option in the Help menu shows you what filters have been loaded by Photoshop. You don't have to wend your way through nested menus to view this list.

Using Filters

I explain how to use particular filters as we go along, but there are some general tips that apply to nearly all filters with which we'll be working. To apply a filter, follow these steps:

Choose Portion of Image in which to Apply Filter

You don't have to apply a filter to an entire image or layer; many times you want to use the filter only with a portion of the image. Use any of the selection tools, including the marquee, lasso, magic wand, or one of Photoshop's advanced tools, such as Select > Color Range or Quick Mask mode.

It's often smart to copy the entire image to a duplicate layer (Layer > Duplicate), and make your selection on a copy. You can play around with different filter effects without modifying your original image. If you don't select a portion of an image, the filter is applied to the entire image. Because it can take anywhere from a split second to a few seconds (or much longer), depending on the speed of your computer and the size of your image and selection, you may want to first work with a representative section of the image before applying the filter to the entire image.

Select the Filter

Some filters, such as Sharpen > Sharpen and Sharpen > Sharpen More, are known as single-step filters and operate immediately. They have no parameters to select, and thus offer less control over their effects. Other filters cause a dialog box to pop up with controls you need to adjust.

Most filters also include a Preview window you can use to get an idea of what your filter does when applied to a selected portion of an image. You can find this useful to make broad changes in parameters, but I think it's still a good idea to select a somewhat larger area of an image and apply the filter to that on a duplicate layer. A typical filter dialog box is shown in Figure 8.5.

Figure 8.5
A typical filter dialog box looks like this.

Apply the Filter

Click OK to apply the filter. If you have a very large image (say, 10 MB or more), a slow computer, or a complex filter, go find something to do. This might be a good time to set up your laptop on top of your desk and go get some work done. Even filter/image combinations that do magical things in less than a minute or less seem terribly slow when you're sitting there staring at the screen. If you've marked the Beep When Done box in the Preferences > General dialog box, Photoshop chirps when it's finished with its calculations.

When the filter is finished, be careful not to do anything else (e.g., move the selection) until you've decided whether or not the effect is the one you want. Although Photoshop has multiple levels of Undo, you save effort any time you can avoid using the Edit > Step Backward (Alt/Option+Ctrl/Command+Z) command multiple times. That way, if you totally hate the result, you can quickly press Ctrl/Command+Z and try again.

FADING FILTER EFFECTS

You can use the Fade command (Shift+Ctrl/Command+F) to reduce the amount of a filter's effects, moving a slider from 0 to 100 percent to adjust how much of a filter's modifications should be applied to your image, layer, or selection. However, I find that I have more options when I apply a filter to a duplicate layer. I can vary the amount of the filtration by changing the opacity of the filtered layer so it blends in with the unmodified layer underneath. I can selectively erase parts of the filtered layer so the filtration is applied only to portions of the image. I can use Photoshop's Mode controls to merge the filtered and unfiltered layers in creative ways. Fade is handy, but it's a fast and less versatile way of modifying a filter's effects.

Save the Image or a Snapshot

When you're really, really certain that the effect is what you want, save the file under another name (use File > Save As and click the Save A Copy box if you want). Only flatten the layers to merge the effect with your main image when you're convinced you have the look you want. Some day, you'll be glad you saved a copy of the file when you change your mind about being really, really certain.

Reproducing Photographic Filters in Photoshop

I'm going to divide the rest of this chapter into two parts. This next section shows you how to reproduce some of the most common photographic filters in Photoshop, whether the technique uses Photoshop's own filters or not. The section which follows this one deals exclusively with using Photoshop's built-in filters. I follow the same pattern in Chapter 9, showing you how to use Andromeda's filters to reproduce photographic filter effects, as well as how to create totally unique looks.

Polarizing Filters

Polarizing filters can provide richer and more vibrant colors while reducing some of the glare that infects many photos taken in bright daylight. Polarizing filters work in much the same way as polarized sunglasses. Figure 8.6 is a simplified illustration that may help you understand how polarizing filters work.

Figure 8.6
Light bouncing from shiny surfaces scatters in all directions.

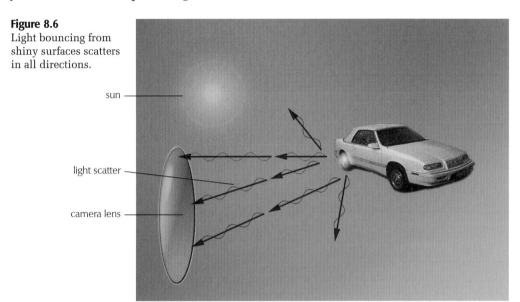

sun

light scatter

camera lens

In this figure, sunlight strikes all the shiny parts of the convertible (glass windows, the shiny plastic wheels and trim, and so forth), although for simplicity I'm showing only the glare off the rear wheel cover. The light bounces off in many different directions. As you probably know, light moves in waves, and in this case the waves vibrate at many different angles; some side to side, some up and down, others at diagonal angles. It's difficult to illustrate this, but I think you know what I'm saying. Some of this hodgepodge of light strikes the lens of your camera, producing glare and reduced contrast.

A polarizing filter contains what you can think of as a tiny set of parallel louvers which filter out all the light waves except for those vibrating in a direction parallel to the louvers. Again, this is difficult to demonstrate in two dimensions, but you can see the net result in Figure 8.7. All the light waves are blocked except for those vibrating from side to side (imagine them moving from side to side in the illustration) so they can pass through the horizontal louvers. The polarizer blocks all the scattered light.

Figure 8.7
A polarizing filter allows only the light waves that are vibrating in a single direction to pass through.

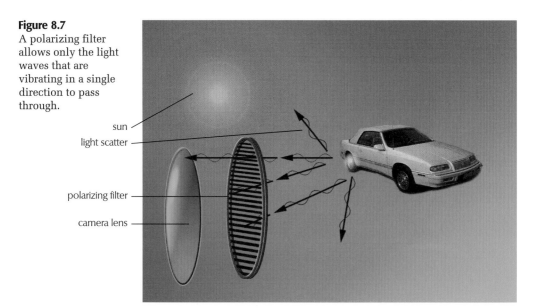

sun

light scatter

polarizing filter

camera lens

A polarizing filter consists of two rings; one is attached to the lens, while the outer ring rotates the polarizing glass. This lets you change the angle of the louvers and selectively filter out different light waves. With a single lens reflex (SLR) camera (which lets you view through the same lens that takes the picture), you can rotate the ring until the effect you want is visible. Blue sky and water, which can contain high amounts of scattered light, can be made darker and more vibrant. You can also reduce or eliminate reflections from windows and other nonmetallic surfaces. The most dramatic changes can be produced when the sun is low in the sky and located off to your left or right shoulder.

As you might expect, polarizers work best with SLR cameras that let you preview the effect. If you're using a non-SLR digital camera, you may want to use the LCD viewfinder instead of the optical finder when making your adjustments.

Simulating a polarizer in Photoshop is tricky, because there is no easy way to replace information that is obscured by glare. Figure 8.8 shows a photo (at top) that's marred by unwanted reflections off the car windows. In this case, I was able to select the area of the glass that had the most glare, and reduce the brightness and contrast to bring that area back to the same level as the rest of the window. In other cases, you may have to use the Clone Stamp or Healing Brush tools to copy parts of the image that are free of glare and paste them over parts that have reflections. Then, you can adjust the overall brightness and contrast of the image to resemble what the image would look like if you had been able to use a polarizer filter.

Figure 8.8
The unwanted reflections shown in the top image can be removed in Photoshop even without resorting to a polarizing filter.

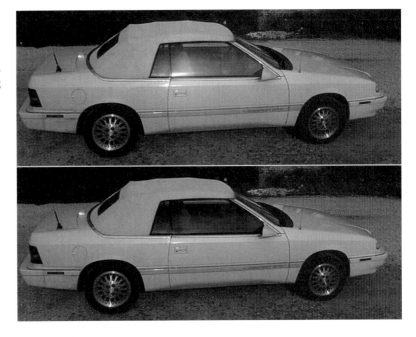

CHAPTER 8

Cross-Screen

Cross-screen filters are simple add-ons that let you make the specular highlights of an object sparkle, while providing a little bit of diffusion. My first cross-screen was a piece of tight-mesh window screen inside a set of empty Series 7 filter adapter rings. Later, filter manufacturers came out with glass versions of these with cross-hatch lines etched in the glass. Cross-screen filters work great with jewelry and other naturally sparkly items. Photoshop can easily duplicate this effect while giving you much greater control over the size and placement of your starbursts. Just follow these steps, using the **Watch** photo included on the CD-ROM, or your own picture.

1. First create a cross-shaped star to add to your image. You can simply draw a star shape on a transparent layer, or do as I did by following the next couple of steps.

2. Click the Brush tool in the Tool palette, or press B to activate it.

3. On the Options bar, click the fly-out menu and select Calligraphic Brushes from the drop-down list, as shown in Figure 8.9. A dialog box appears asking if you want to replace your current brushes or append these new brushes to your current set. Choose Append.

Figure 8.9
Add Calligraphic
Brushes to your
Brushes palette.

4. Select the 28-pixel calligraphic vertical stroke, and use it to draw one ray of the star on a transparent layer in black. Draw another vertical ray directly underneath it.

5. Use the Lasso selection tool to select the two rays and then choose Edit > Transform > Rotate 90 Degrees Clockwise. The rays are now horizontal.

6. Use the same brush to create another pair of vertical rays at right angles to the first two.

7. Choose Filter > Stylize > Emboss to give the star a 3-D texture, as shown in Figure 8.10.

8. Although you can use the star shape as is, you may want to rotate it 45 degrees (Edit > Transform > Rotate), and reduce it to a size more appropriate to the object to which you are adding cross-stars. (Use Edit > Transform > Resize.)

CREATE A STAR-SHAPED BRUSH

You can also create a brush shaped like the star you just created. Select the star with the Lasso tool, choose Edit > Define Brush, and give the new brush a name. Henceforth, anytime you want to add this star to an image, use the brush you just made.

9. Copy the star and apply it to several places on your image in a separate transparent layer.

10. Choose the Color Dodge mode for this transparent layer from the Layer palette, as shown in Figure 8.11.

Figure 8.10
The Emboss filter gives the star a 3-D texture.

Figure 8.11
Use Color Dodge to merge the star layer with the rest of the image.

11. Use Image > Adjustments > Brightness/Contrast to make the star as bright or as dark as you want for your particular image.

12. With the star layer still active, choose Filter > Blur More. This enhances the blurry star effect. Your finished image should look like Figure 8.12.

Figure 8.12
The finished image
with artificial "stars"
looks like this.

Split Filter

Split filters are nothing more than glass filters divided into two halves, each a different color. You see these used a lot in still photography to give the sky and ground an eerie look, and cinematographers use them extensively to create a moody atmosphere. Creating your own split filter in Photoshop is easy. Just follow these steps:

1. In a new, empty document create two transparent layers.

2. Choose the Gradient tool from the Tool palette.

3. Select Linear Gradient from the Options bar, and choose the Foreground to Transparent gradient from the drop-down list, as shown in Figure 8.13.

4. Select your two colors as the foreground and background colors, using your favorite method (the Eyedropper tool in the Swatches palette works for me).

5. Drag from the top to the bottom of one of the transparent layers, holding down the Shift key to make sure you drag in a straight line. This applies the foreground color as a gradient in that layer.

6. Press X to swap the foreground and background colors.

7. Drag from the bottom to the top in the other transparent layer to create the lower half of your split filter.

8. Choose Layer > Merge Visible to combine these two layers.

9. Save your split filter document so you can use it as you want.

Figure 8.13
Use two gradients to
create a split filter
effect in Photoshop.

10. To use the "filter," copy the filter layer and paste it onto the image with which you want to use it, resizing so the filter covers the entire image. Use the Darken or Multiply layer modes to merge the filter layer with the underlying image without completely obscuring it. Figure 8.14 shows one typical result.

Figure 8.14
The split filter effect
can add a moody look
like this.

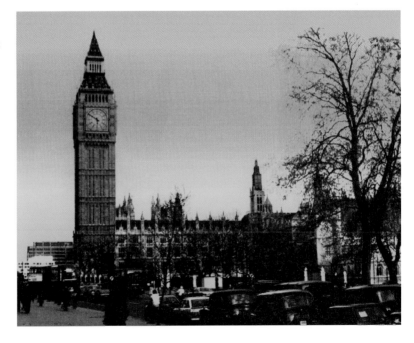

CHAPTER 8

Modifying Images with Photoshop's Filters

Photoshop's own filters offer a wealth of special effects you can apply to your photographs. They may not resemble the filter effects you can get with conventional glass or gelatin filters, but that's the whole point. Photoshop lets you go beyond the limits of both film and digital cameras to create entirely new looks. This section explores some of the things you can do with Photoshop's own filters.

The section does not cover every one of the 100 plus Photoshop filters. Many of the filters, such as the Sharpen, Blur, Grain, and Lens Flare filters, were covered in other chapters. Quite a few other filters, such as the Offset filter, do things that aren't particularly useful from a photographic standpoint, but which are consummately handy for other applications, such as creating seamless backgrounds for Web pages. Instead, in this section we look at the best of the rest. I won't stick rigidly to Photoshop's filter menu hierarchy, either. Filters that provide painterly effects are grouped together, while those that add textures or drawing effects are bundled among their own.

I've found that the easiest way to compare filter effects is to compare the same image as it is transmogrified by a variety of different filters, so the examples in this section use the same basic image (**Cathy10** on the CD-Rom), shown in Figure 8.15. I have to warn you that not all filters look good with human subjects.

Figure 8.15
This picture is our starting point for the filters that follow.

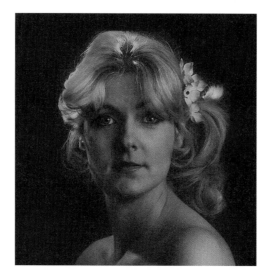

Painting Filters

If you want to create pictures that look like they were painted, Photoshop offers some great filters. You can get brush strokes without ever touching a brush. You find these filters in Photoshop's Artistic, Brush Strokes, and Sketch submenus in particular. Digital

effects applied with these filters can produce results in seconds that can't easily be achieved by an artist equipped with brush, paints, and traditional tools. It's also fairly easy to generate effects that are strongly reminiscent of the styles of real artists, using a group of filters found in the Pixelate and Stylize menus of Photoshop.

These kinds of filters all have one thing in common: They reduce the amount of information in an image by combining or moving pixels. Some overlay an image with a texture or pattern, while other plug-ins group similar colors together or transform groups of hues into new tones. The result is an image that has been softened, broken up, selectively increased in contrast, or otherwise "pixelated."

At first glance, these filters seem to have turned a photograph into a painting. Instead of the harsh reality of the original image, we have a softer, more organic picture that appears to have been created, rather than captured. The process resembles the way in which video and film cameras convert moving images.

Just as the crystal clarity of video productions adds realism to documentaries and intimacy to videotaped stage plays or situation comedies, original photographs look real to us. For romantic stories and fantasy images, motion picture film provides a softer look with a feeling of distance, much like what digital processing does for still images. Would Star Wars or Forrest Gump have been as effective if originated on video? Do your hyper-realistic original photos qualify as portraits?

Of course, both kinds of images have their place. Painting-oriented filters are excellent for portraits, figure studies, or landscapes in which fine detail is not as important as general form, colors, or groups of shapes. Indeed, brush strokes or other textures can mask defects, disguise or diminish distracting portions of an image, and create artful images from so-so photographs. That's especially true when the original image was too sharp, or, paradoxically, not sharp enough. Filters can tone down excessive detail while masking the lack of it.

You want to select your subjects for painting filters carefully. Pictures of older men and women may not look right when you blur all those hard-won wrinkles and character lines. Teenagers of both sexes, on the other hand, may prize the improvement to their complexions. Judicious application of a painting filter can add some softness to a glamour portrait, too.

Keep in mind that painting filters mimic, but do not duplicate, the efforts of an artist. In real paintings, each brush stroke is carefully applied with exactly the right size, shape, and direction needed to provide a particular bit of detail. Years of experience and a good dose of artistic vision tell the artist where and how to lay down those strokes.

A filter, in contrast, can base its operation only on algorithms built into it by the programmer. A skilled software designer can take advantage of variables such as lightness, darkness, contrast, and so forth to produce the illusion that an organic human, and not a

CHAPTER 8

silicon simulacrum, is behind the effect. You can further enhance the image by using your own judgment in applying parameters and choosing which sections of the picture are to be processed by a filter. However, you won't exactly duplicate the efforts of an artist with one of these plug-ins.

Craquelure

Professional photographers pay big bucks to have their photo labs give portraits an old masters look by cracking the surface as if it were a painting that had started to age. Paints used in ancient times weren't stable, as they were composed of egg whites, clay, and plants used as pigment. So, old paintings tend to crack. Professional photographers sometimes have this texture applied to their photographs to give them an old masters patina. You can achieve a similar effect, which adds a nice 3-D look, using the Craquelure filter.

Your controls can specify the crack spacing, depth, and brightness. You can adjust the spacing to produce a mixture of cracks and image area, and modify the depth and brightness settings to create deeper or shallower cracks.

Dark Strokes

The Dark Strokes filter reduces the number of tones in the image through a posterization-like effect that combines similar tones in an unusual way. Instead of grouping similar colors together, Dark Strokes makes dark tones darker and light tones lighter, increasing contrast, while rendering the image with diagonal brush strokes. Short strokes are used for dark tones and longer strokes for light tones. Figure 8.16 shows the Craquelure and Dark Strokes filters applied to the portrait image.

Dry Brush

Dry Brush filter mimics a commonly used technique of painters, that of stroking a canvas with a brush that's almost devoid of paint. It doesn't obscure as much detail as other painting-style filters, but retains a distinct painting look. As it posterizes your image, Dry Brush produces more distinct banding than Dry Strokes, combining all similar colors in a particular area. Adjust the size of the brush to produce different effects.

Figure 8.16
Craquelure (left) and
Dark Strokes (right).

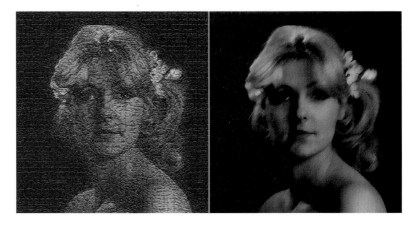

Paint Daubs

This brush strokes filter includes a selection of brush types and sizes, plus sharpness controls. You can select from simple, light rough, dark rough, wide sharp, wide blurry, or sparkle brush types. Figure 8.17 shows the Dry Brush and Paint Daubs filters in action.

Figure 8.17
Dry Brush (left) and
Paint Daubs (right).

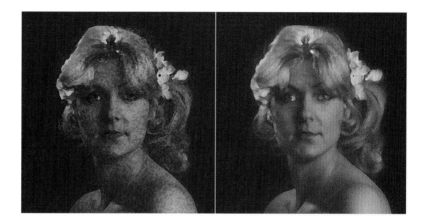

Fresco

Traditional fresco is a technique in which water colors are applied to wet plaster and allowed to dry, forming a permanent image on the wall or other structure containing the plaster. If you're an artist-type, and can work fast, fresco is a great way to produce murals using short, jabbing strokes. If you're a photographer, you want to use the Fresco filter to create a smeary effect. This filter is otherwise quite similar to Dry Brush.

Poster Edges

This filter transforms your image into a poster by converting full-color or grayscale images into reduced color versions by combining similar colors into bands of a single hue, like the Photoshop Posterize command. However, Poster Edges outlines all the prominent edges with black, giving the photo a hand-drawn look.

Of course, the original nonelectronic poster effect was created to allow the simulation of continuous tone images without actually using detailed halftones. The broad bands of color could each be printed on a separate run through a sheet-fed press at a relatively low cost. Posters were often created in this way for circuses, plays, and, later, motion pictures. Even when halftoning was a common and inexpensive process, poster printing techniques were an economical way to produce very large posters on thick stocks.

Poster Edges gives you three controls, allowing you to adjust the relative thickness of the black lines used to outline the edges, and specify their darkness or intensity. A third slider lets you specify the number of tones used to produce the effect. Figure 8.18 shows the Fresco and Poster Edges filter effects.

Figure 8.18
Fresco (left) and Poster
Edges (right).

Spatter

The Spatter filter creates an airbrush-like painterly effect. You can use it to soften portrait or landscape subjects. Its controls include a Spray Radius slider, which adjusts the number of pixels covered by the spray of the airbrush, and a Smoothness control, which modifies the evenness of the effect.

Watercolor

Watercolors produce great pastel effects because their water-soluble pigments are not as opaque as oils or acrylics, and they tend to soak into the paper, producing a soft, diffused effect. It's a good plug-in for landscapes, female portrait subjects, or any image which can be improved with a soft look. While you can select the amount of brush detail, Watercolor doesn't work well with detailed strokes. Figure 8.19 shows the Spatter and Watercolor filters at work.

Figure 8.19
Spatter (left) and
Watercolor (right).

Angled Strokes

Angled Strokes paints your image using diagonal strokes in one direction for the dark tones, and diagonal strokes going in the other direction to represent the light tones in an image.

With high resolution files, the effects may not be as noticeable unless you either reduce the size of the image from 25 to 50 percent of its original size before applying the filter (scale it back up when you're finished), or use a high sharpness setting. This filter can be applied to primary subjects, but also makes a good tool for creating artsy background textures.

Palette Knife

This filter applies irregular gobs of color to your image. The Stroke Size slider adjusts the size of the digital knife you're using. The Stroke Detail control can be used to specify how much of the detail in your original image is retained. The Softness control increases or decreases the roughness of the edges of the palette strokes.

While you can use this filter alone, it works well with other plug-ins, possibly as a first step to reduce the amount of detail before you apply a second filter, such as Watercolor or Grain. Textures, particularly canvas, can add to the painterly effect of this filter. Figure 8.20 shows the Angled Strokes and Palette Knife filters.

Pointillize

This filter provides a randomized image with lots of little dots on it, produced by cell sizes that range from three to 300 pixels. The tricky part about using this filter is choosing your background color, as all the spaces between the dots are filled in with your current background color. Instead of using white, try soft pastels that won't overpower the tones of your image. Figure 8.21 shows the kind of effects you can get with the Pointillize filter.

Figure 8.20
Angled Strokes (left)
and Palette Knife
(right).

CHAPTER 8

Sketching/Drawing Filters

You can also apply drawing-like effects, such as pen and ink, using Photoshop's filters. Here are the best of them:

Graphic Pen

The Graphic Pen filter applies monochrome strokes that can be applied diagonally, horizontally, or vertically, using the foreground color while filling in the rest of the image with the background color. If you keep that in mind, you can create both positive (black on white) and negative (white on black) images. Controls include a Stroke Length slider that manages how much detail is preserved, and a Light/Dark Balance slider to select the areas of the image to which the strokes are applied. Lighter settings sketch in the highlights, while darker settings use the shadow areas for the strokes. Your choice of stroke direction should be determined by your subject matter: Horizontal strokes are great for vertically oriented subjects, such as buildings, while vertical strokes are best used on landscapes and other subjects with horizontal lines. Figure 8.21 shows the Graphic Pen filter's effects.

Figure 8.21
Pointillize (left) and
Graphic Pen (right).

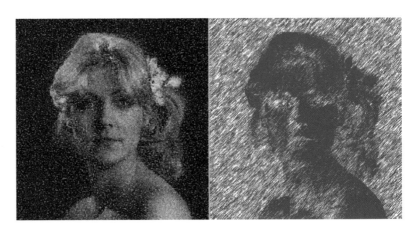

Ink Outlines

Ink Outlines produces an image with the outlines and edges enhanced, but retains the original colors of the image. It creates an almost cartoon-like appearance.

Sponge

Sponge creates textured images with contrasting blobs of color. You can adjust brush size, definition, and smoothness, using the filter's slider controls. Figure 8.22 illustrates the Ink Outlines and Sponge filters.

Sumi-e

Sumi-e is a Japanese technique that involves using a wet brush loaded with ink to draw on highly absorbent rice paper, much like painting on a blotter. It works best with abstracts or landscapes, as it blurs portrait subjects a bit too much. The only controls are stroke width, stroke pressure, and contrast.

Figure 8.22
Ink Outlines (left) and
Sponge (right).

Edgy Filters

Some filters do their work by finding the edges in your image, then enhancing them in
some way. These filters all produce somewhat abstract effects, but if you check out some
photography magazines, you see that such filters are quite popular with traditional and
digital photographers.

Find Edges

The Find Edges filter produces some dramatic effects, similar to drawings created with
colored pencils. There are no controls or dialog boxes. This filter is a great springboard
for combining several filters or using other controls to generate outrageous variations.
Use the slider controls in the Image > Adjustments > Hue/Saturation dialog box to warp
the colors in your edge-enhanced image, to juice up the saturation, or to lighten or
darken the effect. Pixelate your image, or merge it with a copy of the original image,
adjusting the Opacity slider in the Layers palette to combine varying percentages of the
unaltered and edge-enhanced versions. Figure 8.23 shows the Sumi-e and Find Edges
filters applied to our portrait.

Figure 8.23
Sumi-e (left) and Find
Edges (right).

CHAPTER 8

Glowing Edges

Glowing Edges adds incredible colors to the edges of your image. None of the images it produces will look realistic—but I guarantee they'll all be interesting! The controls are the same as with Accented Edges, but this filter does not reverse the tones of your image. The Edge Width control adjusts the relative width of the edges, Edge Brightness controls whether the edges are stroked in a dark or light tone, and Smoothness determines how closely the edges follow the actual edges in the image.

Accented Edges

The Accented Edges filter works a little like Find Edges, but with additional control over the width, smoothness, and brightness of the edges in the image. Edge Width adjusts the relative width of the edges, Edge Brightness controls whether the edges are stroked in a dark or light tone, and Smoothness determines how closely the edges follow the actual edges in the image. Higher settings produce more gradual transitions from one angle to the next. Figure 8.24 shows the Glowing Edges and Accented Edges performing their edgy magic.

Figure 8.24
Glowing Edges (left) and Accented Edges (right).

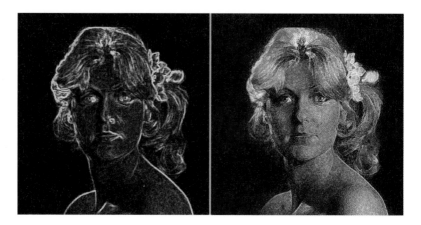

Trace Contours

The Trace Contours filter is similar in concept to the Find Edges filter, but it produces very different looks. You can adjust the brightness level that Trace Contours uses as the threshold to outline edges in your image. Trace Contours creates different outlines for each color channel. Experiment with this filter. This is another filter that can be used as a jumping-off point. Try different level settings, merge a contoured image with the original, or invert your contour to create new effects.

Emboss

Emboss finds the edges in your image and raises them, discarding most of the colors in your image in the process, and producing a stamped-metal effect. You can specify the angle for the imaginary light source that casts the shadow of the raised surface. Values from 0 degrees (right side of the image) to 90 degrees (directly overhead) and on to 180 degrees (left side of the image) produce a raised effect. Values from − 1 (right) to − 90 degrees

(directly underneath) to −179 degrees (left) make the image seem to be pressed into the surface.

You can also specify the height of the embossing, from one to 10 pixels. The larger the number, the greater the 3-D effect. Use this control with the Amount slider, described below. You can get some lovely, grainy effects even with only a one-pixel-high emboss if you ramp up the contrast by specifying 500 percent with the Amount slider. Also try adjusting the amount of embossing from 1 to 500 percent. I've obtained some great results from using a very small height with a large Amount setting—and vice versa.

On its own, Emboss often isn't particularly useful with some images, since the 3-D effect, while interesting, has bland coloration and featureless backgrounds. You'll want to combine this filter with other effects—pixelation, distortion, or even sharpening—to create a really outrageous image. Figure 8.25 shows the Trace Contours and Emboss filters applied.

Figure 8.25
Trace Contours (left)
and Emboss (right).

Distortion Filters

Distortion filters are all "pixel movers." They operate by shifting pixels from one location to another. Because distortion filters cause such dramatic changes, you want to carefully select the images with which you use them. Here are descriptions of some of the more useful filters that distort:

Pinch

The Pinch filter squeezes the contents of an image towards the center, or pushes it out toward its outer edges. The only control available is the Amount slider, which can be varied from 0 to 100 percent (to pinch inward) or from 0 to −100 percent (to push outward).

Figure 8.26 shows an entire image that has been pinched by 50 percent. However, if you're pinching a rectangular-shaped selection, the filter automatically blends the affected area into the surrounding image. That's because Photoshop applies the filter to the largest ellipse that fits inside the square or rectangle. The effect is feathered into the rest of the selection, providing a smooth transition.

Ripple

The Ripple filter gives you a wavy effect, supposedly something like the ripples on a pond, except when we think of those we usually expect them to be concentric. If that's what you want, investigate the Zigzag filter instead. Personally, I think Adobe has the names of these two filters reversed.

The Ripple dialog box allows you to specify an Amount from 0 (little ripples) to 999 (big ripples) or 0 to −999 (the ripples go the other direction). You can also choose Small, Medium, and Large from a drop-down list, which controls not the size of the ripples (as you might expect), but how closely spaced together they are. Go figure. This ripple frequency is calculated in proportion to the selection: Choosing Small produces differently sized ripples in small selections than in large selections.

This is one filter that produces a stark transition with the rest of your image unless you remember to feather the selection before you apply the effect. You can also produce some wonderful textures by applying the Ripple filter to the same selection multiple times, alternating negative and positive values, or mixing Small, Medium, or Large frequencies. Figure 8.26 shows the Pinch and Ripple filters.

Figure 8.26
Pinch (left) and
Ripple (right).

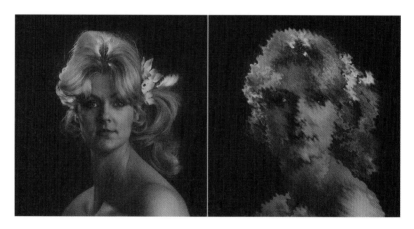

Spherize

This filter wraps your image or selection onto a sphere. The dialog box shows a wire frame representation. You can specify outward and inward bulges from 0 to plus or minus 100 percent. The effect is quite similar to that of the Pinch filter. However, the Sphere filter also lets you distort your image around a vertical or horizontal cylinder by choosing Horizontal Only or Vertical Only from a drop-down list. If your selection area is not round, Spherize carves out a circular area in the middle of the selection and distorts that.

Spherize is great for creating spheres from scratch. If you want a plain sphere, try this trick: Select a circle and fill it with a radial gradient. Position the center of the gradient up and to one side of the circle. Use Filter > Render > Lens Flare to make the surface even more realistic. Then apply the Spherize filter. Presto! One ball-shaped object, ready to roll.

Twirl

The Twirl filter swirls your image around like so much wet paint. The center pixels move more drastically than those on the periphery. The only control available is the slider that specifies degrees of twisting from − 999 to +999 degrees (more than two full rotations), so you can create a whirlpool-like effect. Positive numbers give you a clockwise spin effect; negative numbers reverse the spin to counterclockwise. Figure 8.27 shows the Spherize and Twirl filters.

Figure 8.27
Spherize (left) and
Twirl (right).

Wave

The Wave filter offers more than a dozen controls you can use to specify how your image is roiled up. There are three kinds of waves, and you can choose the number, size, and frequency of the ripples. The key controls include:

- ▶ **Number of Generators:** the number of points where waves are created. Can have as many as 999, but that's far too many for most images—the effect is so muddled that each wave may be only a pixel or two wide. In my tests, high numbers ended up producing areas with plain tone, and no waves at all! You want to use from five to 20, tops.

- ▶ **Wavelength Minimum/Maximum:** sets the distance from one wave crest to the next. In this case, wavelength minimum and maximum (from 1 to 999) refer to the number of individual waves produced by each generator.

- ▶ **Amplitude Minimum/Maximum:** controls the height of the waves, from 1 to 999.

- ▶ **Horizontal/Vertical Scale:** adjusts the amount of distortion provided by each wave, from 1 to 100 percent.

- ▶ **How Undefined Areas Are Filled In:** controls whether pixels wrap around from one side to another, or stretch from the edge to fill the empty spaces.

> ▶ **Type of Wave:** includes smooth sine waves, sharp triangle waves, or blocky square waves.
>
> ▶ **Randomize:** applies random values to your waves parameters.

ZigZag

The ZigZag filter is excellent for producing ripples in an image. You don't actually get zigzags at all with most settings. Choose the amount of distortion (from -100 to +100) and the number of ridges (from 1 to 20). You may also select pond ripples, ripples that emanate from the center of your selection, or whirlpool-like ripples that revolve around the center of the selection in alternating directions. The ZigZag filter is a good choice for creating any type of water or liquid effects, as well as special textures. Figure 8.28 shows the Wave and ZigZag filters at work.

Figure 8.28
Wave (left) and
ZigZag (right).

Pixelation and Stylizing Filters

These filters range from the mildly interesting to the wildly useful, and all of them provide distinct effects. You may have no parameters to enter, or just a few simple controls. Here's a quick rundown of the best of them.

Color Halftone

Don't confuse the Color Halftone filter with actual halftoning. Instead, it simply looks at the color layers of your image and changes them into a pattern of dots. As with real halftones, the highlight areas are represented by small dots, and shadow areas are represented by larger dots. The filter is a good way to add an interesting texture to your image.

Halftone Pattern

This is a versatile effect, changing your image into a black-and-white halftone screen, replacing all the original colors with shades of gray—or another set of colors, since Halftone Screen uses your application's current foreground and background colors. Only three controls are required. A Size slider controls the size of the fake halftone dots used. You can also

select the type of screen, from dot, line, and circle, and adjust the contrast of your image as the filter is applied. Figure 8.29 shows the Color Halftone and Halftone Screen filters.

Figure 8.29
Color Halftone (left) and Halftone Screen (right).

Crystallize

Crystallize converts an image to a series of random polygons, using a cell size you specify using a slider. As with the Color Halftone filter, the smaller the cell size, the more detail is retained from your original image. Larger cells simplify your picture and mask defects.

Facet

Facet converts blocks of pixels of similar colors to a single tone, producing a faceted, posterized effect. This filter masks details, so it makes a good cover-up for subjects with defects in complexion or texture. This is one of those single-step filters that has no dialog box. Just apply it once or several times until you get the effect you want. Figure 8.30 shows the Crystallize and Facet filters at work.

Figure 8.30
Crystallize (left) and Facet (right).

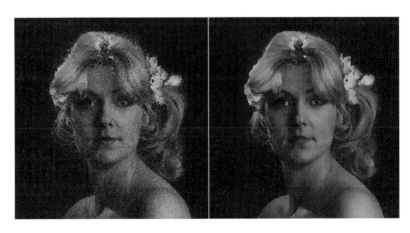

Diffuse

If you know a bit about photography, don't confuse this digital diffuser with the kind you're used to. If you're a true photo nut, you know that diffusion can be produced by a conventional filter with a texture—something as simple as women's hosiery stretched over a frame is sometimes used in the darkroom to provide a diffusing effect when a print is exposed. A glass filter placed in front of the camera lens with petroleum jelly applied can also be used to create diffusion.

The Diffuse filter carves up your picture into four-pixel elements then moves pixels towards the higher-contrast areas of your image, producing a smudgy effect. In photography, diffusing a positive image "spreads" lighter areas into darker areas, so an on-camera filter smudges highlights into the shadows. Diffusing a negative image during printing also spreads lighter areas into the darker areas, but in that case, those are the more transparent shadows of an image, smudged into the denser highlights. The final image diffused under the enlarger has a much different look than one diffused in the camera.

Photoshop's diffusion does not work in this way, so don't bother inverting a picture or selection before applying the diffusion filter, and then converting it back. Even with multiple applications, the effect is virtually identical, whether you diffuse a positive or negative image. Your only controls are options to perform this diffusion on all pixels, only darker pixels, or lighter pixels, and a new option, anisotropic (which is a type of surface in which long, thin features are aligned in one direction, such as brushed metal objects. You have to try this one out to see the interesting texture it produces).

Wind

Wind can create dozens of windy and streak effects. Although it works in a left to right or right to left direction, you can achieve vertical "wind" by rotating your image before applying the filter, then rotating it back to its original orientation. You get the best results if you work with images that have empty areas the wind can streak into. You can apply the filter several times from different directions to get some unique looks. It also works well with sports images. Wind looks especially good on silhouetted images. Figure 8.31 shows the Diffuse and Wind filters.

Figure 8.31
Diffuse (left) and
Wind (right).

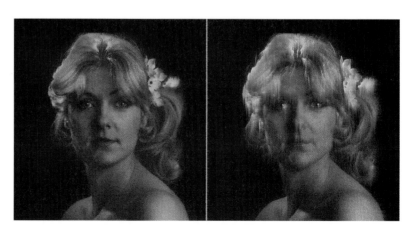

Chalk & Charcoal

This filter gives you the effects of a mixed-media drawing using rough chalk to express the midtones and highlights, and charcoal for the shadows. The diagonal lines that are used obliterate image detail, so this filter works best with photos that have strong areas. Choose background and foreground colors carefully to achieve different types of chalk and charcoal effects.

Crosshatch

Crosshatch adds a cross pattern of pencil-like strokes to your image, adding texture without destroying all the original colors and details. Crosshatch produces a good arty effect with an unusual degree of control. Not only can you specify the stroke length and sharpness, but also the number of times in succession the filter is applied. The more repetitions, the stronger the effect. Figure 8.32 shows the Chalk & Charcoal and Crosshatch filters.

Figure 8.32
Chalk & Charcoal (left)
and Crosshatch (right).

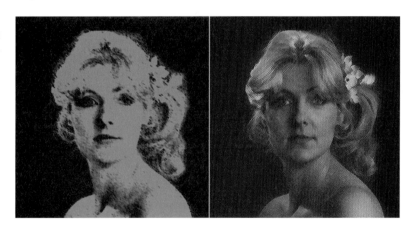

Glass

The Glass filter provides effects you might get if you placed a glass block in front of your lens. You can specify the amount of distortion and the smoothness of the glass. A separate Surface Controls dialog box allows you to choose from glass blocks, frosted glass, tiny glass lenses, and even canvas. For images with individual features, you can select a scaling to control the relative size of the image and the underlying texture, or invert the texture. Figure 8.33 shows two variations of the Glass filter.

Figure 8.33
Glass filter variations.

Next Up

In the next chapter, we're going to look at filters, filters, and even more filters, using Andromeda's line of photography-oriented plug-ins as the basis for our exploration.

9

Working with Andromeda Filters

Lots of companies market third-party filters that work with Photoshop. However, Andromeda is the only company with an extensive line of filters designed specifically for photographers. Their offerings include a nifty perspective control plug-in that makes it easy to manipulate the apparent depth of your images. There's a "lens doctor" filter to fix the pincushion or barrel distortion effects that plague some lenses. Andromeda lets you mimic various depth-of-field effects with its variable focus filter, or create multiple images that resemble those you get with high-priced glass filter sets.

Because Andromeda filters go so far beyond being run-of-the-mill filters, I'm going to devote an entire chapter to their use. You can find demo versions of some of these filters on the CD-ROM that accompanies this book, so you can try them out yourself. The bundled filters include versions of cMulti, VariFocus, LensDoc, and Perspective for the Macintosh and Windows operating systems. You can look for more demos and information at www.andromeda.com. In a world where too many third-party filters do nothing more than imitate yet another kind of artistic brush stroke, Andromeda's unique products are a breath of fresh air.

Series 1 and Beyond

Andromeda has bundled eleven useful photography-oriented plug-ins in its Series 1 Photography Filters set. This versatile bag of tricks includes the cMulti and sMulti filters, which generate circular or straight multiple lens and kaleidoscopic effects. The Designs filter includes dozens of textures and patterns that can be rotated, colored, bent, and warped, providing an almost 3-D effect. The Mezzo Line-Screen filter uses patterned screens to convert your photographs to mezzotint line art in more flexible ways than is possible with Photoshop's built-in mezzotint filter.

You may also like the Diffract, Prism, and Rainbow filters, which have versatile geometric controls to create spectral effects far easier than any gradient tool. The Halo filter provides

controlled highlight diffusion, allowing you to adjust the direction, amount of spread, and intensity of the diffusion.

Andromeda's Reflection filter easily outdoes anything Photoshop's ZigZag and Ripple filters can do on their own, producing realistic clear pool reflections you can fade into your images with great precision and then roil up using Photoshop's own filters if you like. There's also a Star filter for adding cross-screen effects, glints, sparkles, and other looks to your images. The Velocity filter includes a variety of motion effects. This section includes a discussion of the Series 1 filters and a few others that work well with them.

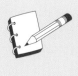

OTHER ANDROMEDA FILTERS

Andromeda has other filter sets not discussed in this chapter that are slightly less photography-oriented, but still valuable for adding special effects to your images. You may want to check them out, too. These include the Series 2 3-D filter, the Series 3 Screens filter, the Series 4 Techtures filter, and Andromeda's versatile Shadow filter. The latest addition to the lineup, introduced after this book was written, is the incredible Scatterlight Lenses filter, which provides an amazing repertoire of glamour and blur effects.

cMulti

The Circular Multiple Images filter takes an area you select and generates multiple images in your choice of several circular kaleidoscopic patterns, using the dialog box shown in Figure 9.1.

Figure 9.1
The cMulti dialog box lets you specify various kaleidoscopic effects.

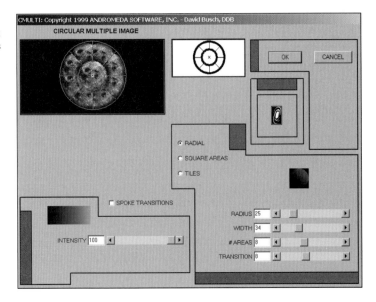

You will notice several controls and windows in the dialog box. Like all Andromeda dialogs, this one is on the Spartan side in terms of user interface. There are no shaded 3-D buttons, floating controls, or fancy pop-up or drop-down lists. Instead, all you see are the sliders and buttons you need to select your options and a preview window in the upper-left corner to show you what your final image looks like. Your main options are:

▶ Buttons to choose Radial, Square, or Tiles for the portion of the image that is multiplied. You can see how these effects differ in Figures 9.2, 9.3, and 9.4.

▶ Sliders to adjust the size of the radius, the width, number of multiplied areas, and the transitions between them. The Transition slider feathers each of the edges of the squares when you're using the Square or Tiles options, or the edges of the circles if you're using the Radius option.

▶ A checkbox and slider to let you feather the transitions of the spokes between the multiplied areas.

▶ A wireframe in the preview window that you can drag to adjust the position of the area being multiplied.

▶ When you apply the Tiles option, buttons appear that let you choose from several different tiling patterns.

Figure 9.2
Here's a radially oriented multiple image.

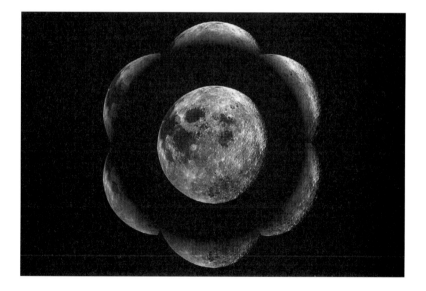

Figure 9.3
Square areas can also
be used to produce
kaleidoscope effects.

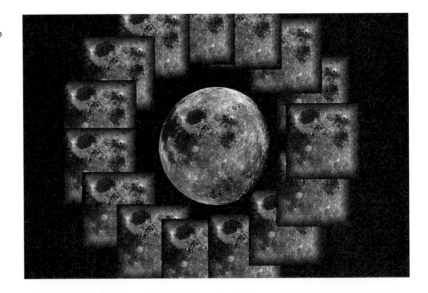

Figure 9.4
Tiling generates an
even different look.

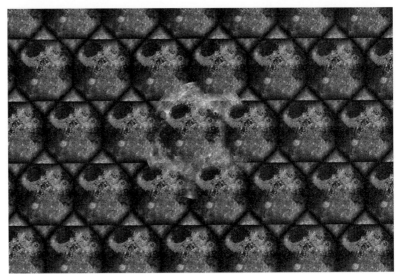

Designs

Andromeda's Designs filter is a great way to create textures for your images, especially since you can stretch, bend, and warm the textures to produce 3-D effects. You can use this filter's designs as backgrounds, fill for text, or as a texture overlaid on an original image. This filter's dialog box is shown in Figure 9.5.

Figure 9.5
The Designs
dialog box.

There are several easy-to-use controls for this filter. The most important options are the Category and Pattern buttons in the lower-right side of the dialog box. These let you browse among thirteen different categories, including Stars, Symbols, Linoleum, and Textures, and around 100 different patterns. Click the Category button to change categories, and the Pattern button to preview, in the window at top center of the dialog, each of the individual bitmaps you can apply.

The sliders arrayed along the bottom of the dialog box let you change the geometry of the area in which the texture is applied, including size, angle, and amount of twisting applied along the X and Y axes. It's easy to get some interesting 3-D effects. You can also control the color of the pattern. Figure 9.6 shows a 3-D background I created with the Designs filter. I also applied one of the mezzotint textures to the camera image itself.

Figure 9.6
This 3-D background
was created with the
Designs filter.

Diffract

A diffraction grating is actually a scientific tool that resolves a beam of light into its rainbow of component colors. Photographers have used diffraction grating filters, which consist of thousands of narrow, closely-spaced slits or grooves, to create special effects for photographs. Andromeda's Diffract filter gives you complete control over how the rainbow effect appears, as shown in the dialog box in Figure 9.7.

The two sliders at lower left let you control the thickness of each rainbow colored spoke, as well as the intensity (actually opacity) of the rainbows. Although the illustration above shows four distinct spokes, you can dial in from one to fifty spokes (which produces a continuous, circular rainbow), adjust the radius (the distance from the centerpoint to the position where the spokes start), and the length of each spoke. You can also rotate the spokes through any angle, and move the centerpoint to any position on the image. Figure 9.8 shows a typical image you can create with the Diffract filter. (The spotlights behind the two rock stars were already there, and weren't created by the filter.)

Figure 9.7
This is the Diffract
dialog box.

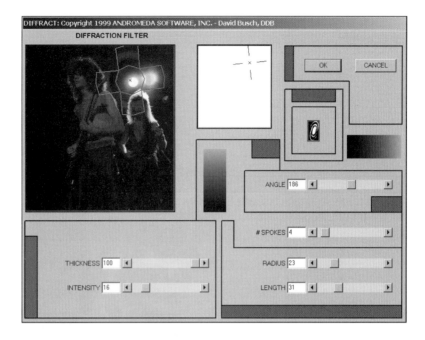

Figure 9.8
A diffraction grating
effect adds to the
glam look of this rock
star photo.

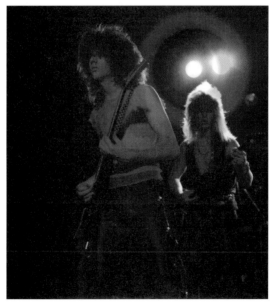

Halo

To use the Halo filter properly, you need to understand how it works. This filter acts as a
diffuser, spreading light from the bright portions of an image out into the darker portions

that surround the highlights. It does not diffuse the shadow areas into the highlights. As a result, it works best with high-contrast photos like our rock concert picture with plenty of light areas surrounded by darker areas. As the filter diffuses the highlights into the shadows, it creates a halo effect, like the one shown in Figure 9.9. To get the "flaming hair" effect, I applied the Halo filter set to diffuse only in one direction, towards the upper left of the photo. After the filter did its stuff, I increased the brightness and contrast a bit to get the stark effect in the illustration.

Figure 9.9
Flaming hair is only one effect you can get with the Halo filter.

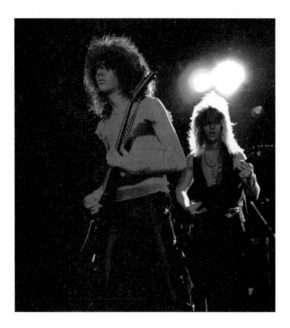

Once you understand how Halo operates, the controls, shown in Figure 9.10, make more sense. As with many Andromeda filters, you set the dimensions of the rectangular area the effect is applied to using the Box Breadth (height) and Box Length (width) sliders in the lower-left corner of the dialog box. The values shown for each of the sliders don't seem to have any precise relationship to the image itself, either in pixels or percentages, although a setting of 100 does produce a selection box that measures the full width or height of the frame. Drag the selection box around in the preview window to set the centerpoint for the effect more precisely. Then, use the Intensity slider to adjust the opacity of the effect.

Next, choose whether you want the diffusion to be applied in one main direction, or in all directions at once. If you prefer the latter, check the All Directions box. If you want the diffusion to operate in a particular direction, uncheck the box and adjust the Angle slider to specify that direction. The Diffusion slider increases and decreases the angle through which the diffusion spreads. It's easiest to think of this control as analogous to the field of view of a lens. When Diffusion is set to its minimum value of 5, the diffusion

is spread over a relatively narrow angle, like the field of view of a telephoto lens. Set to larger values, the diffusion is spread over a wider angle, like the field of view of a wide-angle lens. At the maximum value of 100 (which, again, doesn't relate to anything such as an actual angle), the diffusion covers a little more than 180 degrees. Experiment with these settings to see the different halo effects you can achieve.

The other three controls include Spread (the size of the halo, from 1 to 8 pixels), Cutoff (the brightness values that are affected by the diffusion, from 0—all tones—to 100—no tones), and Angle, which rotates the direction of diffusion from 0 degrees (right to left) through 360 degrees, moving in a counterclockwise direction. (That is, 90 is vertical towards the top of the frame, 180 is left to right, and 270 is vertical towards the bottom of the frame.)

With a little practice, you can use the Halo filter to produce watercolor effects and other looks that may surprise you. This is a simple little filter with a great deal of potential.

Figure 9.10
The Halo filter dialog box looks like this.

Prism

Prisms bring out the spectral components of light by redirecting each of the primary colors in a slightly different direction. Andromeda's Prism filter lets you use this effect as a creative tool, giving you control over how much the colors spread as they are dispersed and the distance between them. You can use it to add visual elements to an image, as I've done in Figure 9.11, or you can create a more abstract, 3-D look, like that in Figure 9.12.

CHAPTER 9

Figure 9.11
The Prism filter can add visual elements to an image.

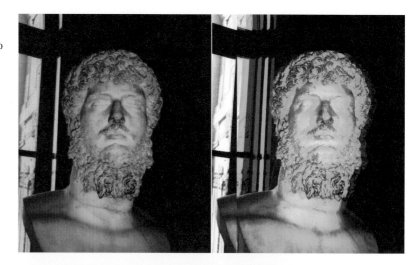

Figure 9.12
The Prism filter can also create a more abstract, arty look.

There aren't a lot of controls to master, as you can see in the dialog box shown in Figure 9.13. You can set the selection box's width and height with the sliders at lower right, and adjust the direction from which the prism effect is applied using the Angle slider. The Spread slider at lower left controls the distance between each of the red, green, and blue

color images, while the Intensity slider adjusts the opacity of the effect. Use a small amount of spread, and your image appears as if it were taken with a really, really bad lens, or as if you used a glass bottle as a filter. Larger spread settings produce distinct and separate red, green, and blue images. The actual colors produced vary, depending on the colors of the image being separated by the prism (white produces red, green, and blue, but other colors provide different combinations of hues). This filter works best on RGB images. I've gotten strange and unpredictable results using it with CMYK images.

Figure 9.13
The Prism filter's dialog box and controls.

Reflection

Andromeda's Reflection filter automates something you could easily do in Photoshop if you had a lot of time on your hands. This plug-in takes part of an image and flips it, mirror-like, making it appear that the secondary image is reflected in a pool of still water. You can do that quickly enough in Photoshop, but the Reflection filter lets you dial in the amount of feathering between the original and reflected image, set opacity, and determine how much of a gap is between them. These controls are all readily available in the dialog box shown in Figure 9.14.

Figure 9.14
The Reflection filter creates reflections like those found in a pool of water.

The controls are virtually self-explanatory. The selection box setting tools are sliders located at bottom right in the dialog box, just above a Gap control that adjusts (what else?) the gap between the reflection and original image. At left are sliders to control the width of the transitional (feathered) area, and the Intensity slider adjusts the opacity of the effect.

I used this filter to rescue a photograph shown at the top of Figure 9.15. I was impressed by the deep green color of the water in the gorge, and liked the contrast with the craggy cliffs. However, I was disappointed in the resulting photograph, which just sort of lies there looking lifeless. Andromeda's Reflection filter perked it up by casting an image of the cliffs onto the water, shown in the center version. As a finishing touch, I applied Photoshop's ZigZag filter, using the Pond Ripples option to create some concentric circles, as you can see at bottom. Oddly enough, if you compare the top and bottom images, the processed image looks realistic, while the unmodified top image looks a little fake, as if someone had painted the stagnant water into the gorge.

sMulti

Andromeda's sMulti (Straight Multiple Image) filter is great for creating abstract images that can be used as textures, backgrounds for Web pages, or as a foundation for impressionistic art in its own right. It offers three different kinds of straight-line multiple images.

Choose Parallel Lines and the filter transforms a single band (horizontal, vertical, or diagonal) and replicates it multiple times parallel to the original image slice. The Square Areas choice reproduces square selections. Parallel Combined is an ingenious variation that first reproduces the original slice, then uses the combined two slices to create the third, the first three merged to create the fourth, and so forth with increasing complexity.

Figure 9.15
The original image (top) was bland, and adding a reflection (center) made it more interesting—the final version (bottom) has some ripples added.

I used this filter on the image shown in Figure 9.16. It was originally intended as a semi-abstract photo I took to test out my digital camera's close-up capabilities. The sMulti filter made it appear even more abstract, as you can see in Figure 9.17.

Figure 9.16
This leaf has an
abstract quality even
before processing.

Figure 9.17
The sMulti filter makes
the leaf look even more
abstract.

The dialog box controls are shown in Figure 9.18. After you've selected the mode you want from Parallel Lines, Square Areas, and Parallel Combined, choose the spacing between replicated areas, the intensity (opacity) of the effect, and the number of areas to be produced. You can rotate the slice using the Angle slider, and clicking in the Fade checkbox will create a smooth transition between them. Figure 9.17 shows how the effect looks with the Fade checkbox marked. Figure 9.19 shows how it looks with the fading turned off.

Figure 9.18
The sMulti filter's dialog box.

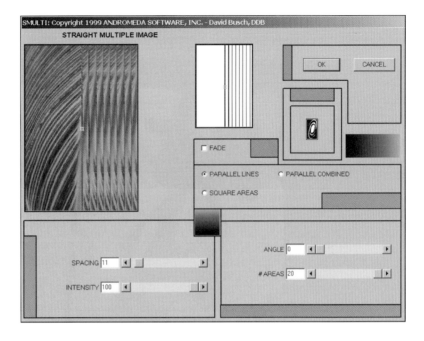

Figure 9.19
With fading turned off, the divisions between sections are more pronounced.

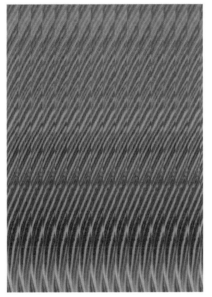

Star

This is one incredible filter with a mind-numbing degree of versatility. You can easily get caught up using it, trying variation after variation, each more interesting than the last.

Yet, Andromeda's Star filter is one of those high-concept tools you can grasp immediately: It produces stars with four, eight, or sixteen different points, with variable background "sun" blurs, and a halo you can control. One of my first uses for this filter was to resurrect a photo of the late blues singer Rev. Gary Davis, shown in Figure 9.20.

Figure 9.20
Addition of a simple star image brings this concert photo to life.

I managed to lose my black-and-white negatives of this particular concert, and could locate only a faded 35mm contact sheet, which I scanned at high resolution in an attempt to recapture a moving performance by the folk legend. The resulting image was OK, but didn't reflect the excitement of the moment. I used Photoshop's Hue/Saturation control to add an overall blue tone to the photo, then applied Andromeda's Star filter to make it come alive.

This filter has a multitude of controls, but they're worth learning. The Star filter's dialog box is shown in Figure 9.21. I used this filter with another image to add a bit of high-tech flair to a partial colorization of a black-and-white glamour photo. The original is shown in Figure 9.22. I'll explain how I used some of this filter's controls to produce the final image shown in Figure 9.23.

Figure 9.21
The Star filter's
dialog box.

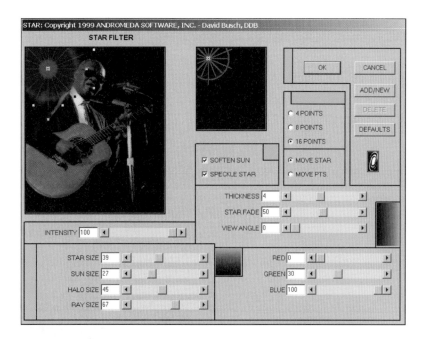

Figure 9.22
This partially colorized
black and white photo
could benefit from
three different kinds
of stars.

Figure 9.23
Notice the stars added to the eyes as catchlights, and to one earring.

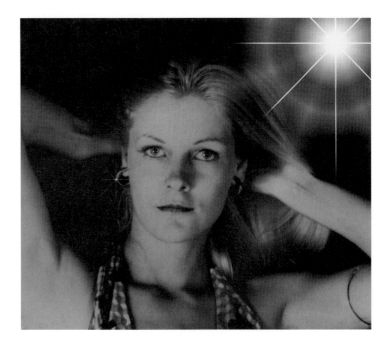

The first thing I added was the large, blurry star in the upper-right corner of the image. I chose 8 Points from the buttons in the dialog box, and marked the Soften Sun checkbox, leaving the Speckle Star box unchecked. Then I manipulated the Star Size, Sun Size, Halo Size, and Ray Size sliders at lower left to get the kind of star I wanted. Notice that you can manipulate all four of these components separately, so you can produce a large star with long or short rays, expand the sun as I did, and create (or eliminate) the secondary halo that surrounds the sun. At the right center of the dialog box are three sliders that let you adjust the thickness of the rays, how quickly they fade out, and set an angle from which to view the star. Our friend the Intensity slider (just under the preview window) can be used to set the opacity of the effect.

The final setting I made before applying this large star was to change its color. By default, this filter sets red, green, and blue colors to 100 percent, producing a white star. I wanted a yellow star to compliment the model's blonde hair, so I reduced the amount of the opposite color of yellow (blue) to about 80 percent. As you learned earlier in Chapter 6, reducing the amount of blue adds yellow, just as reducing the amount of green adds magenta, and dialing down the red boosts the cyan.

Next, I added some star-shaped catchlights to the model's eyes. I kept the eight-pointed star, but reduced its size to a setting of 5, cut down the length of the rays to the same amount, and set the sun and halo size to zero, eliminating them entirely. Oddly enough, if there weren't all the other stars in this photo, you probably wouldn't notice the star catchlights. Test viewers have remarked on how sparkly the model's eyes look, but didn't specifically notice the star shapes until I pointed them out. One subtle change I made was to mark the Speckle Star checkbox, so the star's rays are softly fragmented rather than blurred straight lines.

You can see the speckle effect more clearly on the star I placed on the model's earring. I also clicked the Move Pts checkbox, so that I could drag the individual points of the star, making them each longer or shorter as I preferred. If you look closely, you can see that the rays are not of uniform length.

One easily overlooked feature is the ADD/NEW button. Ordinarily, you'd want to create each star individually using the parameters you want, and clicking the OK button to apply the star before moving to the next one. If you click ADD/NEW while working on one star, the plug-in adds another star in the *same* preview window. You can move this star to the position you want, and then apply the other parameters to all the active stars at once. This is a good technique for creating multiple stars with the same characteristics.

Velocity

The Velocity filter smears your highlights in a direction you choose to simulate a motion blur. Unlike Photoshop's own Motion Blur filter, Andromeda's Velocity filter lets you smear in arcs, merge in different ways, and create a fade-out effect. Figure 9.24 shows the filter's dialog box.

Figure 9.24
The Velocity filter's
dialog box.

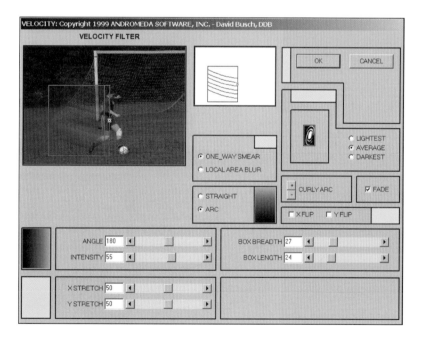

Use the Box Breadth and Box Length sliders to set the size of the box that is used to create the blur, and choose an angle and intensity (opacity) for your effect. The blur always extends from the rectangle with the X mark in the direction shown in the parameter pre-view window (the smaller pane to the right of most Andromeda filter main preview windows). You can choose two kinds of blur: The Local Area Blur uses repeating copies

of the smeared area which gradually fade out, and the One Way Smear blurs the colors from one edge of the selected rectangle and spreads them across the entire rectangle, as you can see in Figure 9.25.

This is one filter that almost demands use of the Intensity slider to provide exactly the right amount of transparency to let some of the background image show through the blur. Other options let you switch between a straight or arced path for the blur, choose a curly or a "comet tail" shape for the blur, and distort the blur in the X and Y dimensions. Figure 9.26 shows a typical application for this filter, to create a motion blur effect in a sports photograph.

Figure 9.25
This is an example of the One Way Smear technique with the Velocity filter.

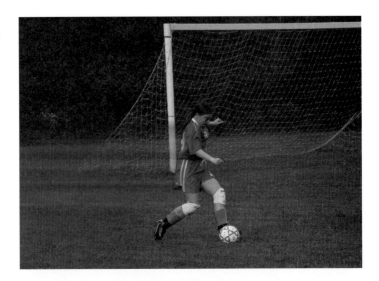

Figure 9.26
The Velocity filter can create a realistic motion blur.

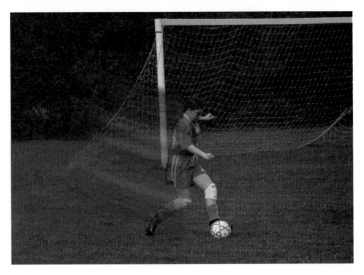

Velociraptor

How's this for cool: A filter with a *secret* dialog box. Andromeda's Velociraptor is a variation on the Velocity filter, with many more options and features, not the least of which is access to a hidden dialog box that turns this plug-in into a whole new tool. The default dialog box looks like the one shown in Figure 9.27. It resembles the dialog for Velocity in some respects, but has additional options, such as Bounce, Diagonal, and Wave, in addition to Straight and Arc shaped blurs. You can opt for ordinary streaks, or have them trail or converge in interesting ways. A Presets button produces a list of predesigned streak shapes, but you can choose from Sine wave and other shapes by clicking the Plus and Minus buttons. Click the Preview button to see how your blurred image will look. In the default mode, Velociraptor can produce images like the one shown in Figure 9.28.

Figure 9.27
Velociraptor's default
dialog box.

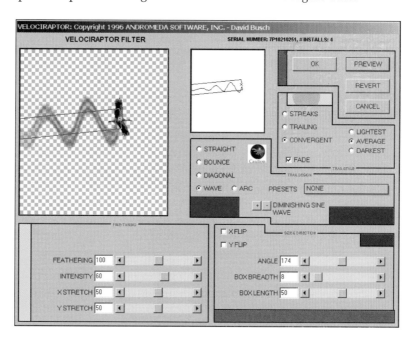

The surprises start when you use the filter through an alternate way. If you select the object you want to blur, and then invert your selection (press Shift+Ctrl/Command+I) and then access Velociraptor, a changed dialog box appears, like the one shown in Figure 9.29. You notice that the Feathering slider has been replaced by a Smoothing slider that blends the edges of the image in a different way, and that Loops have been added to the available trail shapes. In the lower-right corner of the dialog box is a pair of sliders labeled Copies and Spacing, which let you produce duplicates of your blurred image, spaced apart from each other by a distance you designate. Figure 9.30 shows the kind of image you can get with Velociraptor in this mode.

Figure 9.28
A drunken stork in
flight, or a
manipulation with the
Velociraptor filter?

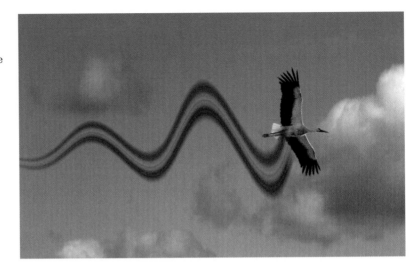

Figure 9.29
Velociraptor's alternate
dialog box.

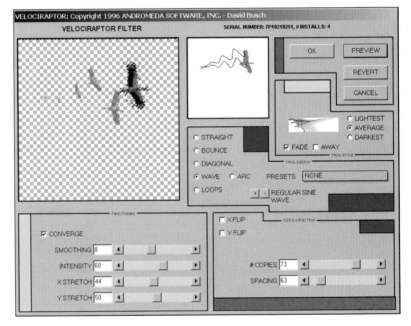

Figure 9.30
Interesting effects
like this one don't
rely on motion blur for
their look.

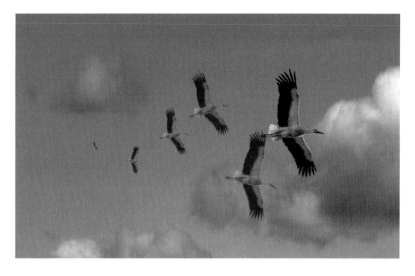

Rainbow

Andromeda's Rainbow filter does things that it would be very, very difficult to reproduce
with Photoshop alone. It can reproduce some very realistic rainbows, too, complete with
the fading that you expect to see with this aerial phenomenon. The filter's dialog box is
shown in Figure 9.31.

Figure 9.31
The Rainbow filter
dialog box.

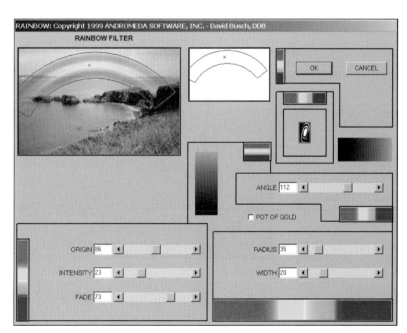

You can bend the rainbow into an arc of your choice, specifying the angle, radius, and width of the effect. Selecting the Pot Of Gold checkbox deposits a little yellow mound at the nether end of your rainbow. You may want to use the Intensity slider to make the rainbow semitransparent, and use the fade control to have it gradually vanish before it touches down, just like a real rainbow does. However, I took some liberties with the image shown in Figure 9.32, as you would never really see a rainbow alighting on the water quite like that, and it would appear in the distant sky, not in the foreground. But if you can't use Photoshop to create things that don't exist in real life, why have all these features at your disposal?

Figure 9.32
There's no pot of gold here, and the rainbow is artificial, too.

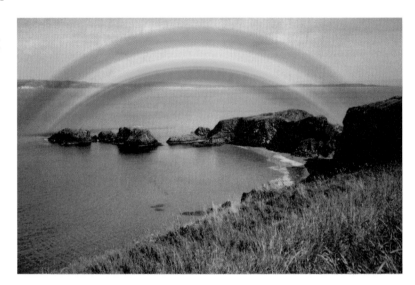

VariFocus

This is an incredible filter that is of particular use to digital photographers. It returns variable focus to the digital imager's bag of tricks. You don't need to be a professional photographer to know that not everything in an image appears to be in focus. The object on which you focus is always sharpest, with an additional range in front of and behind that plane of focus acceptably sharp. This depth of field varies depending on the lens opening (f-stop) used, distance to the subject, and the magnification used. A very large f-stop or a long (telephoto) lens or telephoto setting on a zoom produces less depth of field than a small f-stop and a wide-angle lens. Limited depth of field is a popular tool photographers use to concentrate interest on the most important part of the picture.

However, one of the big problems with digital cameras is that the lenses have relatively short focal lengths for the amount of magnification they provide, so the photographer's usual tool of using a large lens opening or a longer lens to limit the depth of field may not be practical. With a digital camera, virtually everything is in focus, all the time, unless you're shooting an extreme close-up.

VariFocus lets you regain some control over what's sharp and what's not. Its dialog box is shown in Figure 9.33. As one of the newer filters in the Andromeda line, it has a less Spartan interface than most of the earlier filters. There is also (thank goodness!) built-in help for this filter. Just point to a control to learn what it does. VariFocus operates by creating selection masks which it uses to selectively blur portions of your image.

Figure 9.33
The VariFocus
dialog box.

You can choose from an array of selection shapes in the lower-right corner of the dialog box, specify whether you want to blur (defocus) or sharpen the selected area, and you can click on any of the four buttons (with a pair of Rs in them) in the middle of the dialog box to rotate the selection. The button with the apple icon stores your selection so you can reuse it later. The Radius slider controls the amount of blur applied, while the Scale slider can enlarge or reduce the selected blur area. Click the Shift button above the blur selection preview window at the upper right of the dialog box if you simply want to move the selection around the image area. Click the Distort button instead, and drag the blur selection to change its shape.

Wondering what the little towel-bar shaped icon is in the upper-right corner of the dialog box? It's a handle, just as it appears to be! Drag it to move the VariFocus dialog box around the screen. Figure 9.34 shows an image that has been given the selective focus treatment with this useful filter.

CHAPTER 9

Figure 9.34
Use variable focus to concentrate attention on a single portion of an image.

Perspective

The Perspective filter provides powerful tools for moving an image or selection in 3-D space, as if it were mounted on a sheet of foam board that you can rotate in any direction. You work as if you are viewing the image from a camera, changing the camera position as necessary to get different effects.

This is a more sophisticated Andromeda filter than most of the others discussed so far in this chapter, offering a library of perspectives to choose from and the facility of saving your own perspectives for reuse later. There are quite a few controls packed into the dialog box in Figure 9.35. I'll start at the upper-left corner of the dialog box and describe each briefly:

▶ **S button**: Saves the current camera position for reuse later.

▶ **Thumbnail window**: Shows the currently selected preset. Click this to apply the preset camera view shown in the thumbnail. This overrides any view you may have created using the other controls.

▶ **Preset button**: Click this to browse a library of camera angles you may want to apply to your image.

▶ **Arrow triangles**: The four large outer triangles move the camera up, down, left, or right around the center of the image. The two angled inner triangles move the camera closer or farther from the image, functioning like a dolly control.

▶ **Spinners**: Directly under the arrow triangles are two spinner buttons that rotate the image clockwise or counterclockwise.

Figure 9.35
The Perspective filter's
dialog box.

▶ **Zoom bar**: The bar under the arrows is a slider that controls zooming in and out of the image. This control differs from the dolly controls in a subtle way. Zooming enlarges or reduces the size of the whole image. The dolly arrows actually move the imaginary camera closer to the center of the image, making the near portions of the image somewhat larger in proportion to the rest of the image, which is "farther" away.

▶ **Camera positions**. The three buttons stacked on the right side directly under the Zoom bar let you choose from various standard camera positions.

▶ **Reset button**: Clicking the hammer icon returns the Perspective filter to its default settings.

▶ **New Color**: This button, directly under the hammer icon, lets you choose a new color for the area outside the selection being rotated.

▶ **Grid button**: Click this to toggle the wireframe grid on or off.

▶ **Save button**: Click the file folder icon to save your current settings as a preset for later use.

The Perspective filter is a powerful 3-D tool for which you can find dozens of uses. Try it yourself using the **Monkey** photo, shown in Figure 9.36, and supplied on the CD-ROM bundled with this book. I rotated the image, duplicated the rotated layer and filled it with a red tone, then used Layer > Layer Style to add a drop shadow to the red layer, producing the final image shown in Figure 9.37.

CHAPTER 9

Figure 9.36
Start with this photo of
a brocade monkey
ornament.

Figure 9.37
Rotate the layer, add a
duplicate layer toned
red, and apply a drop
shadow to create
this effect.

LensDoc

The LensDoc filter simplifies correcting for the barrel distortion (outward bulging) or pincushion effect (inward bulging) produced by some lenses. See Figure 9.38 for examples. Although you might be only vaguely aware of the phenomenon (unless you have a photo with straight lines that don't appear totally straight), it's common enough. Indeed, the LensDoc filter includes presets for correction of barrel distortion in some common lens types, including three for the Nikon CoolPix 950, two others for additional digital cameras, and a very long list of lenses from Canon, Nikon, Minolta, Sigma, and other vendors. Choose one of these presets to automatically fix the built-in distortion in your lens. The dialog box is shown in Figure 9.39.

Figure 9.38
Pincushioning (left) and barrel distortion (right).

Figure 9.39
LensDoc's dialog box.

You can correct for perspective problems, fix rotated images, and perform other first aid. While the filter can correct many problems automatically, most manual repairs just require dragging some marker handles to line up the photo's ideal orientation. If that's not enough, this filter also has presets for some fun-house effects, such as the one shown in Figure 9.40.

Figure 9.40
LensDoc can create
neat fun-house effects.

Next Up

The final chapter in this book deals with the end result of many digital or conventional photographs: a print. You learn about your printing options, as well as some tips for getting the best, most economical hard copies you've ever seen.

10

Hard Copies Made Easy

The photographic print has a long and glorious history in photography. The earliest daguerreotypes and tintypes were very print-like, even though they were made of thin sheets of metal: They were positive images viewed by reflective light that could be displayed in frames or passed around for viewing. Later, paper prints grew beyond the original fuzzy efforts of William Fox Talbot to evolve into fully detailed copies made from film or glass-plate negative originals, becoming the standard destination for photographic images.

Prints are what we think of when our mind's eye pictures a "photograph." Even photos originally captured and viewed as transparencies on a light box or with a slide projector frequently end up as reflective hard copies. Conventional photographers creating images with 120-format and larger transparency film or 35mm color slides make prints of their work. Digital photographers may capture, view, and store their images on a computer, but they still prize hard copies for display or distribution. Despite entirely new channels for viewing photographic images, such as Web pages or electronic presentations, prints remain an important destination for a significant number of pictures. This chapter explores some of the print options available with Photoshop, as always, from the photographer's viewpoint.

Why Prints?

Back in 1990, I worked on the PR team that created publicity materials for an exciting new product: the Kodak Photo CD. The scientists who developed the technology showed me dozens of exciting applications for this high-resolution digital format. Many of these have come to pass, and today, more than a dozen years later, you can drop your pictures off at any retail photofinishing outlet and receive an inexpensive photo CD along with your prints. Professional photo CDs are an important option for photographers who want to distribute their portfolios electronically in a format that allows both previewing of low-resolution prints and sale of "locked" high-resolution versions.

However, one of the most hyped capabilities of photo CD technology never caught on. The prototype photo CD players I looked at were cool enough. You could flip through your photo CD albums at high speed on your own television screen, zooming in to view interesting details, moving back and forth in slide-show fashion. Plans were to have inexpensive printmakers attached to the photo CD player to make hard copies. By the twenty-first century, families would view their snapshots clustered around their television or home entertainment center. Certainly, prints would still be made, but viewing pictures on the TV would soon be the most popular mode.

What happened? What saved us from endless hours viewing the neighbor's vacation pictures on television? The answer is a simple one: Humans are in love with prints. We fight to get the first look at handfuls of snapshots fresh from the photofinisher. We select our favorites for sharing, and we like to hide or destroy the ones that make us look ugly. It's fun to pass a stack of photos around, letting each person view them at his own speed, hurrying through the boring ones and stopping to linger over the compelling images. Most of the time you don't want to call everyone into the family room to look at photos on the TV. You want to look at them where and when you want to.

Moreover, you can't stick a photo CD on the refrigerator with a magnet or tack one on the wall of a cubicle at work. Photo CDs don't look good framed on the mantel, and they can't be shown off in a gallery. Despite the encroachments of technology, we still like *prints*.

As a result, you can expect that prints will remain the favored end result of photography in both digital and conventional realms. Most amateur photographers who use film cameras work with negative films and make prints. Even color transparencies, favored by professional photographers for their superior quality when reproduced, usually end up as paper prints or published in magazines.

Recently, digital photography has made some dramatic changes in the way we work with our images. Unlike photos captured on film, every digital picture you take isn't routinely converted into a print by a photofinisher. In that respect, digital pictures are like the color slides favored by amateurs and pros alike in the 1950s. Color slides and digital pictures are typically viewed on a screen and only the very best end up as prints.

Digital technology has further refined photographic Darwinism. Thanks to the "quick erase" buttons on many digital image grabbers, some pictures are deleted from your solid state "film" before they even make it out of the camera. Only the most photographically fit images survive. Anyone who has shot an entire roll of film just to get a shot or two that was worth printing can appreciate the film-saving economy of a digital camera.

A significant number of electronic images are never intended for hard copies that you can pass around and show to friends. You might take a picture for a Web page—such as the one shown in Figure 10.1—drop a shot into your PowerPoint presentation, or place an image in a desktop publication without the slightest need for a print.

Figure 10.1
Many photos are displayed only on Web sites and never are made into hard copies at all.

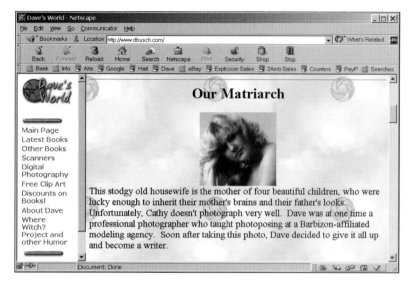

Even so, we'll always need prints, and, if anything, the availability of inexpensive photo-quality printers encourages digital photographers to make bigger and better prints of their efforts, where they might have been satisfied with small 4×6-inch prints from the photo-finisher before. Photoshop and rampant computer technology not only lets you limit your hard copies to the prints you really want, but make the prints you do create better looking, with better colors, in larger sizes, and more quickly than ever before.

Color Prints as Proofs

Most of the time, your color prints are your finished product, whether your intent is to display the print in a frame or pass it around among friends and colleagues. A print is a typical end product for most amateur and professional photographers. If the print looks good to you, that's usually enough. You may need to work with Photoshop's color correction tools or your computer's color management system (as outlined in Chapter 6) so that producing pleasing color prints is fast and easy.

PROOFS VS. PROOFS

The word "proofs" has a dual meaning in photography. Portrait and wedding photographers create proof prints that are used by clients to select their final images. Today, it's more common to display proofs using a projection system or digital viewing system in the actual finished size of the print, but hard-copy proofs are still used for this purpose. A second kind of proof, discussed in this section, is a print used to judge the color balance and quality of an image as it will appear when printed.

However, professional photographers and serious photographic artists may have additional hard-copy concerns related to print permanence and image accuracy that aren't addressed fully by any of the output options outlined in the rest of this chapter. One of the most common pro applications for color prints are as *proofs*, which are high-accuracy color prints designed to reflect as closely as possible how an image will appear when printed. While prepress operations are beyond the scope of this book (and covered in depth by classics like Dan Margulis' *Professional Photoshop*), you should know some of what is involved.

In the printing industry, proofs are made of images that have been separated into their component colors (cyan, magenta, yellow, and black in the case of full-color images). Chromalin proofs are a standard, albeit expensive, way of producing accurate color proofs of these color images. Chromalins are film proofs made using a patented DuPont system of mixing colored cyan, magenta, yellow, and black dye powders to approximate the printed colors, in the case of full-color images. (Chromalins can also be produced to proof spot color images using other colors of ink.) They provide a way of previewing a printed image without actually making plates and printing it on a press.

For digital prints, it's becoming more common to use Scitex Iris digital proofing devices, a kind of superexpensive inkjet printer on steroids that can produce hyperaccurate, hyperdetailed photos, for both proofing and making art prints intended for display. The quality is truly gorgeous, but the equipment is expensive (justifiable only by a service bureau or a high-volume internal department), and you should be prepared to pay $50 and up per print. Affordable desktop proofing devices, priced at a few thousand dollars, but capable of printing 11×14 and 11×17-inch photos or larger, are available from companies such as Hewlett-Packard and Epson.

Once you reach this print-output stratosphere, you find that Photoshop has all the tools you need to create professional output. For example, Photoshop lets you print CMYK hard proofs from files that have been saved in CMYK format (not RGB) and include color calibration bars and registration marks. The File > Print with Preview dialog box, shown in Figure 10.2, lets you select any of these aids.

Figure 10.2
Photoshop lets you print hard proofs of CMYK images with registration marks and color calibration bars.

Your Output Options

If you want to examine digital printers using the darkroom analogy, they roughly correspond to an automated print-processing system. You feed the paper into the processor, and the finished print comes out the other end. As with a darkroom print processor, you have relatively little control over the print once processing begins. The job of the printer/processor is to control variables and produce similar results every time when fed similar photos. A printer provides the repeatability and ease of use that a print processor offers. Photoshop and the printing controls included in your printer's driver software are the "enlarger" component in our digital darkroom.

If you still have doubts that paper prints will continue to thrive in the digital age, check out the ads in your local newspaper. You'll find sales on dozens of different color printers, including many capable of photo-quality reproduction priced from $99 to $149. You'll also see blurbs for photofinishers eager to make prints from your digital images sent to them over the Internet, on CD-ROM, or the most popular memory card formats. You'll also see promotions for those stand-alone photo kiosks that make it easy to capture an image of a print through a built-in scanner, or view your digital pictures from CD, floppy disk, or memory card, then crop, rotate, enlarge, and print them while you wait. There are many options for creating hard copies, and you'll find all of them useful from time to time.

Laser Printers

If you work with text documents, create desktop publications, generate lots of overhead transparencies, or are involved in other business printing, you may already have a black-and-white or color laser printer (or, alternatively, one that uses light-emitting diodes—LEDs—to create an image instead of a laser). For business printing and making copies of documents, laser printers are great.

They're fast, especially when multiple copies are made, they use ordinary paper, and subsist on a diet of powdered toner that is, page for page, much less expensive than the pigments or dyes used for other printing systems. However, these printers are best suited for text and line art. If you have business documents with black text spiced with spot color charts and graphs or colored headlines added for emphasis, a laser printer is ideal.

Photographers find many applications for both black-and-white and color laser printers. For example, even a monochrome laser can produce an acceptable grayscale image that can be pasted into a layout on a "for position only" (FPO) basis. You can run off twenty or thirty copies quickly and inexpensively and route them for approval of pose or content, saving color hard copies for final approval. A color laser printer can be used for the same purposes at a slightly higher per-page cost, but with the added dimension of color. You might not want to use your laser printer for proofing, but it can have many other uses. When my daughter's cat ran astray, we printed up 100 "Have You Seen Our Kitten?" miniposters on my black-and-white laser printer at a cost of a few cents per page. I've also used color laser printers for low-cost, print-on-demand publications, such as the one shown in Figure 10.3.

Laser page printers are particularly fast when making multiple copies of the same original. The image is downloaded to the printer once, charging an electrically-sensitive drum, which revolves at high speed, picking up toner and applying it to a sheet of paper. Once a page has been imaged on the drum, you can print multiple copies as quickly as the printer can feed sheets of paper. Inkjet printers, in contrast, must print each and every page dot by dot, line by line, whether you're printing one copy or 100 of the same image.

Color page printers work in much the same way as their black-and-white cousins. However, each image is run through the exposure, image writing, and toning steps four times, once each for the cyan, magenta, yellow, and black portions of the image. Obviously, separate toning stations must be provided inside the printer for each color, making for a larger, bulkier device. Once all four colors of toner are transferred to the electrically charged drum or belt, they are transferred to the paper and permanently fused with heat to the paper.

Because of their complexity, color page printers are often considerably more expensive, with the least expensive models starting at around $1,200 and moving swiftly to the $3,000 and up price range. Laser-type color printers typically don't provide quality that is as good as other types of printers for photographic output, but do much better on fine lines and text. These printers are best suited for spot color—images with specific elements that must be represented in cyan, magenta, yellow, red, green, blue, or some other

shade. The consumables cost for ordinary paper and the color toners is likely to be less than for an inkjet printer, so if you have many images to print, a color laser can reduce your incremental per-print costs.

Figure 10.3
Color lasers are excellent for low-run, print-on-demand publications.

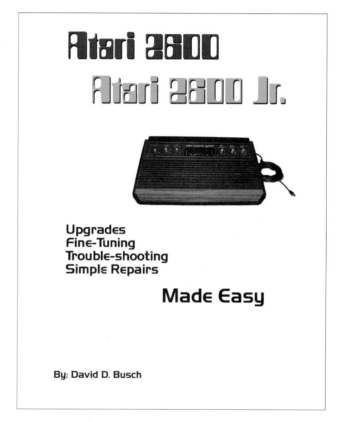

Inkjet Printers

Inkjet printers have become ubiquitous. You can buy them in your supermarket for $50, trot down to your electronics or computer store and purchase a photo quality model for around $100, or spend as little as $300 to $400 for an inkjet specifically designed to print eye-popping color photos on glossy or matte paper. These printers are cheap enough to buy so that virtually any amateur photographer can afford one, and serious amateurs and pros can easily justify the best models available.

Whether you can afford to *operate* an inkjet printer is something else again. One of the reasons inkjets are priced so low is that the vendors tend to make lots of money on the consumables. One inkjet printer I purchased last year cost $75 on sale. One month and two ink cartridges later I'd spent more than my original investment on ink alone. I ended up giving the printer away and purchasing a more economical model.

Why do inkjet printers cost so much to operate? Start with the paper. Most inkjet printers can make acceptable prints on ordinary copier paper that costs a cent or two per sheet. However, the paper is thin and flimsy, has a dull paper-like finish, and neither looks nor feels like a real photograph. Plain paper inkjet prints have a look and quality that resembles a picture you might clip out of the newspaper rather than an actual photo.

For best results, you must use special "photo" papers that cost 50 cents to $1 a sheet or more. These sheets have a water-resistant plastic substrate that doesn't absorb ink, and they are coated with glossy and matte surfaces (on alternate sides, so you can print on whichever side of the sheet you need). Because the ink doesn't spread, the printer is able to apply smaller, more distinct dots of color, producing sharper photographic-quality prints. While the improved quality is important, a buck per print isn't cheap, especially if you like to experiment or if you make many mistakes.

Special paper is only part of the cost. Color ink cartridges can cost $25 to $35 each and generally must be used in conjunction with a black-and-white ink cartridge at $20 and up. Some printers use two color cartridges (a "strong" color cart for cyan, magenta, and yellow; and a "weak" color cart for cyan and magenta) to provide additional tones. A single cartridge may generate hundreds of pages if you're printing text that covers roughly 5 to 15 percent of the page. A full-color image, on the other hand, typically covers 100 percent of the area printed (whether it's a 4×6 print or a full 8×10) so you may get as few as 20 to 30 full-page prints per ink cartridge. Plan on allocating another $1 per page just for ink.

It gets worse. If your particular printer's ink cartridge includes all three colors in a single module, you may find that one color runs out even more quickly (because, say, you're printing images that contain lots of yellow) and you must throw away a cartridge even when there are plenty of the other hues in the remaining tanks.

Of course, you may want to try out one of those inkjet refill kits, which come with bottles of ink and one or more syringes. They can provide two or three fillings at less than the cost of a single, new tricolor cartridge. Some people swear by them, although I swear *at* them. The process takes a lot of time, which can be better spent taking pictures or working with Photoshop. If you have only one syringe, you must clean it with distilled water to remove all the ink before refilling another tank with a different color. If you use three syringes, you have to clean all three when you're done. The ink tends to spill and get all over your fingers and everything else in the vicinity. If you don't refill at exactly the right time, the innards of the cartridge may dry out, leaving you with a freshly refilled, nonworking ink cartridge. Nor can cartridges be refilled indefinitely. If your printer uses nozzles built into the cartridge itself, these nozzles may wear out after a few refills. You'll have to buy a new one at full price and start over.

Many inkjet printers accept third-party ink cartridges that cost half or a third of what the vendor sells them for. Of course, you must take your chances that the cartridges are as good and that the ink is of the same quality and permanence as that in the vendor's own cartridges.

Saving Money with Inkjets

In the long run, of course, even an inkjet printer that is the most expensive to operate is still cheaper to use than your photolab, and, for the Photoshop-adept, it provides much more control. Printing your own pictures is the equivalent of working in a darkroom: You can tailor your output precisely to your own needs. Even so, you don't have to pay top dollar for your inkjet prints. Here are some tips for saving money.

Reducing Paper Costs

Paper costs are easy to trim. Try these cost savers:

▶ Buy photo paper in larger quantities. A 50-sheet or 100-sheet pack can be 50 percent cheaper per sheet than the 10-sheet or 25-sheet packages. Buy smaller quantities only to test the quality of a particular kind of paper. Once you're certain you like it, stock up on the larger packages.

▶ Don't lock yourself into the vendor's product line. Vendors guarantee that their papers are compatible with their inks. In practice, there have been some combinations of paper stocks and inks that perform poorly, particularly when it comes to archival permanence. Use the wrong paper with the wrong ink and you may find yourself with faded photos in a few months. However, you should test a variety of papers, including generic store-brand stocks, to see which provide the best combination of performance and longevity. For example, many of the color prints I make are submitted to newspapers. I don't care what they look like three months later; I never see them again.

▶ Experiment with premium-quality, plain paper. I've used various brands with Bright White, Heavy Weight, or Premium Weight designations, including some that have a fairly glossy finish. I've even used old thermal printer paper stocks with inkjet printers. Paying $5.00 and up for a ream of "ordinary" paper can pay off if it gives you superior results when printing photos. You may have to test to see which of your printer's paper settings work best. For example, when I use glossy plain paper with my inkjet, I must use a high-resolution paper setting (but not any of the glossy photo paper settings) to get the best results.

▶ Choose appropriate print sizes. If a 5×7 can do the job (which is the case with the prints I submit for publication), don't make an 8×10. You can fit two 5×7s on a single 8.5×11-inch sheet, which cuts your cost for paper in half.

▶ Use plain paper instead of photo paper where plain paper does the job. You don't always need a glossy or matte photo-quality print. You'd be surprised at how good a picture can look on $2-a-ream paper that costs less than half a cent a sheet.

Reducing Ink Costs

The cost of ink is the consumable expense that offers the most options for control. Try these:

▶ Choose an ink-frugal printer. When I chucked my old ink-hog inkjet, I invested a whopping $149 in a Canon model that uses individual ink tanks for each color, plus black. I no longer worry about what mix of colors my prints have, or whether I'm about to deplete my yellow, cyan, or magenta inks. When one color runs out, instead of dropping a new $35 cartridge in the printer, I replace only one color tank, for $10 or less. As a bonus, my new printer's larger tanks get many more prints per color than my old clunker.

▶ Investigate less expensive ink sources. Actually, I don't pay anywhere near $10 for an ink tank. I found a source that sells Canon ink tanks, still factory sealed, for half the regular price. If you can't find discounted ink cartridges or tanks for your printer, check out third-party cartridges, which are available for the most common Epson and Hewlett-Packard models.

▶ Give one of those ink refilling kits a try. If you like to tinker and aren't as clumsy as I am, these could work for you. Shop carefully so you purchase kits with good quality ink. And don't forget to buy some extra syringes.

▶ Watch those print sizes. An 8×10 uses a lot of ink. Save the larger sizes for your portfolio, or for display on a mantel.

How Inkjets Work

Inkjet printers work exactly as you might think—by spraying a jet of ink onto a piece of paper, under precision computer control. Images are formed a dot at a time with a fine stream of ink, either water based or solid (which is melted just before application) in disposable or (sometimes) refillable ink cartridges. With one common technology, piezoelectric crystals in the print head vibrate as electric current flows through them, issuing carefully timed streams of ink from a tiny nozzle, generating a precisely positioned dot.

Liquid inks tend to soak into regular paper, which enlarges the size of the dots in a process similar to the dot gain you see on printing presses. A low-end 720 dpi printer may produce output that looks no better than 300 dpi when the page dries. Liquid inks can also smear when wet. You may need to use a special paper stock for optimal results with this kind of printer.

The very first inkjet color printers used just three ink tanks—cyan, magenta, and yellow— and simulated black by combining equal quantities of all three colors. There may even be a few very low-end inkjet printers available that still use this method (I've seen no-name inkjet printers advertised as low as $19). However, there are several problems with the three-ink approach. So-called "composite blacks" tended to be brown and muddy rather than true black. In addition, black ink is a lot cheaper than colored ink, so it made little sense to use three times as much expensive ink to create black tones. Three-color printers are particularly wasteful when generating black-and-white pages, such as pages of text. So, most color inkjet printers today use four tanks, adding black. Some vendors have

experimented with printers that use a total of six color ink tanks, black, plus a "strong" cyan, "strong" magenta, and yellow ink plus a diluted "weak" cyan, and magenta (yellow only comes in one color: weak), to allow for creating many more color combinations.

The results with inkjet printers can be amazing. Figure 10.4 shows a nearly full-frame digital camera image of about 2000×1500 pixels. The yellow box around the little girl's face marks a 240×200-pixel area. Figure 10.5 shows the original digital camera image of that area at left, with a high-resolution (6400 dpi) scan of that area from an actual 5×7 digital print. While you can clearly see the ink dots in the close-up scan, the original print looks, for all intents and purposes, as if it were made on photographic paper from a photographic negative.

Figure 10.4
The original image looks like this—the enlarged portion in Figure 10.5 is highlighted in yellow.

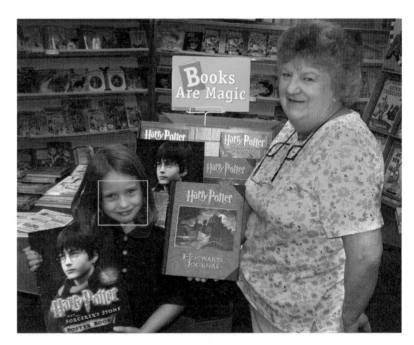

Figure 10.5
Even a tiny portion of the original image looks sharp when enlarged, both in the original (left) and the inkjet print (right).

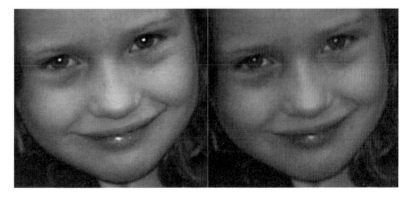

Inkjet printers are fairly low-maintenance devices. You have to clean the nozzles from time to time (the printer's driver software may offer an option for that chore). If the printer's nozzles are built into the printer itself rather than the ink cartridges, you may have to replace the nozzles after making many prints. I've personally found this to be a nonissue. My first "photo" printer, an ancient Epson Stylus Color from 1995 (which didn't produce true photo quality at all) is still plugging away with its original built-in print head after thousands of prints. Inkjet printers are now so inexpensive that you're likely to replace any model you own with a built-in print head within a year or two in favor of a newer, cheaper device that provides better quality, long before the original print head expires.

The chief danger to built-in heads is frequent changing of ink cartridges, especially those that have been refilled, because each change can introduce some dirt that can clog the head. I've had some luck cleaning my old Epson's print heads with a cotton swab dipped in alcohol.

It's also important to keep the paper path and advance mechanism clean, because any "stutter" in the movement of your paper can cause a pattern of white lines in the finished output.

Dye Sublimation Printers

A third type of color printer uses a thermal process to transfer dye to the printed page. The advantage of thermal dye sublimation is that the heat used to transfer the dye can be varied continuously over a range of zero to 255, so, many, many different shades of a given color can be printed; the hotter the printing element, the more dye is melted and applied. Other printers, in contrast, can provide only a single color of each pigment per dot (or, both strong and weak colors of each pigment), providing many fewer colors. Indeed, inkjet and laser printers use a dithering process to vary the amount of color by producing digital dots that are larger than the minimum size the printer can reproduce. That's why inkjet printers need high resolutions, on the order of 1440 to 2400 dots per inch or more, to achieve photo quality—dithering results in much lower effective resolution.

Dye-sub printers don't need dithering to produce many different colors. With 256 variations on each color available, such a printer can reproduce $256 \times 256 \times 256$ individual colors (16.8 million hues) at its maximum resolution. That's also why dye-sub printers don't need the superhigh resolution that inkjets require to achieve true photographic quality. If you want the absolute best quality reproduction of your images, a dye sublimation printer is your best choice.

Unfortunately, most affordable dye-sub photo printers produce only snapshot-size prints, chiefly because of the complexity of the printing system and the fact that dye-sub consumables make inkjet materials look cheap by comparison. So, you can't use a low-cost, dye-sub printer for enlargements, and their relatively low resolution means you can't use them to print documents. They are strictly photo printers. However, if you want to make lots of snapshots, a low-cost printer in this category can be a good choice.

Unlike inkjet devices, the typical dye-sub printer doesn't complete each line in all four colors before moving on to the next. Instead, each page is printed three or four times,

once in each color, depending on whether a three-color or four-color process is being used. These printers must maintain rigid registration between colors to ensure that the dots of each color are positioned properly in relation to those of other colors. The need for precise registration makes larger-format dye-sub printers (8×10 and larger) commensurately more expensive to design and produce. In most cases, only a professional photographer can justify a large-format dye sublimation printer.

How Dye Sublimation Printers Work

The dye sublimation device's print head includes tiny heating elements, which are switched on and off to melt dots of dye coated on a wide roll of plastic film. The roll contains alternating panels of cyan, magenta, yellow, and often black, each the size of the full page. The print head applies all the dots for one color at a time as the page moves past. Then the roll advances to the next color (each panel is used only once) and those dots are printed. After three or four passes, the full-color page is finished.

The dye-sub printer's image quality comes from its print head. However, these heaters aren't just switched on and off; their temperature can be precisely controlled to transfer as much or as little dye as required to produce a particular color. The dye sublimates—turns from a solid into a gas, without becoming liquid—and then is absorbed by the polyester substrate of the receiver sheet. However, a special receiver paper with a substrate and coating that accepts the dye transfer is required for this type of printer. Media costs can run to several dollars per page.

Because a dye-sub printer always uses all three or four panels in a set, some capacity is wasted if your image only requires one or two of those colors, or applies color only in a small area of a page. On the other hand, it costs no more to produce pages that have heavy color demands (such as overhead transparencies), so you may come out ahead of inkjet printers in cost (as well as image quality) if you do much work of that type. In addition, the capacity of each roll is precisely predictable: A roll capable of 100 images produces 100 images, no more, no less. You'll never wonder about when your dye-sub printers colors are about to poop out.

Because they don't need dithering to reproduce colors, dye sublimation printers can offer photographic quality without needing as high a linear resolution as other printers. The dots diffuse smoothly into the receiver sheet, producing smooth blending of colors. However, while you'd never notice that a dye-sub printer uses many fewer dots per inch to generate vivid full-color images, text printed in small sizes and finely detailed line art at that resolution definitely suffer from this diffusion. These printers are great for 24-bit images, but less stunning when your bitmaps are combined with text or lines. You might find such output useful for preparing special reports and other photo-intensive material in small quantities. Thermal sublimation printers are expensive (both to buy and to operate), and slow. Since these printers are entirely practical for use as color proofing devices, make sure you get and use a color matching system to calibrate your printer to the final output device.

Other Printer Types

There are other types of color printers, each with its own roster of advantages and disadvantages. For example, there are thermal wax printers, which use wax instead of ink or dye. While not as cheap as inkjet models, they are capable of producing great quality at high speeds. These printers no longer necessarily require special ultrasmooth paper, and many can now use ordinary paper cut into sheets.

Solid-ink printers use a block of wax or resin ink, which is melted and sprayed directly onto a page or applied to a drum that rolls against a piece of paper like an offset printing press. These so-called phase change printers are less finicky about paper quality, since the ink is not readily absorbed by the substrate. On the flip side, solid inks can produce washed-out overheads when you print on transparency material, so your choice between these two technologies should include that factor, as well as the extra ink costs of phase change printers.

Using Professional Services

Serious photographers can be loathe to let their pictures out of their control. After all, making a print can be as important a part of the creative process as taking a photo. Even so, your best choice for getting the hard copies may be letting a professional service handle it. There are hundreds of eager picture services ready to create prints for you. They'll output your images directly from your camera's film card or allow you to upload them over the Internet for printing at a remote site.

The easiest way is to stop in at your local department store and look for one of those stand-alone kiosks, like the Kodak Picture Maker. I've used these when I was on the run, going directly from a photo opportunity to a nearby discount store, making a print, and dropping it off at a newspaper with a handwritten cutline. Total elapsed time was 30 minutes, and the cost was only $5.99 for two 5×7 prints made from my camera's memory card.

Photo kiosks accept images in many formats, including SmartMedia and CompactFlash memory cards, plus CDs and Kodak Photo CDs, floppy diskettes, or original prints, slides, or negatives. The latter are captured with a built-in scanner. It's worthwhile to check out your local kiosk *before* you need pictures in a crunch. The one located nearest to me doesn't accept memory cards and works only with original prints, floppy disks, and Photo CDs (not conventional CD-Rs with photos you've burned yourself). Determine whether the kiosk accepts the file types with which you want to work, such as PCX or TIF. You may have to present the device with a JPG file when using a memory card, for example. (Save your JPG in its highest resolution, and you may not notice any loss of quality.)

This option is quick-and-dirty, but you don't lose all control. The kiosk's software has tools for fixing bad color, removing red-eye, and adding borders or text. You can crop, enlarge, or reduce your photos, but not with complete freedom. You may have to crop using the aspect ratio of your selected picture size (for example, 5×7 or 8×10) and you may be unable to produce an odd-size image (say, a 3×7) using the kiosk's controls alone.

(You can add white space yourself using Photoshop's tools, then print a 5×7 with very, very wide borders along the long dimension, for example.)

The kiosk lets you print various combinations of pictures that will fill an 8.5×11-inch sheet, such as a single 8×10, two 5×7s, four 4×5s, and so forth, but only with duplicates of a single image. You can't print two different 5×7's on one sheet, for example, without creating a special image in Photoshop. I've done this on occasion, ganging several images in one file, then printing it on the kiosk as an 8×10.

You can also find printing services online. Companies like Kodak PhotoNet let you upload your images, display them on Web pages, or order prints. There also are firms that accept unprocessed or processed film and convert them to both hard copies and digital images that you can share, download over the Internet, or choose to receive on a Photo CD. These are a good choice for those using conventional film and prints, but who don't have a scanner to make digital copies.

Getting Set Up

If you're setting up your first photo quality printer, there are a few things to consider beyond those already discussed. Here are some points to think about.

▶ If you're selecting a printer and have a choice between one that has only a parallel port connection and one that has a universal serial bus (USB) connection (or both USB and parallel), choose the USB printer. Printers used with Photoshop have traditionally had parallel port connections (under Windows) or conventional serial port links (under Mac OS). While those worked fine in the past, the traditional ports had some serious drawbacks, including limitations on the number of printers you could attach to your computer. The universal serial bus can handle 127 different devices, eases installation (especially under Windows; Microsoft's operating system will automatically locate your new printer and install the right drivers under most conditions), and allows hot swapping. You could, for example, unplug one USB printer and replace it with another, or with another device, such as a scanner, without bothering to reboot. While you can buy parallel-to-USB adapters that let you plug a parallel printer into a USB port, a native USB printer is your best choice.

▶ Take the time to calibrate your monitor, scanner, and printer, as described in the manuals that came with each, and use Photoshop's calibration/ characterization tools (discussed in Chapter 6). Spend the time now so that what you see more or less resembles what you get.

▶ Use plain paper rather than the expensive photo paper to do all your test prints and calibrations. As the long-distance commercial says, you can save a buck or two.

▶ Take some time to compare the results you get with different paper stocks and using different paper settings in your printer's driver. Don't automatically assume that choosing Plain Paper, Pro Paper, or Glossy Paper in the driver will give you the best results with any particular type of printing media.

▶ Don't go overboard when you first get your printer set up. Resist the urge to print everything on your hard disk just to see how it looks. Instead, use Photoshop's Contact Sheet and Picture Package features to create multiple images on a single page to save time, paper, and ink.

A Typical Print Session

Each color printer you use will have its own options and features. I'm going to follow the typical workflow you might use to print a particular photograph to illustrate the choices you may have to make. Unless you use the same Canon inkjet printer I used, you can't follow along exactly, but I hope you'll get the general idea nevertheless.

1. Choose File > Print and, if you have more than one printer attached to your computer, select the printer you'd like to use from the drop-down list. The printer you've selected as your default printer will appear in the dialog box automatically, as shown in Figure 10.6.

Figure 10.6
Your printer dialog box will show your default printer automatically.

2. Click Properties to produce your printer's particular options dialog box, shown in Figure 10.7. Your printer's dialog box will probably include several tabs to divide the choices by type of feature. This illustration shows the Canon printer's General properties.

Figure 10.7
Set the default printer options in a dialog box like this one.

CHAPTER 10

3. Choose the general properties you want to apply. In this case, I can choose from among:

—Paper type, including plain paper, various types of photo paper, photo film, transparencies, and other specialized stocks.

—Paper source, including the autofeed paper tray and individual sheet feeder. Your printer may have additional paper trays to choose from.

—Image quality, from among High (slow), Standard, and Draft (fast) choices.

—Automatic or manual color adjustment, letting you use the printer's built-in color tools or settings that you manipulate yourself, like those shown in Figure 10.8.

—Whether you want grayscale printing of a color image.

—This particular Canon printer also has a Print Advisor wizard that leads you through the various options for printing.

Figure 10.8
Many printers have automatic and manual color adjustment, a tool of last resort or a way of by-passing Photoshop if you're in a hurry.

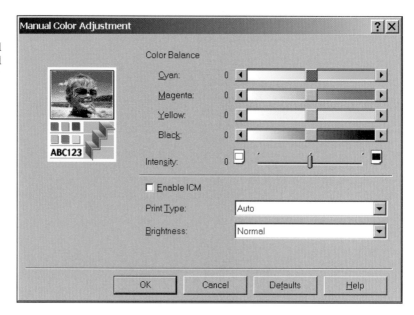

4. Click the Page Setup tab (or your printer's equivalent) and choose from among options like those shown in Figure 10.9.

 —Page Size, which is different from Paper Size. Some printers let you print pages that are larger than the paper size by automatically scaling the image down to fit the paper size you choose.

 —Paper Size. Choose any paper size supported by your printer.

 —Printing Type. Choices may include normal size printing, printing a page scaled to fit your particular page, poster printing (an image will be divided and printed in segments on several sheets which can be butted together to form a larger, poster image), and banner printing (which divides an image to create a long, banner type print made up of several sheets).

 —Orientation, either tall (portrait) or wide (landscape).

 —Number of copies.

Figure 10.9
Set the orientation,
paper size, and other
page parameters in
a dialog box like
this one.

5. Click the tab for your printer's stamp/background or overprinting tab (or the equivalent). This option, shown in Figure 10.10, lets you create proof prints by putting watermarks or other messages on top of the image, as well as a background image of your choice. Portrait and wedding photographers like this feature because it lets them mark their proof prints in such a way that a client can't easily take their proofs to another photographer or their local photo kiosk and make their own copies.

6. If your printer has an Effects tab, or something similar, you can use this dialog box to apply some Photoshop-like effects at the last minute, such as image smoothing, monochrome toning, and so forth. This option, shown in Figure 10.11, can be handy if you're in a hurry and don't have time to apply these effects in Photoshop.

Figure 10.10
Some printers let you overlay an image with a watermark of some sort.

Figure 10.11
Some Photoshop-like effects may be available with your printer driver.

7. Profiles are an option provided by some printers to let you set up categories of print jobs that can be selected with a few clicks. Parameters include the type of paper, paper source, quality level, orientation, and most of the other choices offered on the previous pages. With Profiles, shown in Figure 10.12, you can reuse a set of parameters with later jobs of the same type.

Figure 10.12
Profiles let you set
printing parameters for
reuse later.

CHAPTER 10

8. Click the Maintenance tab, shown in Figure 10.13 and found in virtually
 every inkjet printer's driver, to perform important tasks like nozzle clean-
 ing and print head alignment. Nozzles should be cleaned when your
 printer has sat idle for a few days or any time enough ink has dried in the
 nozzles to partially or completely block some of the head's orifices. You'll
 want to realign your print heads when you change ink cartridges. Realign-
 ment doesn't actually change the alignment of the print heads themselves;
 it informs your printer's driver software of their precise position so the
 actual location can be taken into account when printing. The printer gen-
 erates a test sheet with horizontal and vertical lines arranged in a pattern.
 You choose the pattern that shows the lines aligned properly, using a dia-
 log box like the one in Figure 10.14.

Figure 10.13
Printer maintenance
tasks include nozzle
cleaning and print
head alignment.

Figure 10.14
Choose the set of
printed lines that are
best aligned to
optimize your results.

Tips for Getting the Best Digital Prints

If you make prints from your digital images yourself, you'll want to keep these tips in mind to get the best quality and best economy.

▶ Use Photoshop's provision for calibrating your monitor, using the Adobe Gamma Control Panel (Windows and Mac OS) or the Apple Calibration Utility (Mac OS). You'll find instructions for using the Adobe tool in Chapter 6. Your scanner also may have calibration procedures to help match your scanner's output to your printer. This will help ensure that what you see (on your monitor) is what you get (in your prints). If you're an advanced worker, learn to use the color matching software provided with your particular printer. Every device comes with different software, so we can't cover them here, but most have wizards and other tools to let you calibrate or characterize your equipment quickly.

▶ As mentioned earlier, if image quality is important to you, get the best glossy photographic paper for printing out your images. Experiment with several different stocks to see which you like best. You'll probably find that the paper offered by your printer manufacturer will be fine-tuned for your particular printer, but you needn't limit yourself to those products.

▶ Don't lose one of those expensive sheets to a paper jam. If you're making prints one at a time, load your printer with one sheet of photo paper each time. Load multiple sheets only if you want to print many pages unattended, and even then make sure that only photo paper is loaded.

▶ Remember to clean your inkjet's print heads periodically and keep the printer's rollers and paper path clean. You'll avoid blurry or spotted prints and unwanted artifacts like visible lines.

▶ Don't touch your prints after they've emerged from the printer. Give them a chance to dry before you handle them. If you can't spread them out individually and must place them in stacks, put a sheet of plain paper between your prints so that any ink won't transfer to the print above.

▶ Experiment with special paper stocks that let you get even more use from your digital prints. You'll find paper designed especially for making t-shirt transfers, fabric printing, making greeting cards, or creating overhead transparencies.

▶ Don't enlarge digital camera images more than the resolution of your camera allows. Use these guidelines as a rule of thumb. The sensor dimensions in pixels are approximate, as different digital cameras offer different sized sensors in the same megapixel range:

Camera Resolution	Recommended Maximum Print Size
640×480 pixels (.3 Mpixels)	4×5-inches
1024×768 pixels (.75 Mpixels)	5×7-inches
1280×960 pixels (1.2 Mpixels)	8×10-inches
1600×1280 pixels (2 Mpixels)	11×14-inches
2400×1600 pixels (3.3 Mpixels)	16×20-inches
3600×2400 pixels (6 Mpixels)	20×30-inches

Next Up

The next step is up to you. Neither photography, in its last 160+ years, nor Photoshop, in its briefer dozen years of life, has been fully explored by their millions of devotees. I hope this book has been an idea starter that showed you some of the exciting things you can do with the power of Photoshop and photography combined.

Glossary

Here is a list of the most common words you're likely to encounter when working with photographs in Photoshop. It includes most of the jargon included in this book, and some that is not within these pages, but which you'll frequently come across as you work.

additive primary colors
Red, green, and blue, used alone or in combinations to create all other colors you view on a computer monitor, or capture with a digital camera. Photoshop's default RGB mode uses these colors, even when you're working in other color modes, such as CMYK (Cyan, Magenta, Yellow, Black). See also *CMYK*.

Figure Glossary.1
The additive primary colors, red, green, and blue combine to make other colors, plus white.

airbrush

Originally an artist's tool that sprays a fine mist of paint, used for illustration or retouching. Photoshop includes an airbrush tool.

ambient lighting

Diffuse nondirectional lighting that doesn't appear to come from a specific source but, rather, bounces off walls, ceilings, and other objects.

anti-alias

A process in Photoshop that smoothes the rough edges in images (called jaggies or staircasing) by creating partially transparent pixels along the boundaries that are merged into a smoother line by our eyes.

Figure Glossary.2
A diagonal line that has been anti-aliased (left) and a "jaggy" line that displays the staircasing effect (right).

aperture-preferred

A camera setting that allows you to specify the lens opening, with the camera selecting the shutter speed automatically, based on its light-meter reading. See also *shutter-preferred*.

artifact

A type of noise in an image, or an unintentional image component produced in error by a digital camera or scanner.

aspect ratio
The proportions of an image. An 8×10-inch or 16×20-inch photo each has a 4:5 aspect ratio. Your monitor, when set to 800×600, 1024×768, or 1600×1200 pixels, has a 4:3 aspect ratio. When you change the aspect ratio of an image, you must crop out part of the image area.

autofocus
A camera setting that allows the camera to choose the correct focus distance for you.

background
Photoshop calls the bottom layer of an image the background, while in photography, the background is the area behind your main subject of interest.

backlighting
A lighting effect produced when the main light source is located behind the subject. You can use Photoshop to simulate this effect by selecting the subject and pasting it down in its own layer, then creating a lighting effect behind it. See also *frontlighting, fill lighting, and ambient lighting.*

balance
An image that has equal elements on all sides.

bilevel image
An image that stores only black-and-white information, with no gray tones; a bitmap in Photoshop terminology.

bit
A binary digit—either a 1 or a 0—now used to measure the color depth (number of different colors) in an image. For example, a grayscale 8-bit scan may contain up to 256 different tones (2^8), while a 24-bit scan can contain 16.8 million different colors (2^{24}).

bitmap
Within Photoshop, a bitmap is a bilevel black/white-only image. The term is also used to mean any image that represents each pixel as a number in a row and column format.

black
The color formed by the absence of reflected or transmitted light.

blend
To create a more realistic transition between image areas, as when retouching or compositing in Photoshop.

GLOSSARY

blur

To soften an area by reducing the contrast between pixels that form the edges.

Figure Glossary.3
Blurring reduces the contrast between pixels.

brightness

The amount of light and dark shades in an image, usually represented as a percentage from zero percent (black) to 100 percent (white).

burn

A darkroom technique, mimicked in Photoshop, which involves exposing part of a print for a longer period, making it darker than it would be with a straight exposure. Photoshop's Burn tool darkens areas of the image.

calibration

A process used to correct for the differences in the output of a printer or monitor when compared to the original image. Once you've calibrated your scanner and Photoshop, the images you see on the screen more closely represent what you get from your printer, even though calibration is never perfect.

cast

An undesirable tinge of color in an image.

CCD
Charge-Coupled Device. A type of solid-state sensor used in scanners and digital cameras.

chroma
Color or hue.

chromatic color
A color with at least one hue and a visible level of color saturation.

chrome
An informal photographic term used as a generic label for any kind of color transparency, including Kodachrome, Ektachrome, or Fujichrome.

CIE (Commission Internationale de l'Eclairage)
An international organization of scientists who work with matters relating to color and lighting. The organization is also called the International Commission on Illumination.

close-up lens
A lens add-on that allows you to take pictures from a distance that is less than the closest focusing distance of the lens alone.

CMY(K) color model
A way of defining all possible colors in percentages of cyan, magenta, yellow, and, frequently, black. Black is added to improve rendition of shadow detail. CMYK is commonly used for printing (both on press and with your inkjet or laser color printer). Photoshop can work with images using the CMYK model, but converts any images in that mode back to RGB for display on your computer monitor.

Figure Glossary.4
Cyan, magenta, yellow colors combine to form the other colors, plus black.

color correction
Changing the relative amounts of color in an image to produce a desired effect, typically a more accurate representation of those colors. Color correction can fix faulty color balance in the original image or compensate for the deficiencies of the inks used to reproduce the image.

comp
A preview that combines type, graphics, and photographic material in a layout. A comp is also called a composite or comprehensive.

compression
Reducing the size of a file by encoding, using fewer bits of information to represent the original. Some compression schemes, such as JPEG, operate by discarding some image information, while others, such as TIF, preserve all the detail in the original, discarding only redundant data.

continuous tone
Images that contain tones from the darkest to the lightest, with a theoretically infinite range of variations in between.

contrast
The range between the lightest and darkest tones in an image. A high-contrast image is one in which the shades fall at the extremes of the range between white and black. In a low-contrast image, the tones are closer together.

Figure Glossary.5
High-contrast image (left); low-contrast image (right).

crop
To trim an image or page by adjusting its boundaries.

density
The ability of an object to stop or absorb light. The less the light is reflected or transmitted by an object, the higher its density.

depth-of-field
A distance range in a photograph in which all included portions of an image are at least acceptably sharp.

desaturate
To reduce the purity or vividness of a color, making a color appear to be washed out or diluted.

diffusion
The random distribution of gray tones in an area of an image, producing a fuzzy effect.

dither
A method of distributing pixels to extend the number of colors or tones that can be represented. For example, two pixels of different colors can be arranged in such a way that the eye visually merges them into a third color.

Figure Glosssary.6
A dithered image.

dodging
A darkroom term for blocking part of an image as it is exposed, lightening its tones. Photoshop's Dodge tool can be used to mimic this effect.

dot gain
The tendency of a printing dot to grow from the original size to its final printed size on paper. This effect is most pronounced on offset presses using poor quality papers, which allow ink to absorb and spread, reducing the quality of the printed output, particularly in the case of photos that use halftone dots.

dot
A unit used to represent a portion of an image, often groups of pixels collected to produce larger printer dots of varying sizes to represent gray.

dots per inch (dpi)
The resolution of a printed image, expressed in the number of printer dots in an inch. You often see dpi used to refer to monitor screen resolution, or the resolution of scanners. However, neither of these use dots; the correct term for a monitor is pixels per inch (ppi), while a scanner captures a particular number of samples per inch (spi).

dummy
A rough approximation of a publication, used to evaluate the layout.

dye sublimation
A printing technique in which solid inks are heated and transferred to a polyester substrate to form an image. Because the amount of color applied can be varied by the degree of heat (and up to 256 different hues for each color), dye sublimation devices can print as many as 16.8 million different colors.

emulsion
The light-sensitive coating on a piece of film, paper, or printing plate. When making prints or copies, it's important to know which side is the emulsion side so the image can be exposed in the correct orientation (not reversed). Photoshop includes "emulsion side up" and "emulsion side down" options in its print preview feature.

export
To transfer text or images from a document to another format.

eyedropper
A Photoshop tool used to sample color from one part of an image, so it can be used to paint, draw, or fill elsewhere in the image.

existing light
In photography, the illumination that is already present in a scene. Existing light can be daylight or the artificial lighting currently being used, but not electronic flash or additional lamps set up by the photographer.

fill
In photography, lighting used to illuminate shadows. In Photoshop, fill is the process of covering a selected area with a solid, transparent, or gradient tone or pattern.

focal length
A measurement used to represent the magnification of a lens.

focus range
The range in which a camera is able to bring objects into sharp focus.

framing
In photography, composing your image in the viewfinder. In composition, using elements of an image to form a sort of picture frame around an important subject.

frontlighting
Illumination that comes from the direction of the camera.

f-stop
The lens aperture, which helps determine both exposure and depth of field.

Figure Glossary.7
F-stop.

filter
In Photoshop, a feature that changes the pixels in an image to produce blurring, sharpening, and other special effects. In photography, a device that fits over the lens, changing the light in some way.

flat
An image with low contrast.

flatbed scanner
A type of scanner that reads a line of an image at a time, recording it as a series of samples, or pixels.

four-color printing
Another term for process color, in which cyan, magenta, yellow, and black inks are used to reproduce all the colors in the original image.

frequency
The number of lines per inch in a halftone screen.

full-color image
An image that uses 24-bit color; 16.8 million possible hues. Images are sometimes captured in a scanner with more colors, but the colors are reduced to the best 16.8 million shades for manipulation in Photoshop.

gamma
A numerical way of representing the contrast of an image. Devices such as monitors typically don't reproduce the tones in an image in straight-line fashion (all colors represented in exactly the same way as they appear in the original). Instead, some tones may be favored over others, and gamma provides a method of tonal correction that takes the human eye's perception of neighboring values into account. Gamma values range from 1.0 to about 2.5. The Macintosh has traditionally used a gamma of 1.8, which is relatively flat compared to television. Windows PCs use a 2.2 gamma value, which has more contrast and is more saturated.

gamma correction
A method for changing the brightness, contrast, or color balance of an image by assigning new values to the gray or color tones of an image to more closely represent the original shades. Gamma correction can be either linear or nonlinear. Linear correction applies the same amount of change to all the tones. Nonlinear correction varies the changes tone-by-tone, or in highlight, midtone, and shadow areas separately to produce a more accurate or improved appearance.

gamut
The range of viewable and printable colors for a particular color model, such as RGB (used for monitors) or CMYK (used for printing).

Gaussian blur
A method of diffusing an image using a bell-shaped curve to calculate the pixels which will be blurred (rather than blurring all pixels), and thus producing a more random, less "processed" look.

grayscale image
An image represented using 256 shades of gray. Scanners often capture grayscale images with 1024 or more tones, but reduce them to 256 grays for manipulation by Photoshop.

halftone
A method used to reproduce continuous-tone images, representing the image as a series of dots.

Figure Glossary.8
A halftoned image.

highlight
The lightest part of an image with detail.

hue

The color of light that is reflected from an opaque object or transmitted through a transparent one.

indexed color image

An image with 256 different colors, as opposed to a grayscale image, which has 256 different shades of the tones between black and white.

interpolation

A technique Photoshop uses to create new pixels required whenever you resize or change the resolution of an image, based on the values of surrounding pixels. Devices such as scanners and digital cameras can also use interpolation to create pixels in addition to those actually captured, thereby increasing the apparent resolution or color information in an image.

ISO (International Standards Organization)

A governing body that provides standards used to represent film speed, or the equivalent sensitivity of a digital camera's sensor.

invert

In Photoshop, to change an image into its negative; black becomes white, white becomes black, dark gray becomes light gray, and so forth. Colors are also changed to the complementary color; green becomes magenta, blue turns to yellow, and red is changed to cyan.

jaggies

Staircasing effect of lines that are not perfectly horizontal or vertical, caused by pixels that are too large to represent the line accurately. See also *anti-alias*.

JPEG (Joint Photographic Experts Group)

A file format that supports 24-bit color and reduces file sizes by selectively discarding image data.

landscape

The orientation of a page in which the longest dimension is horizontal, also called wide orientation.

lens aperture

The lens opening that admits light to the film or sensor. The size of the lens aperture is usually measured in f-stops. See also *f-stop*.

lens flare

A Photoshop feature borrowed from conventional photography, where it is an effect produced by the reflection of light internally among elements of an optical lens. Bright light sources within or just outside the field of view cause lens flare. Flare can be reduced by the use of coatings on the lens elements or with the use of lens hoods. Photographers sometimes use the effect as a creative technique, and Photoshop includes a filter that lets you add lens flare at your whim.

Figure Glossary.9
Lens flare.

lens hood
A device that shades the lens, protecting it from extraneous light outside the actual picture area which can reduce the contrast of the image, or allow lens flare.

lighten
A Photoshop function that is the equivalent to the photographic darkroom technique of dodging. Tones in a given area of an image are gradually changed to lighter values.

line art
Usually, images that consist only of white pixels and one color, represented in Photoshop as a bitmap.

line screen
The resolution or frequency of a halftone screen, expressed in lines per inch.

lithography
Another name for offset printing.

lossless compression
An image-compression scheme, such as TIFF, that preserves all image detail. When the image is decompressed, it is identical to the original version.

lossy compression
An image-compression scheme, such as JPEG, that creates smaller files by discarding image information, which can affect image quality.

luminance
The brightness or intensity of an image, determined by the amount of gray in a hue.

LZW compression
A method of compacting TIFF files using the Lempel-Ziv Welch compression algorithm, one of Photoshop's optional compression schemes.

maximum aperture
The largest lens opening or f-stop available with a particular lens, or with a zoom lens at a particular magnification.

mechanical
Camera-ready copy with text and art already in position for photographing.

midtones
Parts of an image with tones of an intermediate value, usually in the 25 to 75 percent range. Many Photoshop features allow you to manipulate midtones independently from the highlights and shadows.

moiré
An objectionable pattern caused by the interference of halftone screens, frequently generated by rescanning an image that has already been halftoned. Photoshop can frequently minimize these effects by blurring the patterns.

monochrome
Having a single color, plus white. Grayscale images are monochrome (shades of gray and white only).

noise
In an image, pixels with randomly distributed color values. Noise in digital photographs tends to be the product of low-light conditions, particularly when you have set your camera to a higher ISO rating than normal.

negative
A representation of an image in which the tones are reversed: blacks as white, and vice versa.

neutral color
In Photoshop's RGB mode, a color in which red, green, and blue are present in equal amounts, producing a gray.

parallax compensation
An adjustment made by the camera or photographer to account for the difference in views between the lens taking the picture and the viewfinder.

Photo CD
A special type of CD-ROM developed by Eastman Kodak Company that can store high quality photographic images in a special space-saving format, along with music and other data.

pixel
A picture element of a screen image.

pixels per inch (ppi)
The number of pixels that can be displayed per inch, usually used to refer to pixel resolution from a scanned image or on a monitor.

plug-in
A module such as a filter that can be accessed from within Photoshop to provide special functions.

point
Approximately 1/72 of an inch outside the Macintosh world, exactly 1/72 of an inch within it.

portrait
The orientation of a page in which the longest dimension is vertical, also called tall orientation. In photography, a formal picture of an individual or, sometimes, a group.

prepress
The stages of the reproduction process that precede printing, when halftones, color separations, and printing plates are created.

process color
The four color pigments used in color printing: cyan, magenta, yellow, and black (CMYK).

red eye
An effect from flash photography that appears to make a person or animal's eyes glow red. It's caused by light bouncing from the retina of the eye, and it is most pronounced in dim illumination (when the irises are wide open) and when the electronic flash is close to the lens and therefore prone to reflect directly back. Photoshop can fix red eye through cloning other pixels over the offending red or orange ones.

Figure Glossary.10
Red eye, caused by light bouncing off the retina of the eye.

red-eye reduction
A way of reducing or eliminating the red-eye phenomenon. Some cameras offer a red-eye reduction mode that uses a preflash that causes the irises of the subject's eyes to close down just prior to a second, stronger flash used to take the picture.

reflection copy
Original artwork that is viewed by light reflected from its surface, rather than transmitted through it.

register
To align images, particularly overlays and color separations, so all components are in the proper spatial relationship with each other.

registration mark
A mark that appears on a printed image, generally for color separations, to help in aligning the printing plates. Photoshop can add registration marks to your images when they are printed.

resample
To change the size or resolution of an image. Resampling down discards pixel information in an image; resampling up adds pixel information through interpolation.

resolution
In Photoshop, the number of pixels per inch, used to determine the size of the image when printed. That is, an 8×10 inch image that is saved with 300 pixels per inch resolution prints in an 8×10-inch size on a 300 dpi printer, or 4×5-inches on a 600 dpi printer. In digital photography, resolution is the number of pixels a camera or scanner can capture.

retouch
To edit an image, most often to remove flaws or to create a new effect.

RGB color mode
A color mode that represents the three colors[md]red, green, and blue[md]used by devices such as scanners or monitors to reproduce color. Photoshop works in RGB mode by default, and even displays CMYK images by converting them to RGB.

saturation
The purity of color; the amount by which a pure color is diluted with white or gray.

Figure Glossary.11
Fully saturated (left)
and desaturated (right).

scale
To change the size of a piece of an image.

scanner
A device that captures an image of a piece of artwork and converts it to a digitized image or bitmap that the computer can handle.

sensitivity
A measure of the degree of responsiveness of a film or sensor to light.

shutter-preferred
An exposure mode in which you set the shutter speed and the camera determines the appropriate f-stop. See also *aperture-preferred.*

SLR (single-lens reflex)
A camera in which the viewfinder sees the same image as the film or sensor.

SmartMedia
A type of memory card storage for digital cameras and other computer devices.

selection
In Photoshop, an area of an image chosen for manipulation, usually surrounded by a moving series of dots called a selection border.

shadow
The darkest part of an image, represented on a digital image by pixels with low numeric values or on a halftone by the smallest or absence of dots.

sharpening
Increasing the apparent sharpness of an image by boosting the contrast between adjacent pixels that form an edge.

smoothing
To blur the boundaries between edges of an image, often to reduce a rough or jagged appearance.

solarization
In photography, an effect produced by exposing film to light part way through the developing process. Some of the tones are reversed, generating an interesting effect. In Photoshop, the same effect is produced by combining some positive areas of the image with some negative areas. Also called the Sabattier effect, to distinguish it from a different phenomenon called overexposure solarization, which is produced by exposing film to many, many times more light than is required to produce the image. With overexposure solarization, some of the very brightest tones, such as the sun, are reversed.

spot color
Ink used in a print job in addition to black or process colors.

subtractive primary colors

Cyan, magenta, and yellow, which are the printing inks that, when combined, theoretically absorb all color and produce black. In practice, however, they generate a muddy brown, so black is added to preserve detail (especially in shadows). The combination of the three colors and black is referred to as CMYK. (K represents black, to differentiate it from blue in the RGB model.)

telephoto

A lens or lens setting that magnifies an image.

thermal wax transfer

A printing technology in which dots of wax from a ribbon are applied to paper when heated by thousands of tiny elements in a printhead.

threshold

A predefined level used by the scanner or Photoshop to determine whether a pixel will be represented as black or white.

thumbnail

A miniature copy of a page or image that provides a preview of the original. Photoshop uses thumbnails in its Layer and Channels palettes, for example.

Figure Glossary.12
Thumbnail images in the Channels palette.

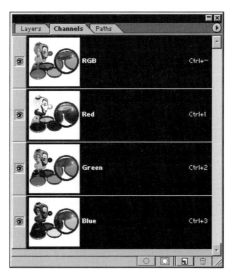

TIFF (Tagged Image File Format)

A standard graphics file format that can be used to store grayscale and color images plus selection masks.

time exposure

A picture taken by leaving the lens open for a long period, usually more than one second. The camera is generally locked down with a tripod to prevent blur during the long exposure.

tint
A color with white added to it. In graphic arts, often refers to the percentage of one color added to another.

tolerance
The range of color or tonal values that will be selected, with a tool like Photoshop's Magic Wand, or filled with paint, when using a tool like the Paint Bucket.

transparency scanner
A type of scanner that captures color slides or negatives.

tripod
A three-legged device used to steady and support a camera during framing and exposure. Single-legged versions called unipods are also available.

unsharp masking
The process for increasing the contrast between adjacent pixels in an image, increasing sharpness.

USB
A high-speed serial communication method commonly used to connect digital cameras and other devices to a computer.

viewfinder
The device in a camera used to frame the image. With an SLR camera, the viewfinder is also used to focus the image if focusing manually. You can also focus an image with the LCD display of a digital camera, which is a type of viewfinder.

vignetting
Dark corners of an image, often produced by using a lens hood that is too small for the field of view, or generated artificially using Photoshop techniques.

white point
In Photoshop, the lightest pixel in the highlight area of an image.

white balance
The adjustment of a digital camera to the color temperature of the light source. Interior illumination is relatively red; outdoors light is relatively blue. Digital cameras often set correct white balance automatically, or let you do it through menus. Photoshop can do some color correction of images that were exposed using the wrong white balance setting.

zoom
In Photoshop, to enlarge or reduce the size of an image on your monitor. In photography, to enlarge or reduce the size of an image using the magnification settings of a lens.

Appendix
Photoshop Menu/Command Summary

Photoshop Working Area and Main Palettes

Figure A.1

Title Bar
name of the application

Menu Bar
select menu commands

Option Bar
choose options for tools

Tool Palette
select tool

Document
work on image here

Navigator Palette
view entire image

Tool Presets
define tool defaults

Info Palette
see color, size, position
information about
document

Channels Palette
work with colors, stored
selections

History Palette
undo steps in any order

Status bar
shows zoom ratio,
document information,
instructions for using
current tool

Paths Palette
work with
curves and
shapes

Styles Palette
create and use
layer styles

Swatches Palette
choose
specific colors

Paragraph Palette
justify text,
choose other
paragraph
options

Actions Palette
create and
run macro
commands

Palette Well
store
palettes here
for easy
access

Character Palette
choose type
parameters,
including
font, size,
and distance
between
lines

Layers Palette
work with
image layers

Color Palette
select colors
using color
chooser,
sliders, or by
entering
color values

File Browser

Figure A.2

file navigation

thumbnails

preview

file information

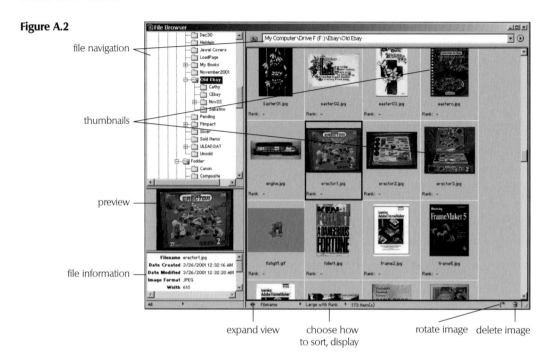

expand view

choose how
to sort, display

rotate image delete image

Brushes Palette

Figure A.3

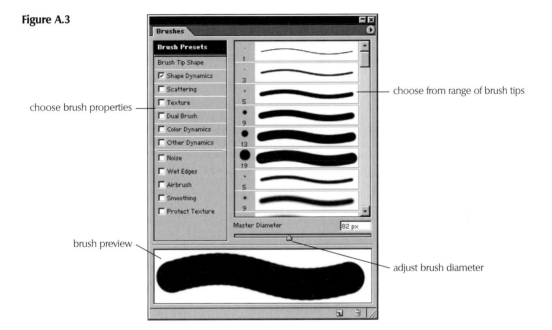

choose brush properties

choose from range of brush tips

brush preview

adjust brush diameter

File Menu

Figure A.4

open new or existing files

close or save files

place PDF, Illustrator, or EPS
files in image

load files from your scanner
or camera

export paths to Adobe
Illustrator

manage documents
within workgroup

use batch processing
features

read saved information
about file

print document

jump to ImageReady

quit Photoshop

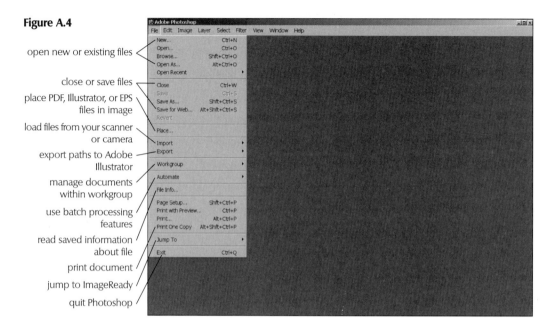

Edit Menu

Figure A.5

undo last step
redo last step
move backward one step
fade last filter
cut from clipboard
copy from clipboard
paste from clipboard
spellcheck
replace or find text
fill selection
stroke edges of selection
transform selection in many ways
perform only one transformation on selection
create new brush
create new pattern
define a shape
remove contents of clipboard, undo, or history

define Photoshop preferences manage tool presets manage color settings

Image Menu

Figure A.6

change color/grayscale mode

adjust brightness/contrast, hue, color, other parameters

create copy of the image

merge layers using blending modes

merge channels using blending modes

adjust pixel dimensions of image

enlarge or reduce image canvas

rotate the image

crop the image

crop image based on pixel color

show all layers

show graph of image pixel color intensity level

create overlap so stacked colors merge smoothly

Layer Menu

Figure A.7

create new layer

duplicate selected layer

delete a layer

change layer parameters

apply drop shadow or
other layer style

create a fill layer

create an adjustment layer

modify layer contents

rasterize type or apply other
type options

rasterize shape or apply
other options

create slice in a layer

create a layer mask

activate/deactivate
layer mask

create vector mask

activate/deactivate
vector mask

group linked objects
together

ungroup objects

align objects

align objects to a selection

remove pixels
from edges of
an object

combine all
visible layers and
discard others

combine visible
layers

combine
linked layers

fix linked
layers

space
objects

Select Menu

Figure A.8

select all pixels in a document

deselect all pixels

redo last selection

reverse selection

make selection based on colors

fade selection edge

expand, contract, or make other changes to selection

expand selection to contiguous pixels

select pixels similar in color values to selected pixels

change the shape of a selection

load a saved selection

store the current selection on disk

Filter Menu

Figure A.9

last filter applied

remove edge pixels

distort image

create new pattern

filter submenus

View Menu

Figure A.10

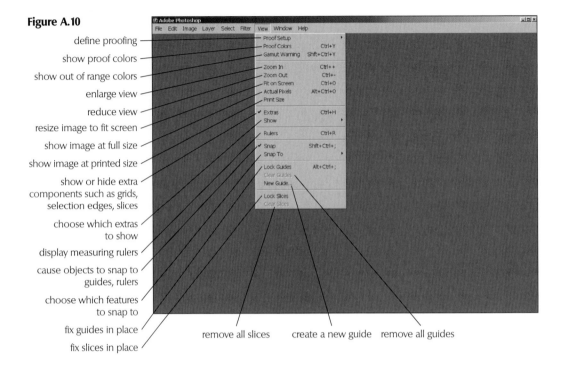

define proofing

show proof colors

show out of range colors

enlarge view

reduce view

resize image to fit screen

show image at full size

show image at printed size

show or hide extra
components such as grids,
selection edges, slices

choose which extras
to show

display measuring rulers

cause objects to snap to
guides, rulers

choose which features
to snap to

fix guides in place

fix slices in place

remove all slices create a new guide remove all guides

Window Menu

Figure A.11

arrange document windows and access specific open document

save current window, palette arrangement, and access saved arrangements

choose which palettes and information bars to display

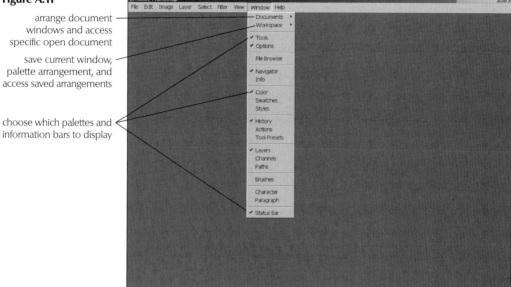

Help Menu

Figure A.12

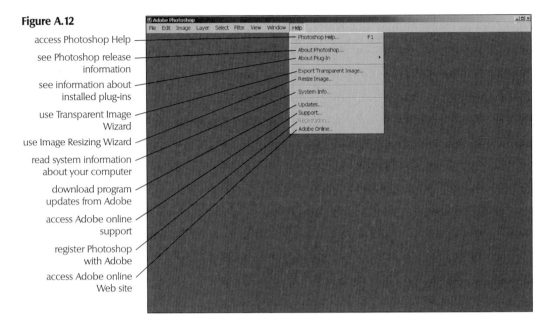

access Photoshop Help

see Photoshop release information

see information about installed plug-ins

use Transparent Image Wizard

use Image Resizing Wizard

read system information about your computer

download program updates from Adobe

access Adobe online support

register Photoshop with Adobe

access Adobe online Web site

Tool Palette

Figure A.13

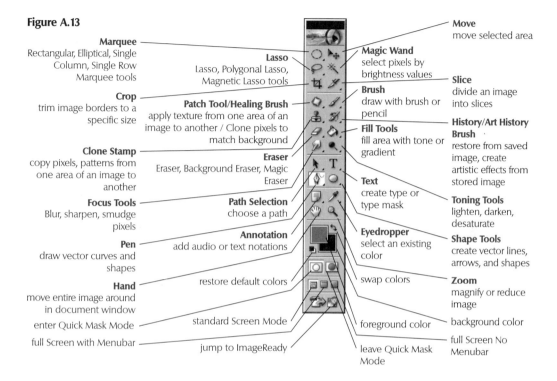

Marquee
Rectangular, Elliptical, Single Column, Single Row Marquee tools

Lasso
Lasso, Polygonal Lasso, Magnetic Lasso tools

Magic Wand
select pixels by brightness values

Move
move selected area

Crop
trim image borders to a specific size

Patch Tool/Healing Brush
apply texture from one area of an image to another / Clone pixels to match background

Brush
draw with brush or pencil

Slice
divide an image into slices

Clone Stamp
copy pixels, patterns from one area of an image to another

Eraser
Eraser, Background Eraser, Magic Eraser

Fill Tools
fill area with tone or gradient

History/Art History Brush
restore from saved image, create artistic effects from stored image

Focus Tools
Blur, sharpen, smudge pixels

Path Selection
choose a path

Text
create type or type mask

Toning Tools
lighten, darken, desaturate

Pen
draw vector curves and shapes

Annotation
add audio or text notations

Eyedropper
select an existing color

Shape Tools
create vector lines, arrows, and shapes

Hand
move entire image around in document window

restore default colors

swap colors

Zoom
magnify or reduce image

enter Quick Mask Mode

standard Screen Mode

foreground color

background color

full Screen with Menubar

jump to ImageReady

leave Quick Mask Mode

full Screen No Menubar

Index

INDEX

best engineered
Photoshop™ compatible plug-ins